Form, Style, Tradition

Form, Style, Tradition

Reflections on Japanese Art and Society

by Shuichi Kato

translated from the Japanese by John Bester

University of California Press
Berkeley, Los Angeles, London

University of California Press
Berkeley and Los Angeles, California
University of California Press, Ltd.
London, England
Copyright © 1971, by
The Regents of the University of California
ISBN: 0-520-01809-5
Library of Congress Catalog Card Number: 79-129612
Printed in the United States of America
Designed by Dave Comstock and Ikuko Workman

Contents

Chronology for Japanese Art

Period	Dates
Period	*Dates*
Asuka	552–645
Hakuhō ⎫ (Nara)	645–710
Tempyō ⎭	710–794
Early Heian	794–897
Late Heian (Fujiwara)	897–1185
Kamakura	1185–1392
Muromachi	1392–1573
Momoyama	1573–1615
Edo	1615–1867
New Japan	1868–

Introduction

The meaning of art is no longer self-evident in our society. Mass education systematically emphasizes the importance of artistic traditions. Contemporary artists, on the other hand, constantly expose the public to puzzling objects, which are not easily reconciled with any concept of art. Never before has art been so popular; never before has avant-garde art alienated such a great part of the educated population. Not long ago Impressionists, for instance, might have shocked the moral sense of the public in Paris, but certainly did not perplex the public over what the art was all about. Dada, rather in a brutal way, challenged the traditional concept of art. But its whole movement was confined to an extremely restricted circle of artists, writers and snobs. In the present situation, a

large public is alienated by artists, and artists themselves are bewildered by their environment: highly industrialized society and its values. "Rome a ses droits, seigneur," said Bérénice, "n'avez vous pas les vôtres?" But what are rights of the artist in a society with values contradicting his own?

The artist is an artisan surviving in our technological age. With his skill and knowledge, which are an integrated part of his personality, the artist exercizes personal control over the whole process of production, in a time when the predominant type of work is marked by rational organization which assigns a specific role to each individual, eliminating largely the need of personal skill and strong character. But this is not all. The artist today still bears the heritage from the nineteenth century: individualism, by virtue of which artistic creation means self-expression before everything else. Striving for self-expression, the artist defines, and constantly redefines, his relation to the world. This attitude is basically incompatible with what society demands: adaptation to the world as it is; efficiency in achieving a given target which is ultimately directed toward an increased sum of material comforts.

Generally speaking, if the values held by the artist are fundamentally different from those prevailing in society, he has two alternatives: either to revolt against the regime, trying to change the society, or to revolt against the traditional style of art, looking for the means to express his own values. When the October Revolution created a new society, Russian painting did not acquire a new style (except perhaps during a brief period which immediately followed the Revolution). When Cubism radically changed the style of Western painting, it had nothing to do with the idea of changing the structure of society itself. Creation of new forms, so it seems, usually takes place in a relatively stable society. A question may arise: why are "revolutionary" artists traditional in style, while those who are "conservative" are often radical in search for a new style?

A high level of industrialization implies an enormous increase in informations of all kinds. Works of art from all historical periods, and from all parts of the world, are now made

accessible to the public by sophisticated techniques of reproduction. Painting embraces everything from Lascaux to Picasso; sculpture means any statue on earth from the banks of the Nile to the plateau in the Andes. The concept of art which was elaborated in terms of the greco-roman classics obviously does not hold any better than the Chinese aesthetic principle, *ch'i yün*, which prevailed for a thousand years in the East. Every period must have its own criteria, every culture should be taken into account. What new concept of art can legitimize all those objects to be included in the vast *musée imaginaire* of the world?

Another implication of industrial society is a series of new means of expression for the artist: television, electronics, steel and plastic, etc. These machines and materials are quickly becoming available everywhere, irrespective of local culture and artistic tradition. Needless to say that the impacts of industrialization are so powerful as to bring about common patterns in different societies. Now given universal means of expression, living in similar environments, facing therefore the same kinds of problems, artists of different nationalities tend to develop a common style, or so to speak, an international artistic language: abstract expressionism in painting, functionalism in architecture, duodecaphony in music, just to quote a few examples.

From the same language, however, does not necessarily follow the same statement. An international style does not always mean, fortunately enough, an art without national character. Artistic creation, if it is creation at all, has been, and still is, bound up with the specific national culture of the artist. In other words, the life of an artist today is inevitably conditioned by the confrontation between the universality of artistic language, created by our technological age, and the particularity of sensibility which grows out of a certain national cultural background. In this respect it may be worth noting the case of modern Japan, where the impacts of industrialization are far-reaching, artistic traditions are firmly rooted in national life, and artists are struggling with the problems which arise

from superimposing two cultures: industrial and traditional.

But what does tradition mean in Japan? There have been, and are, many national and regional traditions. Some are dead, others alive. Artistic traditions in Japan are alive in the sense that the past unmistakably conditions the present, and the present constantly redefines the past.

Japanese art has been characterized by two trends which I would like to underline. In the first place, different types of art, generated in different periods, did not supplant each other, but co-existed and remained more or less creative from the time of their first appearance up to our time. Buddhist statues, a major genre of artistic expression in the period from the sixth to the ninth century, continued to evolve in style during the following eras, even when the picture scroll opened new possibilities for the visual representation of the world in the Heian period. Brush works with india ink flourished during the Muromachi period, but one school of artists remained faithful to the techniques and style of the picture scroll. Under the Tokugawa regime a new style of painting and decorative art was established by Sōtatsu and Kōrin; the technique of the wood-cut print was elaborated to perfection. Yet artists never ceased to carve Buddhist statues or engage with great passion in brush work painting. No major art form was actually replaced by another. Practicially no style ever died. In other words, the history of Japanese art is not one of succession, but one of superposition.

In the second place, traditional Japanese culture was structured, so to speak, with its aesthetic values at the center. Aesthetic concerns often prevailed even over religious beliefs, ethical duties, and material comforts. After early Buddhist sculpture, which emulated continental models, the Buddhas and Bodhisattvas of the Heian period became gradually japanized and took the shape of gentle, graceful human figures, thus reflecting the aesthetic ideals of the time rather than interpreting Buddhist rejection of everything this-worldly. Here the art was not illustrating a religion, but a religion was becoming an art. Once again, in the thirteenth century, a con-

tinental influence intervened in Japan: the transcendental faith
of Zen. But what happened in the time that followed, from
the fourteenth to the sixteenth century, was a process of grad-
ual dissolution of this originally mystic disicipline into poetry,
theater, painting, the aesthetics of tea (the style of *wabi*), in
one word, into art. The art of Muromachi Japan was not in-
fluenced by Zen. Zen became the art. Looking at painting, one
can say that the picture scroll of the Heian period summed up
the aesthetic life of the courtiers in a kind of "painting-litera-
ture." And much later, the Sōtatsu-Kōrin school in their
"painting-calligraphy" well represented the hedonistic opti-
mism of the merchants flourishing in feudal towns. Needless
to mention genre painting and woodcut prints which owe
their existence to the theater and gay quarters, where the
whole of Edo culture met in the late eighteenth and early
nineteenth century.

As the core of Japanese culture, the art in different periods
of Japanese history tended to be well-integrated into human
life. As life changed, different types of art dominated in dif-
ferent periods. But the close relationship between art and
daily life remained unaltered. Here the question arises: how
could such a relationship survive in an industrial society?

In the following pages, general problems, such as those
mentioned above, are not systematically discussed. The essays
in this book deal with Japanese art of various periods. At first
glance they may appear to be only loosely connected with
each other, but all of them are related to fundamental prob-
lems of art in general.

The first three essays discuss the relationship between the
artist and society. "Role of the Artist in Modern Society" is
a sort of general survey of the subject. "On New Forms" and
"Individualism and the Artist" are additional remarks on two
specific aspects of the same subject: art as creation of new
forms, and art as expression of its creator. The question: what
is art? was always in my mind, as I wrote the four essays on
different phases in Japanese art history. "Style in Buddhist
Sculpture" is an inquiry into a set of concepts by which the

evolution of style in Buddhist sculpture may be described more accurately than before. "The Tale of Genji Picture Scroll" and "Notes on Sōtatsu" discuss the significance of visual art in the development of national culture. "Notes on Tea Ceremony" is concerned with a particular type of human attitude toward art and life. Finally in "Artistic Creativity Today" I tried to demonstrate through an analysis of the Japanese case, what kind of difficulties for the artist can emerge in a situation of culture conflict.

Thus the purpose of this book is not to give a survey of Japanese art history, nor to introduce the reader to interesting art objects in Japan, but to expound some ideas concerning the meaning of art in the context of one particular culture. I hope that the reader may find those ideas thought-provoking and useful for application to different situations.

The Artist in
Modern Society

Generally speaking, it is impossible in uncivilized societies to separate art from the total culture of a society. However, in societies where culture is highly refined and complexly diversified, it is possible to distinguish two different types of relationship between culture as a whole and art, between society and the artist.

Art is well integrated into the culture of some societies; in them, the artist plays an indispensable role in their functioning, and it is possible for the artist to accept that society's prevailing system of values. In such cases, the aim of art is not art itself. A good example of a context in which the artist was integrated is European society in the age which saw the building

of the great Gothic cathedrals; another is post-revolutionary Russia, which produced so much painting and sculpture of the school of socialist realism.

In the other case, the artist is alienated from society, and his role is essentially irrelevant to its functioning. In the eyes of the artist, that society's system of values is unacceptable. In such cases, art tends to be felt as an aim in itself. One example is the European society of the nineteenth century which gave birth to the *poètes maudits* of the Romantic school and later. Another is Western society today, with its vogue for abstract painting.

The distinction between these two types of relationship between artist and society is not directly related to the artist's social standing. The social position of the artists who built the Gothic cathedrals was low, and in many cases we no longer even know their names. Yet the painters and sculptors of socialist realism—who were equally "integrated" into their society—held a high position in it, and some of them were even awarded official decorations. In the same way, many of the *poètes maudits* lived out their lives in poverty in the back streets of Paris, whereas the more reputed of today's abstract artists, though just as "alienated" from society, lead lives of ease in villas in the south of France.

Nor does this difference between the two types of artist-society relationship have any direct bearing on the quality of the art produced. It is true, perhaps, that the nineteenth century failed to produce one cathedral comparable to the splendors of, say, Rheims, yet neither could the thirteenth century show any lyrical poetry comparable in artistic refinement to that of a Mallarmé.

The age which in Japan gave rise to the integrated artist-society relationship in its most typical form was the Fujiwara period. The condition of alienation emerged in characteristic form in the Kamakura period, the shift from the one to the other taking place with dramatic clarity. The alienation of the artist which began in the Kamakura period persisted in most respects throughout the Muromachi period, until in the Edo

period—more specifically, from the latter half of the seventeenth century on—the artist began once more to be integrated into society. What one might call the "reconciliation" of artist and society which took place in this latter period was shattered once more following the Meiji Restoration; the alienation of the artist became a general trend, and remains so to the present. Nevertheless, there is a great difference in the pattern of alienation between the period from the Meiji Restoration up to World War II and the postwar period. This difference is of the greatest significance for us today, and it is necessary for an understanding of our own times not merely to determine whether or not a particular age was one of integration or alienation, but to inquire more deeply into the precise pattern each took at a given time.

There is no space here, however, to analyze in detail the relationship in Japanese society throughout its history, and I shall deal with the periods before the Tokugawa as briefly as possible. I shall go into the period since the latter half of the seventeenth century in somewhat more detail, since a vast area of Japanese society remained basically unchanged from that time on. This unchanging area corresponds to much of what is popularly referred to today as "traditional" or "Japanese."

Art in the Heian period formed an important part of the culture of the court. Poetry and music were the twin foci of the education of the aristocracy, an ignorance of which would certainly have handicapped the individual in his everyday life. In his *Mumyōshō*, for example, Kamo no Chōmei discusses delicate tactics for avoiding embarrassment when a woman addresses one with a line from a poem of which one does not know the rest: not to know a poem, in short, was considered shameful. In order to gain access to the court, the men and women of the Heian period almost certainly had to be equipped with most of those many accomplishments which Molière's *bourgeois gentilhomme* hoped to have teachers instill in him at his own home. Art was indispensable to making one's way in court society, and that society, in its turn, was the only milieu where the people living in it could hope to lead a cul-

tured life. Exchanges with China had been at a halt since the tenth century, while the culture of the provinces was not appreciated by aristocratic society in the capital. The world, in fact, did not extend beyond the city of Heian (the present Kyōto). When Fujiwara Michinaga declared, in a poem, "this world is my world," the "world" he was referring to was court society. The essence of that world was a culture of extraordinary sensuous refinement, a culture whose nature is apparent in the style of the secularized Buddhist sculpture of the Fuijwara period, and in the color and line of the scroll paintings.

Yet the court society which constituted the whole world for Fujiwara Michinaga and the rest of the higher-ranking nobility cannot be said to have played the same role in practice for the lower-ranking nobility. It was the Fujiwara period which saw the development of the extensive private estates of the higher-ranking aristocracy (and of the great temples) known as *shōen* (manors). The *shōen* were exempt from the taxation which was provided for under the administrative code established in the preceding Nara period. This meant that there was a serious clash of interests between the lower-ranking aristocracy, whose sole economic prop came from the tax revenue, and the higher-ranking aristocracy, who monopolized the income from the *shōen*. Thanks to this clash of interests, though court society for the low-ranking aristocracy may have been "*the* world," it was in no sense "*their* world." They were integrated, not into the heart of court society, but into its fringes. Thus while they accepted in toto the system of values of their betters, they themselves were in a better position to gauge the distance between those values (or ideals) and reality. Most of the artists of the Heian period—typical among them the authoress of the *Tale of Genji*, Murasaki Shikibu—came from this lower stratum of aristocratic society. Murasaki's ideal was Michinaga, who had lived at a distance neither too close nor too far for her to observe him and portray him. This kind of thing is probably more important in her art than the fact that she happened to be a woman. Indeed, the "feminine" quality of

Heian culture—assuming that talk of the "femininity" or "masculinity" of a culture has anything more than a metaphorical meaning—has hitherto been given excessive emphasis. The appearance of large numbers of poets and authors from among the women of the court was not directly due to the fact that they were women, but to the fact that the activities around which society revolved—the power politics of the court, the formulating of poetic theory, and the judging of poetry contests—were carried on close to them, yet completely outside their responsibility. (In a later age, samurai society and Confucian morality were to remove women from the political and cultural heart of society, to the point where it was even forbidden for women to play women's roles on the stage!)

In the Heian period, an artist could still take a Michinaga as his ideal. In the Kamakura period, no such thing was possible with Minamoto Yoritomo, the first Kamakura Shōgun, even though his position may be likened to that of Michinaga during the Fujiwara period. And though Sanetomo, the third Kamakura Shōgun, may have taken Teika, the poet and art theorist, as his ideal, the reverse would never have been possible. The transition from the centralized society of the aristocracy to the feudal society of the samurai which took place in the latter half of the twelfth and first half of the thirteenth century could only mean the end of the world for an aristocracy for whom "the world" signified the court. In referring to this age of transition as the "end of the world" or "the Latter Day of the Law"—an idea borrowed from Buddhism, which held that the beginning of the twelfth century marked the beginning of a period when Buddhism and morality generally were due to go into a decline—they were rejecting the newly emerging social order and its system of values. The artists, who found themselves in effect under samurai authority while at the same time bearing on their shoulders the whole weight of the tradition of Heian art, were keenly aware of their estrangement from the society around them, and the only thing left for them was to go into rural retreat in the manner of the author of the *Hōjōki* or, as did Kenreimon'in

Ukyō Daiyu, spend their days lamenting the beauty of things past. Those with a more theoretical turn of mind either applied themselves to examining history from the viewpoint of the family that had supplied the regents and chief ministers of the preceding age—as did Jien, author of the *Gukanshō*—or, as Teika did in writing his *Maigetsushō* and *Meigetsuki*, they equated an art which lived on in their own minds alone with the whole world, and developed a theory of art as an end in itself. Again, the artists who painted the *Jigoku Zōshi* and *Yamai no Sōshi*—two picture scrolls dealing, respectively, with the horrors of hell and the bodily ills to which man is subject in the present world—turned their minds to transcendental realms by means of a religion that rejected the present world. The Kamakura period, in short, was an age in which the artist was alienated from society; among the results of this alienation were the emergence of a new awareness of history and of artistic tradition, the idea of art for art's sake, the ideal of the artist as a man leading a life of seclusion from the mundane world, and a transcendental art bound up with the newly emerged sects of Buddhism. All of these had been unknown during the Heian period up to the mid-twelfth century.

The same state of affairs persisted in most respects during the Muromachi period. The contact with China which began in the Kamakura period exerted a great influence, principally through the influence of Zen Buddhism, on the relationship between the artist and society in the Muromachi period. The alienation of the artist under the Sung dynasty following its conquest by an alien race from the north (the Mongols who founded the Yüan dynasty) was similar in many ways to the situation in which the Japanese artist found himself from the Kamakura period on. The new Buddhist sects (including Zen Buddhism) of the Kamakura period, with their severely transcendental nature, subsequently underwent a steady process of secularization, and the transcendental art that began to emerge in the same years soon vanished, never to be reborn throughout all the course of Japanese history. Nevertheless, the ideal of the artist as being cut off from the mundane world

was undoubtedly developed considerably even after this, both by the Zen sect itself and by the secular culture of Sung China which was imported into Japan hand in hand with it; one example of this is the tendency to idealize figures such as the "Seven Sages of the Bamboo Grove," who were used so often as a theme for painting. The priests of the "world within a world" formed by the "Five Monasteries"—the five great temples of the Zen sect—followed the fashion of Sung and Yüan monks in producing large quantities of ink monochrome paintings, as well as masterpieces of garden design and architecture that are known all over the world today. Ikkyū Sōjun, a Zen priest and poet who, significantly enough, adopted a pseudonym whose characters mean literally, "mad cloud," rebelled even against the Five Monasteries, and created yet another little world of his own within the separate world that they represented. A genius, said to have been the illegitimate son of an emperor, he was in a sense, the François Villon of fifteenth-century Zen. In such a case, the alienation of the artist made itself felt as an out-and-out challenge to all the social conventions from the artist's side. It is true that Zeami served the family of the Ashikaga Shōgun, that Sen no Rikyū served Hideyoshi, yet in no sense does their action imply a reconciliation between artist and society. Zeami spent his last years in poverty and exile, while Rikyū was forced to take his own life at the whim of Hideyoshi. Their art leaves no room for compromise either with authority or with the masses. Indeed, Zeami's Noh truly begins with the moment when the brief, penetrating note of the flute liberates us from all social convention. It does not deal with the social complexities of human relationships: it is a metaphysical drama in which the individual being confronts the realm of the supernatural. The tea ceremony in the austere, "rustic" form into which it evolved with Rikyū succeeded, via a paradoxical switch in aesthetic values which placed supreme importance on the unpretentious and the seemingly artless, in developing Teika's "art for art's sake" still further till it became "life for art's sake," thereby posing a head-on challenge to the con-

ventional outlook of society. (The tea ceremony referred to here, as goes without saying, is unrelated to the accomplishment considered indispensable for young ladies of good family contemplating marriage, or to the pastime of Nipponophile American ladies.) The one sign of a trend toward reconciliation with society in the Momoyama and early Edo periods was the artists of the Kanō school. However, this trend was not yet predominant among the artists of the day; the general tension between the artist and society was to persist until the middle of the seventeenth century.

The Tokugawa period from the mid-seventeenth century on was unique in that it saw the artist integrated into the larger society without the use of religion as a catalyst; indeed, in this respect, it can be said to occupy a unique place in world, and not merely Japanese, history. The period demonstrates at least four features which call for special attention. They are first, the bureaucratization of the samurai; second, the rise of the merchant class; third, the emergence of intensive agriculture, and of agricultural communities with a high land-productivity; fourth, national seclusion.

For more than two centuries—from the first half of the seventeenth century, when they fought the Christian rebels at Amakusa, until the latter half of the nineteenth century, when the clan of Chōshū confronted a combined British, American, French, and Dutch fleet—the samurai of the Tokugawa period were not called on to make war. What was required of them instead was administrative work within a complex bureaucratic organization. It was a paradox of the Tokugawa system that at the very time when it required not so much martial valor as administrative ability it should have maintained a rigid social hierarchy which forced it to use the samurai—the uppermost of the four classes in that hierarchy—as its administrative officials. Yet though they were officials in practice, they were still samurai in name, and had to be addressed with corresponding respect for their ranks. It was under such circumstances that *bushidō*, the way of the war-

rior, was first rationalized and codified. Specific mention of *bushidō* as a readiness to die a noble death first came to be made at a time when there was no need whatsoever for any samurai to die by the sword.

Nor was *bushidō* the only case where the Tokugawa regime codified what had become a mere name divorced from reality. The secularization of Buddhism had been proceeding apace ever since the Kamakura period (to the point where, in the Muromachi period, the greatest contribution of the Zen sect to Japanese literature was the development of a literature of pederasty!) That the truly Buddhist literature of the Kamakura period should have vanished so utterly without trace is an indication of how far Buddhism had lost its popular appeal. Nevertheless, when, toward the end of the sixteenth century, a vogue for Christianity developed, the Shogunate responded with oppression, and obliged every member of the population to register with a Buddhist temple. The result was that every Japanese became a nominal Buddhist precisely at a time when Buddhism had lost most of its power to capture men's minds, and when it had ceased to be a focus of cultural creativity. The Buddhism of the early Tokugawa period is typified by Tenkai Sōjō, a high-ranking priest of the Tendai sect who participated in the councils of the Shogunate, who was a devoted reader of *Chin P'ing Mei*, and who could quite happily indulge in a blend of Shintoism and what he chose to call the "mysteries of Tendai Buddhism."

Nevertheless, it was something more than playing with names that enabled the Tokugawa regime to maintain order for more than two hundred years. In fact, a vertical system of relationships between superior and inferior pervaded the whole of samurai society. Beginning with the relationship between the Shogunate and the various clans, it extended through the relationship between the lord of the clan and his retainers and down to family relationships such as those involving family head, eldest son, and wife.

The same pattern spread beyond samurai society—extending, for example, to the relationships between patron and pro-

tégé and between landowner and tenant farmer. This pattern in actual society was backed up by a system of Confucianist ideas, developed by making amendments to Chinese Confucianism wherever necessary and laying emphasis on the concept of loyalty. Thus the great significance of Confucianism in the Tokugawa period lies, not in the fact that the Shogunate happened to adopt the neo-Confucianism of Chu Hsi as its official system of learning, but in the fact that it was geared to relationships of superior and inferior in the actual, existing social order—here differing both from *bushidō* (about the only outlet for which was in taking revenge on an enemy, a matter of purely personal wrath), and from Buddhism (the main merit of which lay in its administrative function).

Actual relationships between superior and inferior were seen at their most rigid within samurai society; although they spread outside that society, they were more relaxed among the merchants, and far more relaxed still—particularly between men and women—among the agricultural population.

The system of ideas which was evolved by samurai society to justify this vertical system of relationships spread, just as it stood, right down to the lower ranks of society, in the form of the concept of *taigi meibun*. It followed, thus, that the gap between actuality and the theoretical values determining vertical relationships in society was smaller in the samurai class and greater in the merchant and peasant classes.

What was it, then, that filled the gap between theory and actuality when it became too great? It was, it would seem, an emphasis on horizontal as opposed to vertical relationships. There were two principal values which controlled these horizontal relationships. One was the claim of natural and universally shared human feelings (*ninjō*). The other, which tied up directly with the sense of belonging to a community, was the claim of duty toward the other members of one's society (*giri*).

Giri and *ninjō* came into frequent conflict, since *giri* linked up with the community whereas *ninjō* linked up with the individual. The conflict usually ended in the triumph of *giri*

over *ninjō*, of the community over the individual; where it did not, the result was tragedy, a type of tragedy that forms the constant theme of Chikamatsu's "domestic dramas." Yet such tragedy is conspicuously absent from the themes of his "historical dramas," in which the principal characters are warriors. In the latter, it is not *ninjō* and *giri*, but *ninjō* and the duty of loyalty that are in conflict. Most historians so far have tended to overemphasize the conflict of *ninjō* and *giri;* what was probably much more important than this conflict in fact was the conflict which existed between the horizontal relationships within the community—whose very existence implied a balance between the claims of *giri* and *ninjō*—and the vertical relationships of the hierarchy imposed by the Tokugawa regime.

It was the merchant class which best represented the *ninjō* of the Tokugawa period in all its ramifications, and which gave it its most powerful expression. (The focus of this merchant class was the merchant of the Kyōto-Osaka area during the latter half of the seventeenth century and first half of the eighteenth century, and the merchant of Edo during the second half of the eighteenth century and the first half of the nineteenth century.) The conscious values implied in *ninjō*—love between men and women, for example, or the love of a parent for his child—are possible, of course, in any society. However, as is amply evident from the works of the novelist Saikaku, the system of values of the merchants gave to these an added element of hedonism. The two main preoccupations of the merchants who appear in those novels of Saikaku that deal with the lives of the ordinary bourgeois are the making of money and the spending of money. The spending of money meant, in short, the pursuit of sensual pleasure. For the merchants, Confucian morality was no more than a borrowing from samurai society. Buddhism—though something more, perhaps, than an empty name—was not a force such as could impose restrictions on human relationships in the everyday world. There was, in theory, no obstacle whatsoever to the pursuit of pleasure so long as it did not threaten the sense of

belonging to the community. And even this one obstacle was cleverly sidestepped by having the community itself institutionalize pleasure. The merchant class of the Edo period showed, in fact, an unprecedented originality in this respect. The gay quarters flourished, and so did the theater. The *samisen* music, the *ukiyo-e* woodblock print, the puppet-drama, the Kabuki, and the *haikai* were almost all direct products of it.

The rise of the merchants meant two things. The successful merchants, by absorbing the traditional culture, came to approximate the samurai class, while the lower ranks of the samurai, who had become petty officials, were influenced by the system of values of merchant society and came, thus, to approximate the merchants. Almost all the artists of Edo emerged from the point where the samurai-merchant and the merchant-samurai overlapped. Their art, quite naturally, came to trace three main courses.

Arts such as *samisen* music, the woodblock print, the Kabuki, the puppet drama, and the *haikai* were completely integrated into merchant culture. In them, the artists concerned invented original forms which they then proceeded, over a period of two hundred years, to refine. As arts, they were thoroughly secularized, and lacked profound connections with any system of ethical values. The contribution of Confucianism to this highly developed world of art was almost nil.

Second, the artists who found themselves at the meeting-place of the samurai and merchant classes also undertook the task of meeting the demands of the samurai class, and of its upper layers in particular. Here, no new art-forms were produced; instead, the classical arts were maintained and reproduced. By giving their support to the troupes who performed the Noh and *kyōgen*, the Shogunate and heads of the clans carried on a tradition which had begun in the Muromachi period—though for two hundred years not a single new Noh or *kyōgen* was produced. The artists of the Kanō school devoted their talents to decorating the residences of upperclass samurai. Large numbers of craftsmen, again, worked to pro-

duce the extraordinary sweep and refinement of the decorative arts of the Tokugawa period. Particularly noteworthy here was the Sōtatsu-Kōrin school, which gave birth to a unique style in the Momoyama and early Edo periods; although eighteenth-century Edo was to add little to it, their work in itself reached rarely equalled heights in the fields of decorative art and painting alike. A number of *daimyō* of the day had such highly developed artistic sensibilities that they ceased to be mere patrons of the arts and became artists themselves. The whole line of *daimyō* who were also adepts of the tea ceremony, from Kobori Enshū through Matsudaira Fumai and on to Ii Naosuke, can be credited with immense contributions to the refinement, within the framework of traditional forms of architecture, garden design, painting, calligraphy, the decorative arts, and literature. What clearer sign could there be of the close relationship between the general culture of the Edo period and the arts than the fact that the arbiters of taste during the period were also the authorities of the day?

Third, and despite these first two trends, the tradition of the anti-establishment artist dating from the Kamakura period had not completely died out. The *nanga*, a style of painting marked by a great freedom and individuality, not to mention eccentricity, was created by the intellectuals—Confucian scholars, priests, doctors, and the like—for their own pleasure and was probably the least socially "integrated" of all the arts of the Edo period. Yet even here, it would be wrong to interpret the eccentric behavior of Ike no Taiga, one of the greatest exponents of the *nanga*, as "anti-establishment" in the true sense of the word. Taiga was no Ikkyū: he did not tussle with society, but ran away from it—not, of course, that this detracts from the magnificence of the result.

Artistic creation in the Edo period was carried on at a great remove from the population of the farming communities. This is an extremely important fact when one comes to consider the Meiji period that followed. Far from having time to refine their sensibilities, the peasants of the Edo period were fully occupied slaving at their land; time and again, indeed,

they rose in despair against the landlords who, in a popular saying, were linked with a child's tears as one of the two things in life to which one must always bow. There was more to the villages than this, however. If the vertical pattern in Edo-period society as a whole was to be seen at its most typical in the samurai class, it was in the farming villages that the horizontal pattern appeared at its most characteristic. The decisive factors in their lives were the community, closed to the outside world, and the sense of belonging to that community; just as the most solid and unshifting reality was the clan for the samurai and his own social circle for the merchant in the cities, so it was the village for the farmer. The farmer was tied to the land, and the fact that, following the Meiji Restoration, the sons of petty landowners and owner-farmers could shoulder their belongings and go to the capital, where they might even graduate from the Imperial University, was in itself quite enough to transform the whole state of affairs there. Throughout the whole of everyday life and of art, they were to bring about a sudden debasement of taste, while the "village community mentality," as many sociologists have pointed out, came to pervade every aspect of the social organization.

The national seclusion also played a large part in furthering the integration into society of the artist of the Edo period. Indeed, the first of the ages of integration had been the Fujiwara period, when a type of a national seclusion already existed. Generally speaking, the intellectual is more sensitive than the average citizen to foreign culture, and more readily influenced by it. As a result, the intellectual's cultural background tends to differ in nature from the feelings and culture of the masses who remain untouched by foreign influences, and thus to become alienated from society at large; this is a phenomenon common whenever one country comes into contact with the culture of another more advanced country, and is not peculiar to Japan. This alienation of the intellectual is accompanied, to some extent at least, by the alienation of the artist. It happened in the Nara, the Kamakura, and Meiji periods. In the Fujiwara period, however, and in the Edo period, there was no chance for it to occur.

For artistic forms to change, one of two major factors is, generally speaking, necessary. One is a major change in the structure of society, the other a stimulus from outside that society. The structure of Tokugawa-period society was established by around the middle of the seventeenth century, while the seclusion of the country restricted the entry of stimuli from without. Thus once the forms of the various arts had, by the end of the seventeenth century, been more or less mapped out, Tokugawa society produced no factors such as could bring about any important changes in them. The Golden Age of the art of the Edo period, which occurred in the eighteenth century, concentrated not on evolving new forms, but on a refinement of taste within the framework of the existing forms. Society, therefore, was already perfectly familiar with the forms the artist handled, and one might say that society and the artist were in a state of close rapport; conditions were such that the artist was able, as we have already seen, to accept society's system of values as it stood.

The Edo period produced no literature which laid out-and-out stress on the independence of the individual, based on the kind of sense of equality that was to make Fukuzawa Yukichi declare in the late nineteenth century: "Heaven created no man above another." Nor did it evolve any art which served transcendental values, or any art whose appeal depended on an abstract ordering of its components. Instead, it provided musical tones charged with atmosphere, graceful lines, an extraordinarily refined use of color, techniques which displayed to the utmost the natural properties of the materials —in short, an art of the senses, an art of sensual delight which was polished to an ineffable peak of perfection within a world of delicate emotional nuances and carefully planned hedonism.

In order to achieve its aim of building up a military state, the Meiji government entered into contact with the nations of the West and pressed ahead with industrialization. At the same time, it took the first step toward equality by abolishing the Tokugawa system of social status. Yet if one sets aside the new militarism—which was directed at the outside world —the system of values of the Edo period was maintained with-

21

out any fundamental change of pattern. Every possible step was taken to emphasize the superior-inferior relationship which extended from the emperor down to the head of each household, while the village community mentality, as we have already seen, spread throughout almost the whole of the social organization.

Under such circumstances, the relationship between the artist and society suddenly grew cool, and since these same circumstances persisted without basic change until 1945, the alienation of the artist similarly persisted, by and large, until the same time.

Militarism is an ideology which accords ill with an artistic culture. Where the national ideal is a wealthy and militarily powerful state, dancing and music are wasteful luxuries better done without. Whereas the Tokugawa Shogunate and the powerful daimyō had maintained troupes of Noh and *kyōgen* actors, the Government after the Meiji Restoration maintained no national theater whatsoever. Since it was a keen advocate of education, it set up colleges of music and art, yet it subsidized no organizations whatsover outside those schools, and though it built the buildings for museums, it made almost no allocations for anything to go in them. (To my knowledge, there is no other country as rich in art treasures as Japan which has so poorly stocked a national museum.) In all likelihood, the government of a country which went to war every ten years or so had no time to worry about art. The days of Kobori Enshū, Matsudaira Fumai, and Ii Naosuke were past. A deep gulf was opening between the artist and political authority.

The abolition of the system of social status once more created a tie between the rural population—which had been cut off from the urban culture of the Edo period—and the cities. This in no way means that the differences between town and village had become smaller; indeed, the distance between the two became, if anything, greater than ever, since the influence of the West spread in the towns, and industrialization went ahead there at a great pace, whereas the villages preserved

almost the same features as in the Tokugawa period, including the same high rents for tenancy. The alienation from the agricultural community of the artist working in the city became even more marked than in the Edo period. The basic difference compared with the Edo period was the increase in the number of people from the agricultural communities to be found in the cities. Equality of opportunity in education brought the children of petty landowners and owner-farmers to the universities in the cities, while industrialization brought the children of tenant-farmers to factories in the cities. Yet they lacked the traditions of the urban culture which had begun in the Edo period. Art cannot exist where there is no tradition, and the artists of the Meiji period were accordingly made to feel alienated, not only from the agricultural community, but from the Tokyo scene as well.

Meanwhile, the influx of Western civilization, thanks to the encouragement of the government, became a mighty torrent. Artists are sensitive to foreign culture; in no time, the styles of Western architecture, painting, and sculpture were being imitated, musical techniques were being introduced, and the translation or adaptation of Western poetry and prose was being undertaken. In the eyes of the artists who set out thus to absorb the artistic traditions of the West, the tastes of the society around them were, of course, too traditional, and this inevitably served to heighten still further the artist's sense of alienation.

At a time when calligraphers, writers of Chinese verse, and Kabuki actors were deploring the utter debasement of taste in a Tokyo taken over by countryfolk and Westernization, the painters in oils, the pianists, and the producers of modern drama were condemning the unrepentant old-fashionedness of a city in which every house had its *kakemono* in the alcove, in which *samisen* music was still the most popular, and in which "drama" meant the Kabuki and nothing else to most people. On the one hand, the artist was alienated by the lack of tradition in his surroundings, on the other by their excessive traditionalism. Nor is this the paradox it might seem, for

if Tokyo was no longer Edo, it was much farther still from being a Western-style city.

The sense of alienation makes the artist unwilling to compromise (a sign, one imagines, of the same psychology as makes a minority left-wing party espouse theories which are militant in inverse proportion to its size). The artists who sought to preserve the traditions of Edo art clung ever more consciously to those traditions, rejecting Western styles and techniques outright, while the artists who sought to imitate Western art became more and more infatuated with the West, and threw overboard the whole of their own artistic heritage without so much as a second thought. This was the state of affairs that gave rise, in post-Meiji Restoration Japan, to the peculiar phenomenon of duplicate schools of artists. Japanese architecture and Western architecture; Japanese painting and Western painting; Japanese music and Western music; Kabuki and the modern drama—artists, performers, and actors alike all belonged to one of the two schools, and had almost no contact with the other. A similar dual structure can, in a sense, also be seen in everyday life, in the coexistence of Japanese dress and Western dress, or of Japanese food and Western food. But Japanese dress and Western dress are worn by one and the same person, and the same person enjoys both Japanese and Western food. The twin schools of artists, however, were so total in their claims on the personality that it was almost impossible for one person to pay allegiance to both sides. Such a state of affairs is only possible where the artist is alienated from society as a whole. Could a court of law function on both Japanese and Western law simultaneously? Or do the armed forces distinguish between "Japanese style" and "foreign style"? From an early date, of course, Meiji Japan had only one legal system, and only one organization of armed forces. Even in the field of medicine, Mori Ogai could declare: "Until I die, nothing will shake my conviction that medicine is one."

However, in the case of the Western-style painter, the nature of his alienation was not so simple that it could be ex-

plained merely in terms of the gap between him and his *kakemono*-hanging neighbors. Post-Meiji Restoration industrialization, which is noted for the speed with which it was accomplished, is also distinguished by the fact that until very recently it had almost no effect on everyday consumer habits —especially taste in food, clothing, and housing—either in the farming villages or, even, in the towns. The Japanese painters who took Cézanne as their ideal lived in houses utterly different from his. As like as not, they sat cross-legged on cushions in those houses, wearing cotton kimono and drinking *sake* accompanied, perhaps, by salted fish intestines. At least until the beginning of World War I, half the Japanese population —the womenfolk—wore kimono at almost all times. The other half, the men, almost always wore Japanese dress in their own homes—a type of dress which has scarcely changed at all since the Edo period. Here too, of course, the Western-style painters were no exception to the rule, and the painter whose ideal in coloring was Cézanne could hardly help experiencing a sense of alienation, not only from the society about him, but also from his own personal experience of color in his daily life. That he shared the experience of everyday life with other ordinary Japanese did not so much lessen the sense of estrangement from the mass of Japanese as intensify the sense of estrangement from the self. There could be no way out other than to go to Paris, a fact of which all Western-style painters —indeed, every aspirant to becoming a Western-style painter —was perfectly well aware.

The problems were still greater where the artist was concerned not with painting in oils, but with performing Shakespeare or Ibsen. For painting, it is possible to import the necessary materials, i.e., the paints themselves. The materials of the drama are the actor's voice and body, which cannot be imported. The actors lived in Japanese society. Their houses were constructed differently from those of the West, and the very way they walked was different. The words they used were different, and so was the order in which their ideas emerged. Human relations were different, and ways of ex-

pressing the most basic human emotions, such as joy and anger, pain and pleasure. There was nothing either producer, actor, or dramatist could do to alter these basic facts of society.

Moreover, the very system of values which underlay the whole of society was far removed from its Western counterpart. For example, it was an accepted principle of Japanese society until 1945 that the emperor was a living god; the Japanese were his subjects, his children. One would have to go very far back in the history of Western society to find anything corresponding to this. One would not find it, for example, in sixteenth-century England. Nor was a system of superior-inferior relationships running vertically throughout the whole of society and extending even to the family to be found in Western society at the time of Ibsen, whatever may have been true at the time of Shakespeare. And it is very doubtful whether there existed even in sixteenth-century England, much less in Western Europe of the later nineteenth century, a system of horizontal relationships within the community so close-knit that it made any individual independence of the community impossible. A system of vertical and horizontal relationships carried over from the Edo period, with the vertical relationships weakened in some respects and intensified in others, and a system of values created by a fusion and combination of the emperor system and the village community outlook—such were the realities which existed in Japanese society, in contradistinction to the system of values based on equality and the freedom and independence of the individual which came to prevail in the West following the French Revolution. It was differences such as these that made it so excessively difficult for the artist, alone and unaided, to progress beyond mere absorption of the techniques and forms of the West and engage in truly creative work. The difficulty to be overcome was not a personal matter for the artist, but involved society as a whole. It represents one of the most important forms which the alienation of the artist assumed.

I am in no sense accusing the artists who fell in love with

the West of frivolity. Their infatuation carried with it no notion that it would be easy to acquire Western culture. They threw themselves heart and soul into the task precisely because they sensed that, even if they gave it all they had, their success was still not assured. Saeki Yūzō went to Paris, and it was while he was living there that he painted his masterpieces. Another artist, Tomioka Tessai, went on working in the tradition of Edo culture, oblivious to what was happening about him, and thereby added a glorious final page to the history of the *nanga*. It is quite pointless today to ask which approach, and which outcome, was the better. Each did what was, for him, inevitable, and did it with a splendid thoroughness. No other road was open to him.

The alienation of the artist drove him either into a nostalgic yearning for the culture of the Edo period, or into an infatuation with the West. In most cases, the conscious clinging to the heritage of the past led to stagnation, while the ignoring of artistic tradition produced sterility. Any adequate exercise of artistic creativity seems to have been impossible, moreover, in a country which, from the end of the nineteenth century until the middle of the twentieth century, went to war approximately once every ten years. Yet even so, what hindered any greater display of artistic creativity was not the fact of alienation as such but the particular pattern which it assumed in Japan. The question we must discuss next is how that pattern has changed today.

Following the Pacific War, or more strictly speaking from around 1955, the industrialization of Japan began to demonstrate a series of phenomena which had been little in evidence before the war. When one takes account of these phenomena, it is possible to see the years from the Meiji Restoration until around 1955 as a first period of industrialization, and the present as the beginning of a second period. The first period was for the most part a time of catching up with the industries of the advanced nations; in the second period, Japanese industry, having caught up, is now preparing to make new advances

alongside the advanced industrial nations of the world. The series of new phenomena which, as I have suggested, characterize this second period are roughly speaking as follows.

First, patterns of consumption are changing, and indigenous habits where food, clothing, and housing are concerned are giving way to habits common to industrial nations all over the world. This is especially true in the large cities, with their multi-story apartment houses in the suburbs, foodstuffs rich in animal protein, clothing made of chemical fibers and subject, in the case of women, to "fashion," and the general spread of automobile transport. In short, the material bases of everyday life are rapidly losing the specifically Japanese qualities which they had possessed since the Edo period.

Second, the industrialization of the first period widened the gap between town and village, a gap which was one of the most characteristic elements of Japanese society as a whole in post-Meiji Restoration times. However, once industrialization passes a certain level, it begins to function in the opposite direction. The agricultural population no longer forms the largest section of the total population of the country, and the influence of industrialization begins to penetrate directly into the lives of the argricultural communities. In Japan's case in particular, the twenty postwar years have seen a number of epoch-making changes, such as the reform of the land-owner-ship system, the rapid increase in the number of farmers with side-jobs, the general spread of motive power, and increasing specialization in the running of the farms. The agricultural communities, which during the first period of industrialization were the most stagnant section of the economy and as such were progressively estranged from the cities, have in many respects begun a rapprochement with those cities.

Third, the industrialization of society in every part of the world has brought with it a great development and popularization of the mass communication media. In Japan's case, the ownership of television sets showed a dramatic increase during the latter half of the 1950s. In pervading every corner of the country, television has overridden regional variations,

creating a tendency to shrink the gap between town and country, and standardizing human beings in a way that ignores individual differences.

Fourth, industrialization at a certain stage begins to convert the principal sectors of everyday consumption—not only food, clothing, and housing, but the consumption of leisure as well —into a market for "service" organized as a mass-produced consumer commodity. In this connection, advertising has developed to the point where commercialism has begun to dominate every aspect of social life.

Fifth, a high level of industrialization is tied up with technological culture, and technological culture has in itself given birth to a unique sense of values. Technology *progresses*. In a society where culture is dominated by technology, value resides in that which shows clear evidence of progress.

Technology does not create objectives, but refines the means to the attainment of given objectives. The refinement of means carries with it a trend toward rationalization and quantification. On the other hand, the objectives pursued by technology are in most cases convenience and comfort, and a society whose culture is dominated by technology is similarly a culture oriented toward convenience and comfort.

Of the phenomena just listed, the first two—the change in consumption patterns and the shrinking of the gap between town and country—represent a tendency toward the loss of the special Japanese qualities that distinguished Japanese society in prewar days (more accurately, the special qualities of Japanese society in comparison with the advanced nations). The other three are phenomena which are common to all highly industrialized societies but which have made their first appearance in Japan in postwar days.

However, although this may serve to sum up the *direct* results of the process of industrialization, it by no means exhausts the list of important changes which have occurred in Japanese society in indirect relation with industrialization and, more directly, in connection with changes made in various social institutions since 1945. We have already pointed out the

three basic values—militarism, the superior-inferior relationship between human beings, and emphasis on the community —which prevailed in Japanese society from the Meiji Restoration until World War II, and we must now consider how these have or have not changed since the war.

First, militarism has given way to pacifism. This does not mean that today there is no trend toward the revival and expansion of Japan's military forces, but that resistance to that trend is stronger. It does not mean that there are not those in power who would gladly revise Article IX of the Constitution, by which Japan renounces war and the possession of any military potential, but that those authorities themselves are obliged to profess their unconditional desire for peace. The Japanese people are tired of war. They lack the ambition to smite iniquity on Heaven's behalf.

This is pacifism, and it is the counterpart of the longest period of continuous peace that Japan has known since Meiji times (twenty years, in fact, is already twice as long as any previous spell of peace during this period)! With a protracted spell of peace plus a general acceptance of the theories of pacificism, it is no wonder, perhaps, that a tradition which lasted two hundred years in Tokugawa times should have tended to revive once more. I refer to a concern with sex and a seeking after worldly pleasure. Today's hedonism, however, is oriented differently from that of the Tokugawa period. Hedonism in the latter period tended toward the refinement of the artistic sensibilities. Today, it ties up with the technological culture, and is oriented toward the attainment of convenience and comfort. At the same time, it is being directly urged by commercialism toward a new emphasis on quantity. The affluent young playboys of today take pleasure in quantity in its comparatively simple manifestations—for example, the speed of a car. One imagines that the dashing, sophisticated youth of Edo would have found its pleasure in something more qualitative, something expressive of a more complex sensibility, than driving an automobile at high speed.

Second, the vertical relationship between superior and in-

ferior was for the first time denied as a matter of principle after 1945. Compared with Edo society, society between the Meiji Restoration of 1868 and 1945 had advanced one step toward the idea that "Heaven made no man above another and no man below another," but it was, after all, only one step. The second step was taken with the declaration of human rights in the Constitution. (This Constitution was, of course, "imposed" on Japan by the Occupation. The Americans probably felt that they had to "impose" this much at least, having found in the country they occupied a ruling class which was still, in the mid-twentieth century, fearful of any declaration of human rights. That Article IX of the same Constitution should later prove inconvenient to the Americans themselves is a different question.) The emperor ceased to be a "god" and the police could no longer arrest at will anyone to whom they took a dislike. Employers were obliged to recognize that the human beings they employed had a large number of human rights. Men and women became completely equal in the eyes of the law. A daughter was on a par with an eldest son; when she grew up, she had the vote, and when she married she had the same rights as her husband. These are the legal aspects of egalitarianism. In actual society, too, egalitarianism can be said to have made great inroads into the established order of superior-inferior relationships. In some cases, it was put into effect too simply and too hastily; in education, for example, the mistake was even made of equating equality of opportunity with "equality" in what was taught.

Third, although the twenty postwar years have seen the collapse of the system of vertical relationships inherited from Edo society, it has not, thus far, proved possible to break down horizontal structure. In a sense, the village mentality of the peasants who were alienated from the merchant culture of the Edo period is the one tradition which has survived the two reforms of 1868 and 1945, persisting unchanged throughout the first and second periods of modernization and up to the present day. Within a community closed to the outside world, community values take precedence over the claims of the in-

dividual. When the harmony of the community and the free-
dom and independence of the individual clash, it is the former,
as a matter of principle, that wins. Nowadays the "commun-
ity" concerned is, of course, no longer the regional commun-
ity. It is the business firm that employs its workers for life; it
is the labor unions formed within individual companies; it is
the faction within the political party, the faculty at the uni-
versity, the "club" in the eyes of the university student. The
fact that the superior-inferior relationship within the company
has been transformed into a horizontal one does not in any
way impair the closed nature of the community toward the
outside world. One sign of this is the "company trip," in
which the employees of a particular firm travel somewhere
for pleasure—all together, irrespective of their personal in-
clinations—or the extension of intra-office relationships out-
side working hours. Again, there is the persisting habit of
obeying the will of the majority as a matter of principle,
rather than giving expression to a minority view. A diplomat
from an Anglo-Saxon country once remarked to me that the
embassies were like small islands, where personal relationships
were more important than anything else. Japanese firms—or
particular sections of them where the firms are large—are all
like these embassies. The possibility of individualism taking
root on such small islands is not great.

To return now to the artist, what is his role in a society of
this type? So long as art is an expression of the artist's individ-
uality—and it is completely impossible by now for it to be
otherwise—the alienation of the artist from his society will
be great in proportion to the number of factors suppressing
individualism. In this sense, there is probably nothing so dif-
ficult for the artist to cope with as the village mentality in a
society where everyone has become equal. Yet this is a prob-
lem, not for the society round about the artist, but for the
artist himself. The reason why so many artists still go to Paris
is not necessarily because of any hankering after that city for
its own sake; it is to escape from the "village" that is the world
of art in Tokyo. "In Paris," one artist told me, "it's ability that

counts. However famous a man, nobody bothers about him unless he's turning out good stuff. That's the only way to produce really good work."

In a sense, this is an accurate account of the situation. There is more to the question than this, however. Commercialism, newly armed with television, and egalitarianism of educational content in the schools and social education—in fact, the whole of the phenomenon generally referred to as "mass society"— are overriding regional and individual differences and tending toward standardization of culture. Since this tendency is strong enough to overwhelm individualism even in countries where individualism is traditional, it is hardly surprising that it should squelch individualism where no such tradition lies behind it. To put it in different terms, the standardization represented by the phrase "mass society"—a standardization affecting even industrial societies which stemmed originally from individualism and egalitarianism—is threatening in Japan, where the twin bases are egalitarianism and the village mentality, to spread and to be exaggerated to an infinite degree.

To say that individualism is necessary for the artist does not imply that it is not necessary for everybody else. The establishment of true individualism is a task facing the whole of Japanese society, and it is precisely in carrying out this task that the artist, it would seem, can play a not inconsiderable part. The conditions which alienate the artist are at the same time the conditions which make him necessary for society if it is to "progress."

The artist himself, of course, needs something more than just individualism. Art develops, but it does not make "progress" (i.e., approach a given goal) in the same way as technology. The style of Buddhist sculpture in Japan showed development from the Asuka period on to the Kamakura period, and the style of Greek sculpture developed from the sixth century, via Phideas and Praxiteles, to the Hellenistic age. It did not, however, progress. Kamakura sculpture is not superior to Asuka sculpture, nor is Hellenistic sculpture superior to the "pre-classical" sculpture. It is difficult to talk of

33

"artistic progress" even within the development of a particular style; and it is completely pointless where many different styles follow each other in succession.

The meaningful element in a discussion of the history of art is not progress, but the development of style. The decisive factor in talking of individual works of art is not style but quality. Quality cannot be measured. Artistic culture is a culture of quality, not quantity. And though it is possible for art to be built on a foundation of hedonism, that hedonism must not mean the pursuit of convenience and comfort. Even a pleasure cannot give birth to art unless it is such that it can be felt by the artist as a challenge.

Society today shows a tendency to take convenience and comfort as its goals, and to rationalize and quantify the processes whereby those goals are reached, taking the means to the end as values in themselves. If this is so, then it follows that the artist's sense of alienation must become serious, and that he will frequently assume attitudes of opposition to the established order. Here again, though, one might say that the conditions alienating the artist are the same conditions that render him necessary. More specifically, society does not need the alienated artist in the sense of his being an element to be re-integrated into itself, but needs him precisely *because of* his alienation: both as a critic, a man who will set up what might be in the future against what is today; and as a creator of values, a man who produces values which are capable of setting themselves up against the values of the present. He is necessary because what exists today—the present system of values—is alienating man himself, and not merely the artist. Man himself must be rescued from a state of affairs in which he accepts convenience and comfort as ends in themselves, feels bored when they are achieved, seeks facile pleasures which, being a quest for stimuli, lead to the demand for ever stronger stimuli, and gets bored with them in turn, until finally his character becomes unbalanced and he ends up consulting the psychiatrist. To prevent this is not easy, of course. Assuming it is possible, it will have to start with an uncompromising

challenge to the way of thinking that considers the quest for convenience and comfort, or progress in means, as constituting in themselves the realization of values, as well as to the whole system of values which a technological culture has imposed on today's society. However, its challenge must be directed against those values, and not against technological progress as such. Technological progress is, for one thing, something against which it is fruitless to pit oneself; for better or for worse, it will go ahead indefinitely. In the second place, technology in itself is basically neither good nor bad; it is no more than the increase of potential. Potential does not choose its objectives. The greatest question facing society today is what objectives it should choose. Here—in choosing objectives—is where the artist can play his part. If he cares to, of course, he can do his work away from all technological progress; but he can also call into service the fruits of technological progress in pursuing human objectives. It is this latter course which represents the greater contribution to society. It is for this reason, perhaps, that in Japan's case it is the architect—for instance, Tange Kenzō in his latest work—who is taking the lead among the nation's artists.

The artist should accept his present state of alienation: the more thorough the alienation the better, in my view. Otherwise, it will be impossible to salvage the concept of quality in today's world of quantity. Where Japan is concerned, the fundamental cause of the alienation is no longer something peculiarly Japanese; it is a universal phenomenon which is merely being aggravated by peculiarly Japanese conditions. Japan's problem has become the world's problem. To that extent, the problem has opened up its confines, so that the artist can now concern himself, not with the Edo period or with the West, but with art. The period of creativity lies ahead; and if an age of creativity really begins, it will see the alienated artist playing his part in rescuing the alienated human being.

On New Forms

In artistic creation, new substance does not necessarily imply a need for new form. The sonnets of Mallarmé are completely different in content from those of Ronsard, yet Mallarmé's content did not make him feel the necessity of a different form. In Japanese literature, the content of Teika's verse is different from that of Hitomaro, and that of Mokichi is different again from that of Teika, yet none of these men felt the need for any form other than that of the thirty-one syllable *tanka*. The same thing is true, I believe, of form in art in general, not only in poetry. It is true that the need to express new content made inevitable the transition from Romanesque to Gothic, yet once the Gothic style was established artists for several centuries to come were to feel that any content,

no matter how new, could be expressed within the framework of that form. The architects of Rheims and Amiens, for example, felt no need of any form other than the Gothic in order to express something quite different from what had preoccupied the architect of Chartres.

However, the most typical case where new subject-matter does not require a new form is found among the authors of most memoirs and journals. It is evident, from the memoirs of Saint-Simon to the memoirs of Churchill, from the journals of Amièl to those of Gide, from the *Meigetsuki* to the *Danchōtei Nichijō*, that Churchill, Gide, and Nagai Kafū each sought to express something new in content, just as it is evident that they were satisfied with the old forms of memoir and journal. The memoir and the journal are direct expressions of the author's experience. Yet all artistic creation is similarly an expression, however indirect, of the artist's experience, and in that sense all artists, at least in one of their aspects, resemble the authors of memoirs and journals. In the light of the view that emphasizes that aspect, it does not always follow that new content requires new forms.

Artistic expression, however, has another aspect that is far from the memoir and the journal. It is the creation of new forms. In order to create new forms, the artist must probably tell something about himself. This is quite different, however, from saying that he needs a new form in order to tell about himself. To tell of the self is the direct aim of the author of the memoir or journal. As we have already seen, new forms are not always necessarily essential to achieving that aim. Where the creating of new forms *is* the aim, the situation is fundamentally different.

Generally speaking, artistic creation is a matter of externalizing something that exists within the artist. It follows that two basically different attitudes are possible towards artistic creation. One emphasizes the things that are within, and sees creation as the process of giving them expression; let us call this, for want of a better term, "self expression." The second attitude emphasizes the things that have been externalized and

sees artistic creation as the adding of something new to what already exists. Let us call this the "impersonal" approach. The first, self-expressionistic approach is common to writers of memoirs and journals in general. The second, impersonal approach is seen at its most thoroughgoing in the poetics of, for example, Mallarmé and Valéry. The distinction between the two categories is, of course, an intellectual one only, and one would never find either in pure form in practice. If it were purely self-expressionistic, the memoir or journal could hardly become a work of literature; and many such works do not, in fact, constitute literature for that very reason. In the same way, a work that was purely impersonal—even though a new form that is in no way an expression of the artist's experience may be possible as an intellectual experiment—would cease to be a work of art. Provided one makes this reservation, however, the theoretical distinction between two attitudes toward artistic creation can be of use in clarifying the actual situation. By "actual situation" here I imply the type of world represented by, say Stravinsky, Picasso, and Valéry when these three artists are contrasted with, say, Schoenberg, Kandinsky, and Thomas Mann. Their impersonal approach to art, their view of art not as a means of self-expression but as a world complete in itself, outside the artist—their view, thus, of artistic creation not as the divulgence of something deep down in the artist's own breast, but as participation in a world that exists irrespective of what is going on in that breast—is essential if the act of adding something new to what has already been made, of contributing a new form to forms already known, is to acquire any meaning; and it is only if it thus acquires meaning that the need for new forms can arise in its turn. Unless such an attitude exists to begin with, new forms are hardly necessary for the artist; indeed, if he is too eager to introduce new forms from outside when the need is not present, it may actually serve to hamper his artistic creativity.

The artists in oil painting who flourished in Japan from the end of the last century onwards were eager to import the new forms created in Paris. It is doubtful, however, whether they

properly appreciated just why it was that Paris had felt the need for new forms. If they had done so, it is unlikely that any of them would have felt the same need, and though some of them might have moved towards a new style, others just as surely would have maintained the old style. One of the reasons why all without exception were so susceptible to the invasion of new forms—where styles of painting were concerned, at least, though there were other reasons as well—was that, despite the fact that they did not personally feel a pressure towards them, the idea that it was a good thing to take over new forms was already present. In other words, new forms in art were being treated in the same way as new methods in science. Form in art, unfortunately, is not method. If some new method of dyeing human blood cells with a particular pigment is discovered somewhere in the world, that discovery belongs to all men from that day on. On the other hand, a new style of applying paint to the canvas using a particular method; for example, Cubism has meaning only to the artist who has felt the need for it, and none for him who has not.

The view of art not so much as a means of self-expression but as something independent of the artist and complete in itself, while partly, of course, a question of the individual artist, is still more a question of the cultural setting in which the artist lives. If the task of adding something new to a particular world consisting of different works of art is to inspire the artist with a sense of significance, with passion, and with the resolve to sacrifice his life for it, it is necessary that he should first believe in the value of that world. The question is whether or not such a world does in fact exist, quite independently of the artist's life, personal experiences, emotions, and disposition. In other words, there must exist a body of works of art, and a scheme of values that guarantees the validity of that body of work. This corresponds to what André Malraux, in modern times, has summed up as "the museum of the imagination." It was the existence of such a world that made it possible for Malraux to state: "one does not create in order to express oneself; one expresses oneself in order to

create." A body of art works is a cultural heritage, and a system of values that emphasizes the importance of a cultural heritage is doubtless conservative. Thus the cultural setting needed to generate new forms in art must contain within itself an ineradicable element of conservatism. The artist who creates a new form will probably fight against conservatism in art. Yet if the adversary is too frail the artist's arm cannot gain in strength—or perhaps one should say that the relationship between the two is a paradoxical one in which the very objects for which the artist fights could not exist without the existence of the adversary.

At the same time, conservatism concerning artistic values cannot appear in isolation within a culture. Conservatism, if it is truly hardy, neccessarily shows itself in all fields of a system of values. In this sense, one might say that the prime condition making possible the boldest innovations in art forms is the generally most stubbornly conservative elements in that culture. Without conservatism, there is no innovation in artistic form. No doubt it is for this very reason that the revolutionary society is seldom innovative in the arts. A revolution changes the content of art, but not its form. The revolutionary painting of Mexico is a case in point. Formal innovation occurred not in revolutionary Mexico, but in conservative Europe. The techniques of Expressionism—the fundamentally new treatment of color, line, and surfaces—made their appearance in Europe, and in Germany in particular, around the time of the First World War. The artists of Western Europe used those techniques in order to paint a world of fantasy—cities and harbors, forests and horses, human beings trembling in anxiety. The revolutionary artists of Mexico devoted the same techniques to portraying tormented workers and workers arising and shaking their fists. The workers at that time were about to create a new society. Yet, they and the artists who stood on their side had no real need of new techniques.

Directly following the Russian Revolution, there occurred a period of artistic experiment; with Mayakovsky, the revolution seemed to be indicating a revolution in the arts also. Yet

that period was short-lived. It was followed, as everyone knows, by a long period of "socialist realism." Was it merely chance that this happened? Was it merely due to the fact that Marshal Stalin's artistic outlook was stubborn and old-fashioned? I doubt it. More likely, it was because it was difficult for the artist to pursue more than one objective at the same time. To portray the new themes—the proletariat and its society—and to find new ways of portraying them were two different things. It was not that the two were unrelated; but to say that two things are closely connected is not to say that they are the same. To take an extreme example of what I mean, it was while Cézanne was engaged in painting an apple that he first discovered a new method of painting in oils. An apple is hardly a new subject for painting; no illustration could more thoroughly smash the popular notion that a new theme requires a new manner. In earlier times, the transition from medieval painting to modern painting, with its technical discoveries and epoch-making changes of style, did not occur when Giotto painted subjects different from those of medieval painting, but when he was depicting traditional themes familiar since medieval times. Pagan and secular subjects were not very common in Renaissance painting until after the establishment of a new style of painting. Even the Italians of the Renaissance, at the time when they were most busy discovering new ways of painting, used old themes; when they turned to new themes, they used whatever techniques they had at hand. This cannot have been a coincidence. In art, it seems, it is impossible to renew everything at once; one chooses between putting old wine in new bottles and new wine in old bottles. Socialist realism, being a theory of new wine, could have no truck with new bottles.

Socialist realism, of course, was sometimes imposed on the artist by political authority. The impeding of artistic development by means of controls imposed by political authority is another question. The fact in itself is not enough to explain why the authorities imposed socialist realism rather than other artistic theories. The argument that, since socialist authorities

preached art for the masses, and the masses are conservative in their tastes, art necessarily became conservative too, doubtless explains the aspect of the question of socialist realism's formal conservatism, but not the whole. The question is not so simple that it can be disposed of as a pandering to the tastes of the masses. Popular taste in art is not of a single kind; a number of varied tastes are to be found or else are latent in the masses. Thus another explanation may stress that socialist realism simply decides to which of these art should appeal and the general direction to be taken in doing so; the art of the class responsible for leading the new generation was realistic, and thus even though not new, cannot be otherwise. This explanation carries considerable weight (just how much does not matter here), in the sense that a newly arising class can see directly and portray realities that the old ruling class either overlooked or deliberately ignored. Either way, though, "realism" here relates to the themes of the art, and not its forms. One can understand the assertion that whereas a bourgeois artist does not portray factory workers, an artist of socialist realism must, and can, do so. However, the argument theoretically speaking affords no conclusion as to choice of form—*how*, in other words, should one portray the worker? Thus when socialist realism is spoken of as comprehending the question of form as well as subject matter, there must be some corresponding reason where form is concerned. Something that has been frequently pointed out in this connection is the historical precedent: Courbet painted stonemasons, so when Courbet's "realism" is discussed, one includes not only the workers that formed his subject-matter, but his technique and form as well. Again, the implications of Balzac's "realism" extend not merely to the fact that he depicted the "realities" of early nineteenth-century French society, but to the very form of the Balzac style novel. However, the precedents set by Courbet and Balzac do not mean that the techniques and forms of Courbet and Balzac are necessary whenever one wishes to paint stonemasons in oils or depict in a novel the "realities" of society. In other words, one must seek the reason why the

theory of socialist realism respected the forms of Courbet and Balzac somewhere other than in simple historical precedent. What reason, then, comes to mind? It is, surely, that Courbet's form was subsequently absorbed into academicism, while Balzac's form provided the prototype for the nineteenth-century novel. By the period after World War I, when socialist realism was first expounded, these forms could be called the most conservative of the oil painting and the novel respectively. Socialist realism demanded new themes for art—which is why it clung to the oldest forms.

Individualism
and the Artist

One of the distinctions between science and the arts is that the scientist can use, as it stands, knowledge acquired by others through their experience, whereas the artist cannot. An accumulation of experience (experiments are no more than experience planned and organized) can result, say, in the knowledge that antibiotics are effective against infection by pyogenic bacteria. There is no need for the individual to repeat the same experience before he can use antibiotics to treat a case of such infection himself. Provided he applies them according to methods established by others, he can reasonably expect them to be effective at once. What of a parallel case in art, however—of, say, the knowledge that the Yakushi Trinity in the Main Hall of the Yakushiji temple is a superb

piece of art? This knowledge, too, is the product of the accumulated experience of countless individuals; the art histories tell us that it is so, and go so far as to state that, of the three figures, the Bodhisattva Nikkō (pl. 2) or Gakkō is particularly fine. Yet, in itself, this knowledge acquired by others can have no meaning whatsoever for the individual. It will only become meaningful when he has accumulated similar experience himself—when he has trained his eye by seeing a certain amount of sculpture, and of Japanese Buddhist sculpture in particular, and has come thereby to appreciate the Trinity for himself. With art, in other words, it is imperative that the individual retrace for himself the same grounds that others have already trodden. Here, one might say, lies the qualitative difference between the Bodhisattvas and antibiotics.

The question arises, though, of whether anybody, provided he fosters his critical faculties, will automatically find the Bodhisattvas in the Main Hall of the Yakushiji admirable. It seems most unlikely. The trained eye may even, occasionally find it dull. It would be strange indeed if it did not, and it is for precisely this reason that the evaluation of a work of art varies from person to person. The major factor behind this variation is the period into which the individual is born. It is sensibility, and not art theory, that is determined by the age. Nineteenth-century Europe, for instance, set little store by medieval art. The value attached to it by twentieth century stems neither from any particular theory nor from any particular view of history, but from the unequivocal evidence of the individual's own senses: he looks, and he finds beauty. It is sense and sensibility, and not, in any direct way, knowledge and reason that are at work here. Where medieval art is concerned, Rodin was strongly attracted to the Gothic, whereas Bourdelle was attracted to Romanesque sculpture. This, too, is doubtless a result of the age in which they lived, as is clear if one considers the views of medieval art held by Rodin's contemporaries and Bourdelle's contemporaries respectively. One might well see this tendency for sensibilities of differing qualities to form strata by period as a distinguishing feature of European culture, and

it is in Europe more than anywhere else in the world of today that the thickness of these strata is most clearly detectable. One of the most clearcut theoretical expositions of this point has been given by Henri Focillon.

It was Focillon's belief that there is a universal pattern detectable in the stages of development of a style, and that all styles, in their own time and place, pass through this same pattern. There are four stages according to him: an experimental period, a classical period, a period of refinement, and a baroque period. The "baroque" referred to here is not, of course, the historical Baroque used to refer to a specific period in art history. The "experimental" period is commonly referred to as the archaic period. The features of each period require little explanation, and one or two examples should suffice. In terms of Greek sculpture, for instance, the four periods correspond to the primitive, the age of Phideas, the age of Praxiteles, and the Hellenistic age. With the Gothic, they correspond to the latter half of the twelfth century, the first half of the thirteenth century, the end of the thirteenth century and the fourteenth century (*"l'art rayonnant"*), and the fifteenth century (*"l'art flamboyant," "cet art baroque du gothique"*). Focillon applies the same theory to medieval Romanesque as well as to the period beginning with the Renaissance, with the aim of illustrating the universal applicability of his graded process. In demonstrating the universality of such a law, however, it is desirable that the styles concerned should be as independent of each other, and as physically far removed from each other as possible. In this connection, there is no denying that the Gothic—Gothic sculpture, at least—has a close affinity with the Greek. This in itself does not, of course, lessen the validity of the original hypothesis, but the fact remains that distant Japan affords a third and unrivalled case that can stand alongside Greek sculpture and Gothic art. I refer to Japanese Buddhist sculpture from the latter half of the sixth century until the thirteenth century: the archaic Asuka period, the classical Hakuhō and Templō peridos, the refinement and academism of the Fujiwara period, and the Kamakura "ba-

roque." As we have seen, there is no need to quibble over the precise use of the word "baroque." What is important is the astonishing range of correspondence whereby these three long periods—from sixth-century Greece until Alexandria, from the early twelfth century until the fifteenth century in French Gothic, and from the late sixth century until the thirteenth century in Japanese Buddhist carving—all passed through stages exhibiting similar formal features, until finally sculpture was freed from architecture and began to move freely in space, form casting aside the restrictions imposed by the materials. Until Tempyō times at least, the development of Japanese Buddhist sculpture was subject to overwhelming influences from the Chinese continent, and some may object to interpreting this development as though it were something that occurred spontaneously. Yet even supposing it were no more than a reflection of stylistic developments on the continent, the fact remains that it affords a chance of tracing that development with an abundance of material unrivalled elsewhere. With medieval Indian sculpture, the art of Central and Southern America before Columbus, or Negro art in Africa, it is possible to detect regional differences, but it is extremely difficult to trace the development by stages of any one style. There may well have been graduated development through stages, but insofar as it is impossible to gather a large number of works from one particular area and arrange them in chronological sequence, it is also presently impossible to discuss stages in development. In the case of Egyptian sculpture, a large amount still survives today. It is possible to trace a chronological development, but the process extends over several thousand years; obviously, it cannot be discussed in the same terms as a process that stretches over a few centuries at the most. In short, Japanese Buddhist sculpture belongs to that select company—also including Greek sculpture and pictures decorating pottery, medieval French sculpture and architecture, Russians icons, Chinese ceramics, and the painting of the Italian Renaissance—in which one can follow the development of a style in great detail. If Focillon's four-stage principle can

be applied so widely, then it is really astonishing. And the question that poses itself immediately is: why should it be so? In *vie des formes* Henri Focillon remarked, "One style comes to an end, and another comes into being. Man must embark on the same quest once more. It is man, the identical unchanging spirit of man, that embarks on that quest." There is, ultimately, no way of explaining the universality of the stages in the development of style other than in terms of the uniformity of the human spirit. One might, indeed, put it the other way round, and wonder if there could be surer proof of that uniformity of spirit. There is no space, however, to delve into this question any more deeply here. What is certain at any rate is that style develops in stages, and that those stages have been repeated within different styles at different areas and at different times in history.

The second fact pointed out by Focillon is that a society at a particular stylistic stage tends to rate highly works produced at the same stage in the styles of the past. "Baroque" he says, "seeks in history the baroque of the past." The romantic style, he says, may not be exactly and in every respect baroque, yet it is natural that an age of reaction against an artificial classicism should have set great store by *l'art flamboyant* that was the baroque stage of the Gothic. In Germany, the age of Lessing admired the Laocoön sculpture, a work that represents the baroque in Greek sculpture. Nowadays, it is considered normal to set Phideas before Praxiteles, much less Laocoön. It was before World War I that Rodin wrote his *Cathedrals of France* in which he dealt with the Middle Ages, yet even between the two world wars Wilhelm Worringer found it necessary sharply to attack Rodin's Hellenism, and to stress that the Italian Renaissance did not have a higher level of culture than medieval France at its peak, but that the two cultures derived from "different ways of thinking that it was not possible to measure by a common yardstick." Today, after World War II, there is no need whatsoever, in the West at least, to emphasize this point. The twentieth century has discovered medieval art. And since the last war in particular, that dis-

covery has become almost a commonplace. More accurately, one should surely say that as a whole the sensibility of the age is drawn towards the medieval; for although the question is in part one of knowledge, more basically it is one of sensibility. It is the age that determines the sensibility, and this quality of the age is what is known as culture. All thought must start from experience. If the quality of the experience is the same, then all the rest is, in a sense, its logical consequence. Where two sets of ideas differ fundamentally, it means that the quality of the experiences that afford their starting-point is different.

Experience, however, does not occur in isolation, but within a period and a culture. The quality of a sensuous experience is already in itself a peculiar to a particular culture, and moves with the age within that culture. There is Vézelay and there is Chartres, and there is Rheims. Contact with them has meaning for us not via concepts but through the senses; not by words, but from direct contact with a spirit realized in sensuous terms. We do not see the ancient stones as valuable; the ancient stones move us. Value means merely the fact of our being moved. The value of the twelfth, or the thirteenth century has not in fact changed; what is new is the fact that what moved no one during the previous age moves us now.

What, however, does "age" here mean in terms of Focillon's theories? It seems that we are about to enter decisively upon an age of archaism. In Greek sculpture, it is the sixth century rather than the fifth century that attracts us. With the Italian Renaissance, the age of Giotto and Uccello has more to say to us than that of Michelangelo and Titian. In Japanese Buddhist sculpture, it is the Asuka rather than Tempyō, in the *ukiyo-e* print Kiyonaga rather than Utamaro, that we admire. What is surprising is the sharp contrast revealed between two facts: the extreme plurality of styles—in the strictest sense, the absence of style—in contemporary art; and our unanimous partiality for archaism in looking back over the development of style in the art of the past. Since it is difficult to detect any predominant contemporary style (it is difficult to define clearly the development of abstract trends in painting, even

assuming that these can be regarded as a "style") and since, in particular, the background of contemporary art is more diversified than that of any previous art, with no indication as to what the present age will eventually crystallize into, it is impossible to account for everything by simple recourse to Focillon's theory, and impossible to say that the present, being an age of experiment, rates highly the ages of experiment of the past. The truth in fact is the reverse: it is the unanimity with which we admire the experimental age in the past that provides the only thing even resembling a clue to the true nature of our own age. If one leaves Greece aside for the moment and turns to the Gothic, the whole situation is still clearer: Amiens rather than Rouen, Rheims rather than Amiens, Chartres rather than Rheims . . . it is true where building, sculpture, stained glass, everything are concerned. This does not necessarily mean that one is of more value than the other. While standing in front of the cathedral of Rheims, it is difficult to imagine that anything could surpass it; in itself it is perfect. Yet granted this, despite this, the building at Chartres appeals to us more strongly—indeed, is overwhelming in its impact. The reason is surely that all archaism comprises a fierce spiritual urge to create a new style, and a dramatic battle between that spirit and the material used. The flying buttressess of Chartres, for example, have none of the delicacy of structure of those of Nôtre Dame in Paris, but create their impression through sheer volume of stone more than anything else. They are structure, but they are structure made of piled-up stones—structure that includes within itself the very act of piling up stones. They do not cling to the ground as does Romanesque architecture, yet neither do they part company with the earth lightly, as do the buttresses of Nôtre Dame de Paris. If Rheims, growing from the earth and rising straight up toward the heavens, can be likened to leaping flames, then Chartres reaches up to the heavens like a great tree. In it one feels the drama of stone striving to become form, of form grappling with the stone. Such an essentially architectural and structural drama admits of nothing ornamental, of nothing intellectual and unrelated

to the materials: in short, of no non-architectural trifling with forms. In the structure itself—sturdy, exposed, of the essence simultaneously of form and material—there is the spirit. Whatever that spirit may be, it is a dramatic spirit that cannot be confined by words such as "harmony"; a fierce spirit that seeks to transcend nature and the senses: a spirit that spurns all self-indulgence. At Chartres, the human body provides both the pillars and part of the building itself. The bodies, however, are not, as in Romanesque sculpture, human bodies locked within a narrow frame of architectural space, straining to move twisted limbs, emphasizing their life and its irrationality, their passion and their untamed quality, but are "humanized" in every sense of the word; the human body in control of itself and its surroundings has become, without effort, part of the building. As for the spirituality apparent in the faces of these stone figures, it is surely true that never before, except possibly in Egyptian sculpture of the distant past and the Buddha-head of Northern Wei, has such an austere and profound spiritual quality found expression in form, as in these saints and angels of Chartres. At Rheims there is no such severity. Where one smiles, the other gazes intently. The gaze, however, is not, as in the Egyptian figures, directed at some infinitely distant horizon, but into the human heart. I am moved, and for me everything starts from there. The rest is nothing but words. It is certain, however, that the emotion I feel is not mine alone. The question is not one of individual sensibility even in the viewer, much less in those who erected the structure in the first place. What makes Chartres attractive to us is something in our own age, and it was something in *their* age that made them raise these piles of stone, and carve these stones on this spot. Surely it is a piling of just such strata as these that constitute history. It is this that is meant, too, when one says that culture is "historical."

The Middle Ages in Europe, however and especially in France, inevitably lead us to a consideration of architecture in general, since at that time "a monumental building in stone was not simply a supplementary piece of historical informa-

tion but was history itself; architect, sculptor, and painter joined with philosopher and poet in building a city of the spirit on the foundations of the life of history. The *Divine Comedy* was nothing but a cathedral."

The question of medieval architecture transcends the field of architecture and becomes a question of history. The cathedral was a summing-up of history. The cathedral building did not serve any practical purpose, yet neither was it purely monumental. Between the practical, or functional present, and monumental antiquity came the spiritual Middle Ages, an age in which architecture gave them their highest all-round expression, and a long process in which architecture gradually disappeared. One should start, however, with the process of coming into being rather than the process of disappearing. Historically speaking, the eleventh century may well have been the decisive period. To talk of the Gothic without reference to the Romanesque hardly makes sense. Nevertheless, it was in the Gothic that the Middle Ages achieved their own most universal and definitive style, in the sense that the particular style that came into being in northern France eventually spread all over Europe, strictly maintaining its basic forms wherever it went. The building of vast cathedrals which began in the thirteenth century forms a sharp contrast with the building of the Romanesque monasteries. The monasteries —erected like fortresses on the tops of hills or hidden in the mountains, or set on isolated islands in the sea or in the middle of lakes—were places where religion took refuge from the secular world. The monasteries were not, like cathedrals, built alongside farms and merchant dwellings in the wheatfields of Beaune and the plains of Champagne, or in the Cité in the heart of Paris. Their stone walls were thick, their windows small; they shut out the outside world; their magnificent cloisters opened onto nothing save the silence of inner courtyards. In these courtyards, meditation reigned supreme—or, perhaps, the imagination that hinders meditation, and the monsters that imagination spawns.

In the age of the cathedral, however, medieval Christianity

began to come into contact with the common people. Except in cases where (as at Albi) retaliation for the suppression of heretics was feared, or (as at Carcassonne) a whole town had to be prepared for an attack by the pagans, cathedrals were no longer fortified, nor did they need to hide themselves in the mountains. Their doors were opened to the multitude, and all might draw near. In this sense, they became part of the daily lives of the masses. The townsfolk heard their bells in the morning and at night, and any event of great moment drew them to assemble in the open space before their portals. The cathedrals comprised in themselves every kind of hope and jealousy and connivance, all varieties of self-serving and self-sacrifice, youthful gaiety and solitary old age—indeed, the whole of life itself. If it were otherwise, the stone angels of France would never have acquired that form that made them in Rodin's eyes "the true woman of France, of the provinces, the beautiful plant of our garden." The doors of the cathedrals were open even to the pilgrim from afar, their walls were large enough to accommodate them. The walls of piled-up stones were thick, no longer as a defense against enemies, but rather to create another, spiritual space within the lives of the citizens. They were relieved by large stained-glass windows, and the lights that shone through the pictures of the saints depicted therein cast rainbow hues on the lofty pillars and the ogive roofs. There was a joy at once sensuous and spiritual, rhythms of rejoicing created by light and color. And in the late afternoon, when the sun began to decline in the west, the rose window glowed like countless jewels in the vast gloom of the building. Beyond doubt, the art of light reached its peak at that time, in northern France in the latter half of the twelfth century, and even today we can still witness it at Chartres in all its glory. The Sainte-Chapelle in Paris is probably already too light, and as is generally known, stained glass after this developed away from "jewelled light" in the direction of the pictorial. In the latter half of the twelfth century and the first half of the thirteenth century, however, the interiors of cathedrals were dark, and the deep reds and blues of the stained

glass combined in an incomparable richness of hue. This is not the place to discuss the colors of stained glass as such—those colors that in our own time were to fascinate Georges Rouault so deeply—but it is worth noting that it was upon coming into contact with the masses that medieval Christianity created this unprecedented world of color. Nor was the world of color the only thing that it created. It was here, too, that medieval church music was born, polyphony and counterpoint. Just as, in the north, stained glass became pictorial and in the south the great age of murals began in Italy, giving rise eventually to the "pictorial" Europe of modern times so church music was eventually, through Bach, to give rise to the whole of European music. The cathedrals at that time embraced the daily lives and religious aspirations of the masses, and the whole of sculpture and music.

This alone, however, would not signify the dominance of architecture, since buildings might merely have been containers —the providers, as it were, of space. The decisive factor in our estimate of a modern art gallery is the oil paintings it contains, and not the surrounding building. The cathedral, however, was something more than an enormous receptacle. In the cathedral, architecture developed from a technique for piling up stones into a composition with vertically climbing lines, from a simple structure to a mode of expression. It is significant that this expression was purely compositional, depending on lines and masses that, in the north at least, eschewed even the use of color, and on light and shadow. Sensuous, concrete expression—sculpture, painting and the swelling tones of the organ—was within, while the building served to synthesize the whole at an abstract, intellectual and universal level. Architecture was not simply a practical container, but was itself expression; it was not simply expression, but was comprehensive expression. This was achieved here for the first—and probably the last—time. Gothic was not merely an architectural style, it was the style of an age. Possibly, even, it was the decisive form of Christian Europe itself, discovered via the medium of this age. Art did not have a style: art *was* the style.

The age of the individual did not begin until style in the sense in which it was synonymous with art had disappeared. When Baroque sculpture forsook the pillars and walls of the cathedrals, and leapt outward into free space, sculpture had already taken the first steps towards the day when it was fated to be put on display in museums. When painting bade a decisive farewell to the stone wall in fifteenth-century Flanders, the magnificent and agonizing history of modern painting, developing according to independent theories of its own had already begun. In the same way, the age of church music was succeeded by the age of music for the concert. The secular theatre required a constant supply of music. Music history, however, was to carry through its own independent theories at a progressively more remote distance from the mass of the people. In the end, it was to produce a Schoenberg. What of architecture? As art emerged from the cathedral and began to follow its own independent course, architecture ceased to be a comprehensive mode of expression, then ceased to be a mode of expression at all. Functionalism in architecture in recent years is no more than a realization of the fact that architecture has ceased to be a form of artistic expression. It is not—one might say—that the dominance of architecture has ceased, but that the age when a culture had its own, all-embracing style has come to an end. Anyone who creates art now must do so entirely on his own responsibility; but the individual cannot create the style of the age. It is only logical that, once it became impossible to look on art and style as synonymous, the view of art and individuality as synonymous should come into its own.

In this sense, it was only natural that the age in which architecture dominated all art should be succeeded by an age in which art was represented by literature: the modern age. And once again, it seems, it was in France that the process was seen at its most typical. The sixteenth century found in the particularity of French a worthy substitute for the universality of Latin. In the seventeenth century, the alexandrine and the three unities were alive, and literature flourished on the

stage of the classical drama—yet how was the alexandrine able to hold its own after that, and how long did the drama remain enthroned in the world of literature? Romanticism pressed ahead—consciously, and thus somewhat noisily; boldly and thus somewhat crudely—with an inevitable process of development that led from verse to prose, from the drama to the novel, from all form that exists independently of the artist's individuality to the "confession" and the "journal" the value of which can only be endorsed by individuality. And in the end, even French prose in itself, became so diversified that two contemporaries could write works differing as widely as *A la Recherche du temps perdu* and *Variétés*. All these things were merely seen at their most typical in France; they were not peculiar to it. Similarly, they were seen at their most typical in literature, but were not peculiar to it either. There is no need, even to go back to the Middle Ages; one has only to listen to Scarlatti and other composers of his time, then turn to say, Wagner and other composers of his day. The comparison shows adequately that even music can be a means to the expression of individuality. The portraits of Titian and Tintoretto were, of course, differentiated by the individualities of their respective artists. But they are not so different as, say, the human figures of Rouault and Picasso.

The characterizing feature of the modern age is not that works of art are individualistic; they were always so: one need only remember how different are the cathedrals of Rheims and Laon, each breathing with its own separate life. In modern times, however, the expression of individuality became, in itself, the object of art. A work of art no longer became something individual only when it succeeded, but was individual even before it was art. This quality could hardly fail to be reflected in the assessment of an artist's work. To assess Rouault and Picasso together is more difficult than to assess together Titian and Tintoretto. It may be that the only way to assess any fierce expression of individuality is for its individualism. Individuality, however, is a fact, not a value. The individual cannot, by itself alone, constitute art. Where art has as its object

the expression of individuality, art is aimed at something outside itself. Modern art's self-consciousness about its methods and its concern with the "purely" pictorial and the "purely" poetic is doubtless connected with this. Without consciousness of method, possibility would lurk of everything being absorbed, once and for all, into literature. Individuality is a phenomenon of human life. It is literature in prose or its equivalent that deals directly with such phenomena.

In seeking to discuss the individuality of the artist, I have dealt with sensuous experience and the age as that which determines the quality of the sensuous experience, and I have touched on the possibility of the quality of the sensuous experience, determined by the age, being made objective as style. That possibility is the possibility of culture. I have done no more than arrive at the beginning of the problem. However, the problem of individuality is that of the transcending of the individuality. Here, I would venture, lies the whole problem of modern art. If the cathedral is art—one might ask—can the modern age really attain to art at all? Granted that the only path for us by now is that of individuality, we, too, still require something that transcends the individual. To transcend individuality is in no sense to destroy it. For example, the relationship between conditions in a mass society on the one hand and art on the other hand probably resolves itself into the question of how powerfully and how long the artist's individuality can resist those conditions and thus survive. The pyramids may be monuments, but they are not art. A society would theoretically be possible that created pyramids and only pyramids. There has been no society without a literature, since human life and language are ubiquitous. But history affords not a few examples of empires that were not creative in art, of cultures that did not succeed in giving form to their own spirit. Can there be any objective criteria for evaluating art? Such a query, and the preoccupations that it implies, are not likely to produce art. Values do not exist: they are created. The confusion of individuality and values has been the persistent disease afflicting the modern age. For all I know,

the disease may be conquered, and a new art may put in its appearance. When that happens, we shall have found the style of our own age. Until then, we must be content, I suppose, to call it the "age of science."

Style in Buddhist Sculpture

The imitation of nature is not art. The faithful imitation of the human body is not sculpture. The wax dummies in the Musée Grevain in Paris are more faithful to their originals than any of the marble statues in the Musée Rodin. Yet despite this, or rather because of it, one never speaks of the "sculpture" of the Musée Grevain. The Pauline Borghese by Canova might almost be alive; its marble flesh seems, almost, to be no longer stone but living female flesh that would feel warm to the touch. But this effect is difficult to distinguish from the impression that the marble woman is merely a substitute for the real thing. No substitute in this sense can ever be art, which is why one has doubts about the quality of Canova's work as art, however accomplished its techniques.

Michelangelo, too, gave human form to marble; but he did not try to create in marble something that might be mistaken for the object portrayed. The French writer Alain expresses this very clearly. "Tradition has it," he says, "that the work of Michelangelo sprang from a block of marble itself. . . . The model was there only to remind the sculptor of the form of details that did not emerge from the marble itself. By dispensing with fortuitous and unnecessary detail, the work reveals the true form of the model."

Thus if the term "realism," whatever it may mean, has any use as a term of art criticism, "a sharp distinction must," as Worringer says, "be made between it and the pure imitation of a model in nature." As to how, exactly, this distinction should be made, Worringer himself is not completely clear, nor do other writers seem to have produced any consistent idea on the subject. Here, however, I will leave the term "realism" as such aside for the moment, and confine discussion to the relationship between a work of sculpture and its model.

The difference in the degree of outward resemblance to the subject has a close connection with historical changes in artistic style. Greek sculpture of the fifth century B.C. showed an obvious increase in faithfulness to the human form, compared with that of the sixth century. The same thing can be said of Gothic sculpture in the twelfth and thirteenth centuries A.D. Thus any account of the historical changes that have overtaken representational style in sculpture—as opposed to its quality—must take the faithfulness to the model into consideration; and almost all art historians, in fact, do so. Most art historians, however, refer not to "the faithful imitation," but to "realism." At times, it is never quite clear whether or not the latter term means merely the same thing as the former, and, if not, what else it implies in addition. Very often, I believe, the result has been a most remarkable confusion.

A typical example of this ambiguity is to be seen in accounts of the styles of Japanese Buddhist sculpture. Some historians use the term "realism" in referring to sculpture as early as that of the Tempyō era, and refer to the twelve Divine Guards

(Jūni Shinshō) of the Shin-Yakushiji temple as representing "the peak of the realistic tendencies of age." On the other hand, however, they compare the "realism" of the Kamakura period with Late Gothic. Other historians refer to Tempyō sculpture as "basically naturalistic," then proceed to refer to Kamakura sculpture as based on "naturalism." If both the Tempyō and Kamakura styles are "based in naturalism," then the concept of naturalism in question is useless in distinguishing what are two enormously different styles, and is a clumsy tool for an accurate account of the stylistic changes that affected Buddhist sculpture.

However, the confusion in writing on the subject, at least in the case of Japanese Buddhist sculpture, is due to something more than ambiguity in the concept of "realism." In the case of Kamakura sculpture, there is scarcely an art historian who does not refer to its "realism." Fenollosa sees a "perfect primitive realism" in the figures of the Six Patriarchs of the Hossō sect (Hossō Rokuso). Yashiro Yukio sees "a powerful realism," in the Guards (Kongōrikishi) of the South Gate of Tōdaiji and the "realism" of the figures of Asaṅga and Vasubandhu (Mujaku and Seshin) is for him "life force." For Kuno Takeshi, "It is natural that Kamakura sculpture, with its basic emphasis on realism, should have produced masterpieces of portrait sculpture." According to Minamoto Toyomune, the figures of Mujaku and Seshin, the Sixth Patriarch in the Nan'endō (pl. 29) and the statue of Chōgen in the Shunjōbō (pl. 30) are outstanding examples of the "naturalism" that characterized the Kamakura style.

In other words, almost all historians—with the exception of Paine and Soper, who cite the Suigetsu Kannon (or Kanzeon, Avalokiteśvara) as an example of "a realism that calls to mind certain types of Late Gothic sculpture"—have had portrait sculpture (or something very close to it) in mind when they characterized Kamakura sculpture as "realistic." In that case, what is the object with which the characteristics of the Kamakura-period sculpture are compared? If it is the sculpture of the preceding Fujiwara era, then what works, precisely, are gen-

erally considered as most representative of the Fujiwara age? If works such as the Amida (Amitābha, pl. 11) and Unchū-kuyō-butsu in the Byōdōin are meant, then it is only to be expected that portrait sculpture should be more "realistic," whatever definition one may apply to that term—than the idealized image of Buddha. In other words, it makes no difference whether one says that Fujiwara sculpture specialized in elegant idealization and Kamakura sculpture in realism, or simply that a large amount of portrait sculpture was produced in the Kamakura period. It was not "only to be expected" that Kamakura sculpture, "with its basic emphasis on realism . . . should have produced masterpieces of portrait sculpture." What was to be expected, perhaps, was that Kamakura sculpture, with its basic predominance of portrait sculpture, should appear to have place chief emphasis on realism.

Why then should the Kamakura period have produced so much portrait sculpture? The answer lies, not in the "realism" of its artists but, among other things, in the Buddhism of the period, and in Zen Buddhism in particular. The Zen sect set great store by *chinzō*, i.e., the portraits that Zen masters gave their pupils as witness to the fact that the esoteric truths of Zen had been transmitted to them. It was the resulting sharp increase in the demand for portraits that led to the great production of portrait sculpture, which in turn created the impression of a sudden surge of realism in comparison with the Amidas of Fujiwara sculpture.

Are the characteristics of Kamakura sculpture really contained, however, in the large amount of portrait sculpture that it produced? I doubt it. In the late Fujiwara era and early Kamakura period, there were major changes, not only in Buddhism, but in the structure of society as a whole. The spirit of the age—if one may postulate such a thing—almost certainly changed greatly, which would have meant in turn that anything the age produced, whatever it might be, would bear the marks of the new spirit. Sculpture would hardly have been an exception. However, in order to confirm that conjecture and find out just what were the characteristics of the age as they

appeared in its sculpture, one would need to compare the portrait sculpture of the Kamakura period with the portrait sculpture (rather than the Amidas) of other ages, and the Bodhisattvas of other ages with the Bodhisattvas (rather than the portrait sculpture) of the Kamakura period.

The case of Kamakura-period "realism," moreover, is no more than one example. The same argument, I feel, applies to the whole of Buddhist sculpture—from Asuka to Tempyō, through the early Heian period, on into the late Heian period and continuing into the Kamakura period. If one is to describe accurately changes in style that occurred as a continuous process of development, it is necessary, I believe, to see the process not as a single line, but as a number of different lines. Thus the changes that occurred throughout the ages in figures of Buddhas (Tathāgata and Bodhisattvas) would count as one line; and in the same way the changes in figures of Rāja (Myōō), Deva (Ten) and on to the portraits would constitute another line or two lines. I feel it is essential, if one wishes to account for the whole picture, to discuss stylistic changes in Buddhist sculpture not merely in terms of the materials used, as has often been done, but also in terms of the iconographic hierarchy.

The influence of China and Korea is, of course, a decisively important element. No argument concerning style in Japanese Buddhist sculpture can be adequate that omits this factor. In particular, it is difficult to explain why the style of a certain period should have been what it was. But one can still discuss the styles of Japanese Buddhist statuary. Descriptions of the historical changes in style affecting Japanese Buddhist sculpture have tended sometimes to imprecision, and my aim here is to discuss ways of describing them more accurately. I shall not go into the backgrounds against which particular styles came into being, nor the reasons why; thus I shall say nothing of the influence of China and Korea, nor of esoteric Buddhism and the background of Kamakura Buddhism. Nor, obviously enough, do I intend to discuss the value of the works as sculpture. I shall discuss the theoretical framework for discussing

historical changes in style, and then I shall try to trace with reference to Japanese Buddhist sculpture a number of stylistic lines based on iconographical hierarchy.

Since I am discussing not words but ideas I shall treat the terms "realism" and "naturalism," insofar as they relate to sculptural styles, as differing expressions of the same idea. While some people do not apply the concept of realism in discussing sculptural styles, many more use it as one of their most important concepts. What do they mean by realism?

First, the term signifies the "faithful imitation of the subject." Worringer calls it *"Imitation eines Naturvorbildes"*; Louis Bréhier calls it *"l'imitation fidèle du modèle et de la nature"*; and almost all cases of use of the word realism involve this meaning to a greater or lesser degree.

Second, it is the "expression of individuality." Fenollosa, while stressing the strength of line of the robes of the Sixth Patriarch of the Hossō sect, also emphasizes the "absolutely individualized heads." Paine and Soper speak of the "new realism" of the Tempyō era, and emphasize how "well individualized" are the figures of the two priests, Gien and Ganjin (pl. 25) in the Okadera and Tōshōdaiji respectively. The "realism" of Kamakura sculpture as expounded by Minamoto Toyomune likewise seems to refer to the "individualized realism" of Muchaku and Seshin, or the "detailed depiction of the unique features," in the figure of Chōgen. Not only in Japanese Buddhist sculpture, but also in sculpture as a whole, there are countless cases where "realism" is made to mean principally the expression of individuality.

Nevertheless, the "faithful imitation of the model" and the "expression of individuality" are two separate things that do not necessarily coincide. To take an example from pictorial art, some types of caricature are obviously expressions of the "individuality" of actual persons, but equally obviously they are not "faithful imitations" of those persons. Some portraits, again, are "faithful imitations" of a person's physical details in a photographic manner, yet do not necessarily give vivid

expression to that person's individuality. The same thing can be said of sculpture also. The "faithful imitation of the model" is a *technical* concept used in contradistinction to abstraction. "The expression of individuality (or of the particular in general)" is a concept relating to the *content* of what is expressed, and is used in contradistinction to the expression of the universal. The former concerns *how* to express, the latter *what* to express.

To put it in more general terms, one might say that what most people have meant by the word "realism" so far has been, first, a mode of expression that is not abstract but representational, and, secondly, the expression not of the universal but of the particular. (The "faithful imitation of the model" is no more than an extreme case of figurative expression. The "individuality" of a character is no more than one case of the particular.) The attempt to incorporate these two utterly different ideas within a single concept has given rise to a tremendous amount of confusion of thought and inaccuracy of description. The confusion and inaccuracy can easily be avoided by making a clear theoretical distinction between two separate ideas.

The argument put forward by Worringer in his detailed study of the concept of "realism" runs more or less as follows:

Anxiety of the man in the hostile world generates the *Abstraktionsdrang:* a desire to liberate himself from the accidental aspect of human life. The harmonious relationship between the man and his environment is by contrast the condition for the "Einfühlungsdrang" directing to his liberation from his individual self. Motivated by the *Einfühlungsdrang*, the man endeavours to put himself in an agreeable form in nature, which leads to "realism" in artistic expression.

Up to this point Worringer's theory is clear and consistent. But when he starts to analyze a concrete case, for example, the medieval sculpture, it turns out that the theory doesn't sufficiently cover the field in question.

In observing and evaluating medieval sculpture, it is necessary to take into simultaneous account elements far

removed from the point of view we have expounded so far. That element is the realism, or naturalism, that is a common characteristic of all art north of the Alps. This realism extends beyond the pure urge towards artistic expression. The pure artistic urge is based solely on the primary artistic sense and as such can only be expressed in terms of form. This realism, however, belongs to an expanded realm of aesthetics; via the limitless possibilities of the complex aesthetic sense it transcends aesthetic experience and appeals to a variety of different spheres in the experience of the mind. . . .

Medieval sculpture forms the most important section of all European sculpture north of the Alps. That its characteristics cannot be explained in terms of "realism" in Worringer's sense signifies something more than the simple fact that one can find exceptions wherever one goes. The idea of "realism" as expounded by Worringer, excluding as it does any consideration of "imitation—whether pure or otherwise—of a model in nature" does not seem to be a particularly convenient concept when applied to art history.

Nor is that all. Worringer continues:

> In the Romanesque and Gothic styles, this realism came into confrontation with a purely formal, abstract artistic urge. The result was a unique hybrid. The impulse towards imitation that characterizes the realism (*der charakterisierende Nachbildungstrieb*) is given shape in the head, as the place where the heart finds expression, while the clothing, which obliterates all the features of the body, is in accord with the abstract artistic impulse . . . The realistic formation (*die realistische Bildung*) of the head coexists, without any intermediary, with the completely abstract and inorganic posture of the other parts.

Since both *Nachbiedungstrieb* and *die realistische Bildung* are used here in referring to the head, it seems safe to view them as having much the same meaning. If that is so, then "realistic" and "imitative" are closely related. Thus Worringer's idea of realism must be considered to have gone astray from the

moment he asserts that a "sharp distinction" must be drawn between the two. This is not merely a matter of trivial differences among words. The question concerns the heart of Western sculpture, the relation between the Romanesque and Gothic styles, and what Worringer himself declares to be the characteristics of those styles.

I imagine that in Worringer's case the inconsistency in the concept of realism came about in the following fashion. First of all, he made a sharp distinction in his theories between "realism" and "closeness to a model in nature." Next, however, he sought to apply the theory to the practical case of medieval art, but in doing so, admitted the idea of closeness to a model in nature— The former point is doubtless an indication that the value of sculpture as art has no relation to the degree of "closeness to a model," so that it is only sensible to eliminate that idea from the theory of aesthetics. The latter indicates, however, that the idea is useful in relating the historical vicissitudes of style and as such cannot very well be done away with entirely.

This two-faced nature of the concept of realism manifests itself not only in Worringer's case, nor solely in relation to medieval art, but lays an elaborate trap in the path of many an art historian. Ueno Naoaki, for example, has this to say of Tempyō art: "It is often said that Tempyō art is essentially realistic. If 'realistic' refers to the imitation of that which exists, or could exist in reality of Nature, then Tempyō art cannot be called realistic." Yet when he compares Asuka and Tempyō art, he declares that the former "rejects humanity or renders it abstract," "deifying" the human form, whereas the latter, "by representational treatment, brings out the humanity," "idealizing" it and "raising it to the divine level." The argument that, insofar as both Asuka and Tempyō sculpture achieve "deification" of their subjects in the end, neither constitutes imitation of nature, makes good sense. (This part of Mr. Ueno's thesis would correspond to the first stage in Worringer's aesthetic.) However, he then proceeds to find the distinction between Asuka and Tempyō sculpture in the dif-

ference between the abstract and the representational. How, then, does one define "representational" if it is not the imitation of a model in nature? Both abstraction and representationalism are ultimately questions of degree. At lease where Buddhist sculpture and medieval Christian sculpture are concerned, there is nothing that is completely abstract, with no representational elements whatsoever, nor is there anything that is completely representational with no abstract elements. Thus to talk of the "representational" in sculpture must always be to discuss the *degree* to which it is present. To discuss degree, some yardstick is necessary. There can be no criterion, for assessing the degree of representationalism, I imagine, other than the model in nature. In other words, to say that the difference between the Buddhist figurts of the Asuka and Tempyō ages is a difference between the abstract and the representational is simply to say that the Tempyō figures show a structure closer to that of the actual human body than the Asuka figures. Here too, the concept of "imitation of nature" (the extreme case of "closeness to a model in nature"), which was in theory discarded at one stage, intrudes itself again as soon as discussion turns to historical changes in style. (This would seem to correspond to Worringer's second stage, his theories concerning medieval sculpture.)

A Buddhist image is not a faithful imitation of a human body. Yet, at least one of the most important points in distinguishing different styles of Buddhist sculpture is the degree to which they resemble the human form. Thus whether one is considering medieval European sculpture or Japanese Buddhist sculpture, the idea of realism in the first of the two senses I have pointed out above—i.e., the imitation of a model in nature —is one element that cannot be omitted from consideration in any account of changes in style.

As I have already suggested, the terms "abstract" and "representational" involve the question of *how* something is expressed, and say nothing about *what* is expressed. In its most generalized form, the question of *what* is expressed resolves itself into the distinction between the universal and the par-

ticular. "Universal" refers to common attributes of all human-
ity, or of all divinity; examples are the "spiritual" quality
observable in the pillar statues at Chartres or the Northern
Wei heads of Buddha. This "spiritual quality" can perhaps be
interpreted as the quality of compassion; yet whatever its pre-
cise nature—whatever its *content* may be—it is certain that
the "spiritual quality" expressed there is not that of a particu-
lar individual, but an ideal common to all humanity, and that
it is not a particular emotion felt under particular circum-
stances, but concerns some basic human attitude that tran-
scends all such circumstances.

In most cases the expression of the universal in sculpture
assumes the form of an idealization of the human body. But it
is not always so. The masks of the Congo, for instance, are for
the members of that society the expression of supernatural ex-
istences. The supernatural is certainly universal, but it is not
an ideal.

Particularity is the individuality that distinguishes a given
human being (or object) from other human beings (or ob-
jects); and it is also that which distinguishes a human being
at one particular moment from that same human being at an-
other particular moment. Individuality in portrait sculpture
falls into the former condition, the expression of wrath (as in
Buddhist statuary) or the ecstasy of love into the latter. The
difference between the Northern Wei head and the statue of
Ganjin is that the former presents a universal, idealized face,
whereas the latter shows the individual man Ganjin and no
one else. The pillar figures at Chartres do not show human
beings under any particular circumstances, but the general
attitudes of those human beings to the world. Rodin's statue
of a man and woman embracing each other does not show the
subjects' attitude towards the world, but relies for its validity
on capturing a single moment in their lives.

These two conditions of particularity—the individual par-
ticularity that distinguishes object A from object B, and the
expressive particularity that distinguishes object A under cir-
cumstances X from object A under circumstances Y—do not

always accompany each other in one and the same work. The figures of Gate Guardians (Niō, or Kongōrikishi; pl. 19) by Unkei, for example, are completely particularized insofar as they represent moments of extreme wrath, but express no individuality in the two figures themselves. The features of the head of the Ganjin statue are completely peculiar to the individual man Ganjin, but have no relation to any special circumstances affecting Ganjin. Thus it is necessary, I feel, to distinguish within the particular between the particularity of the object and the particularity of the circumstances.

What then, of the relationship in sculpture between universality and particularity of content, and between the abstract and figurative where technique is concerned? If one restricts discussion to the most typical cases, there are four, and only four, possible combinations.

1. The universal and abstract; e.g. the Congo masks.
2. The universal and figurative; e.g. the divine statues of classical Greece.
3. The particular and abstract, e.g. the terra-cotta figurines of ancient China.
4. The particular and the figurative, e.g. the portrait sculpture of the Italian Renaissance.

Since the masks of the Congo (or most of them) are supernatural, they transcend natural time and space, and in this sense can be called "universal." The degree of abstraction varies from mask to mask, but is frequently carried to the extreme limit beyond which it would be impossible to recognize the mask as a "face." The addition of expressionistic coloring to this cubist abstraction, as one might call it, creates an incomparable impression of power. The statues of the gods of classical Greece are idealizations of the human body; this is obviously true, at least, of the thoroughgoing representationalism of the fifth century B.C. and later. These statues do not, however, express individual physical characteristics employing particular models, but the expression of ideal proportions, i.e., of a universal beauty. Thus the universal (the transcendental)

may appear in sculpture in either abstract or figurative guise. Nor does the expression of the particular necessarily involve out-and-out representationalism. The terra-cotta figurines of ancient China attest to this fact, and in particular, the dancing figures in black pottery. In the omission of a considerable number of details of faces, bodies, and clothing, one notes a fair degree of abstraction. Yet the abstraction here is clearly aimed at emphasizing the posture at one particular moment of a dance. What it conveys is not something generalized, such as a concept of the ideal human form, but the particularized view, showing the appearance of the human body at one unique moment, a moment that differs definitively from the next. Particularity in this sense has, of course, no connection with human individuality. It is not until the figurines of the T'ang dynasty that one notices a progress towards the figurative, and something close to individuality in the figures—a trend of which the most thoroughgoing example is the portrait sculpture of the Italian Renaissance.

The examples given here are no more than the most typical. Yet even in these most typical cases, the terms *universal, particular, abstract,* and *representational* are each a matter of degree. If one wished to show accurately the continuous difference of degree, one would need to devise not the set of four types just given, but a two-dimensional graph. The vertical arm would show, from bottom to top, the progression from the particular to the universal, while the horizontal arm would show, from left to right, a progression from abstract to representational. But for the following discussion it is not necessary to develop such a graphic presentation. The question is to know whether these concepts—universal, particular, abstract and representational—are useful and convenient for describing accurately the style of sculpture. This question will be now examined in relation to Buddhist statues in Japan.

It is usual to distinguish six periods in the history of Japanese Buddhist sculpture from the end of the sixth century until the thirteenth century, the reason being that each period

has always been considered to have its own style clearly distinguishable from the styles of all the rest. The six styles are: Asuka, Hakuhō, Tempyō, Early Heian, Late Heian, and Kamakura. I shall follow this conventional practice where division into periods is concerned. Some scholars doubt whether it is possible to distinguish an independent "Hakuhō style," but I shall not go into that here; whatever one's view of the Hakuhō style, I see no particular harm in distinguishing the Hakuhō period as transitional, between Asuka and Tempyō.

Generally speaking, it does not follow that each period has its own integral style. Where there are very marked regional differences, for example, it may be possible to distinguish several principal styles in the sculpture of one period. It seems to me, however, that this element is not particularly important in considering the Buddhist sculpture that developed mainly in Nara and Kyōto. If it is necessary in discussing Japanese Buddhist sculpture to distinguish a number of styles within the same age, then the differences, it seems to me, will depend on three things only: 1) influences from the Asian continent; 2) differences in materials; and 3) iconographic ranking.

Where an influence from abroad is very marked, it is sometimes necessary to distinguish two styles, depending on whether or not it is present. The most handy example in Japan's case is seen in the painting of the Meiji and Taishō eras. The difference between the styles of Kuroda Seiki and Tomioka Tessai is quite obviously that one was influenced by the French academic and Impressionist styles, while the other was not. Any discussion of the differences between their two styles that ignores this fact is almost totally pointless. Again, what distinguishes Saeki Yūzo from Kuroda Seiki is the influence upon Saeki of the École de Paris, rather than any process of development from the style of Kuroda to that of Saeki. The styles of the Asuka, Tempyō, and Kamakura eras could certainly not have come into being without influences from Six Kingdoms, T'ang, and Sung China respectively. Yet the styles of the Tempyō and Kamakura periods, it seems to me, do not contain—or at least do not contain many—works that would

be impossible to classify without reference to differences in the nature of the influence each received from abroad. In other words, although an analysis of the influence of T'ang or Sung China may be a necessary factor in explaining the reason why those styles came into being, such an analysis is hardly required to describe their formal characteristics. My aim here is to examine methods of describing changes of style, and not to advance hypotheses concerning the reasons for those changes. At least from the Tempyō period on, it is possible, I believe, to discern more or less what was happening in Japan without reference to influences from the continent. Where the Asuka period is concerned, such an assertion is not so easy to make.

Some of the works grouped together as Buddhist sculpture of the Asuka period show great stylistic differences from the rest. It would be exceedingly difficult, for example, to lump together within a single style works as diverse as the Shaka (Śākya-muni) Trinity in the Hōryuji (pl. 4), the Guze Kannon in the Yumedono (pl. 8), the Forty-eight Buddhas in the Tokyo National Museum (pl. 6), the Miroku (Maitreya) in the Chūgūji (pl. 7), and the Kudara Kannon (pl. 5). Might it be possible, then, to classify them in groups, each with its own stylistic unity? The materials used for the five works just listed are, respectively, bronze, wood, bronze, wood, and wood. Yet it is impossible to distinguish any marked affinity between the bronze works or among the wooden works. Their iconographic rank places all of them in the highest category, that is, among Buddhas or Bodhisattvas; thus, it is difficult to insist upon hierarchical distinctions. Even the meditative pose adopted by the Chūgūji Miroku, though it might be related to the similar pose of a Miroku in the Kōryūji, is quite different in both its facial characteristics and the treatment of the body, from figures in the same posture among the forty-eight Buddhas. In short, it is also difficult from an iconographic point of view to split up Asuka Buddhist sculpture into a number of unified styles. Thus the only alternative left, if one is to consider the Buddhist sculpture of the Asuka period (and

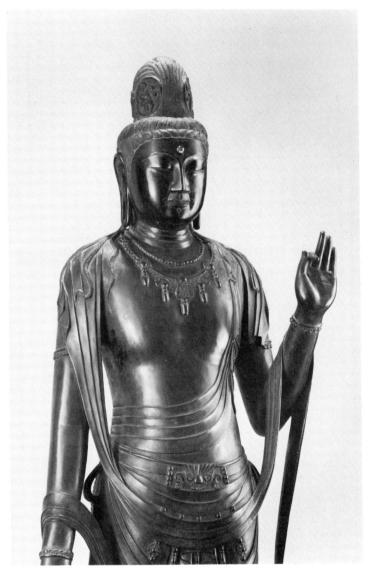

PLATE 1. Shō Kannon (detail). Copper Hakuhō, late 7th cent. *Yakushiji.*

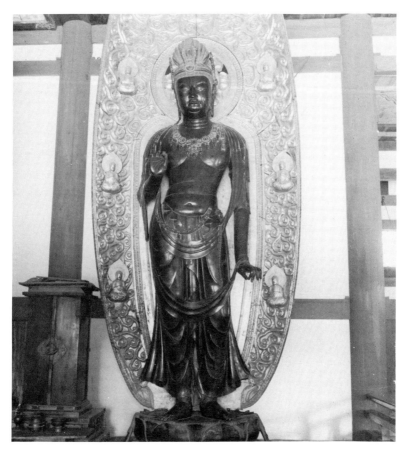

PLATE 2. Bodhisattva Nikkō. Copper. Tempyō, early 8th cent. *Yakushiji.*

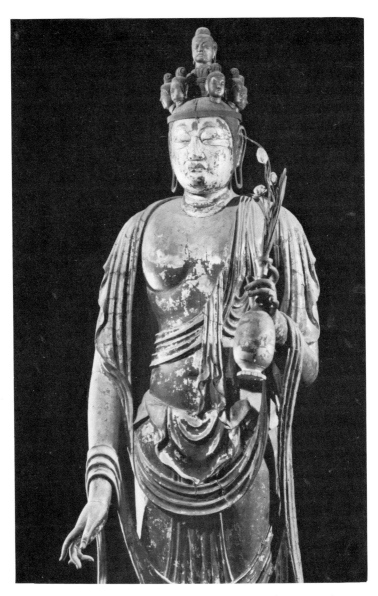

PLATE 3. Eleven-faced Kannon. Dry Lacquer. Tempyō, 8th cent.
Shōrinji.

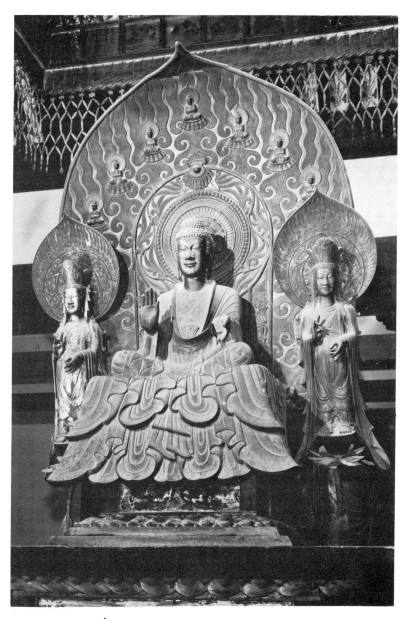

PLATE 4. Shaka (Śākya-muni) Trinity. Copper. Asuka, early 7th cent. *Golden Hall, Hōryūji.*

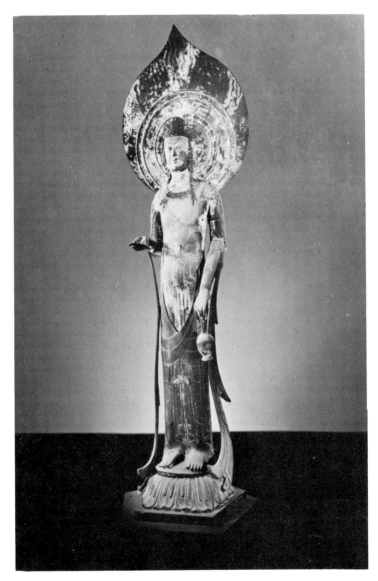

PLATE 5. Kudara Kannon. Wood. Asuka, 7th cent. *Hōryūji.*

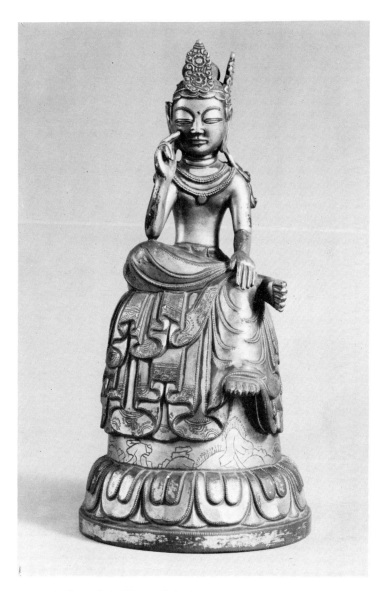

PLATE 6. One of the Forty-eight Buddhas. Copper. Asuka, 7th cent.
Tokyo National Museum.

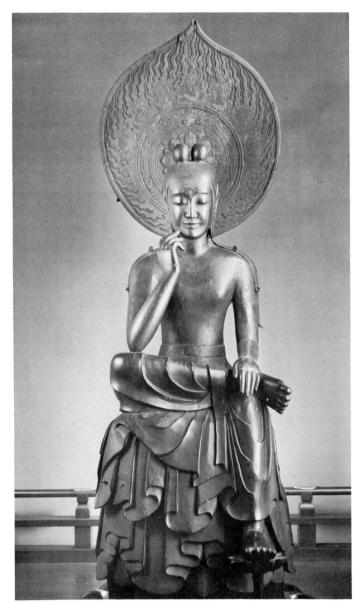

PLATE 7. Miroku (Maitreya). Wood. Asuka, 7th cent. *Chūgūji.*

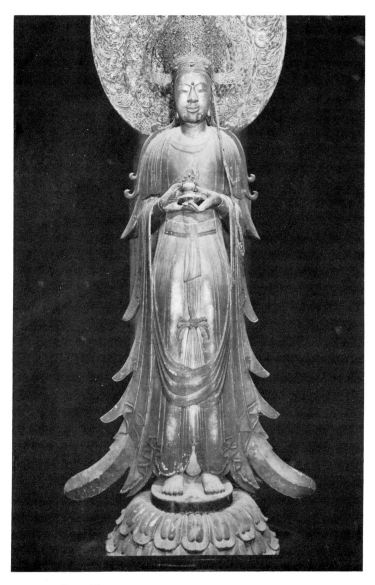

PLATE 8. Guze Kannon. Wood. Asuka, 7th cent. *Yumedono, Hō-ryūji.*

some would include the Hakuhō period also) as a compound of a number of different styles, is to form groups of works according to what influences from abroad they exhibit.

Professor Mizuno first divides the northern style of the Six Dynasties into four by distinguishing three periods within Northern Wei and adding to it Northern Ch'i and Northern Chou. He then puts forward the view that the influence of the third period of Northern Wei (Lung-mên) created the Asuka style, while that of Northern Chou (Tien-lung Shan, Hsiang-t'ang Shan) and Sui (Yün-kang) went to form the Hakuhō style. His theory is a fine piece of work insofar as it succeeds in explaining the independence of the Hakuhō style in relation to the continent, but it fails to explain in relation to the continent the many-sided nature of Asuka art. I am not qualified to discuss this relationship with the continent in detail. However inadequate the approach may be, I can only accept the Asuka style in its own right—with many inner discrepancies, it is true, yet obviously distinguishable from the Tempyō style.

Broadly speaking, six different types of material are known to have been used in Buddhist sculpture: metal (copper, bronze), wood, dry lacquer, clay, terra cotta, and stone. At no period was terra cotta or stone used as the principal material. The principal materials thus were copper and wood in the Asuka and Hakuhō period; metal, wood, dry lacquer, and clay in the Tempyō period; wood from the early Heian period on.

Three methods were used for making copper (bronze) figures. They were made by using a wooden core-model from which the casting mold was obtained by burning out the wooden model after it was covered with casting investment; or, by using a wax core-model in the investment and then melting it out (lost-wax technique); or by placing sheet copper over a wooden core and beating the metal to its shape with a hammer. The latter was a supplementary technique used only in special cases. The use of wooden cores began at an early period, while wax cores seemed to have been used chiefly in the Tempyō period, suggesting that even in gilt metal figures, the Tempyō

artists were more interested in the treatment of details than were their Asuka predecessors. Generally speaking, gilt bronze is a difficult material to handle compared with wood, dry lacquer, or clay; it is inconvenient for the figurative treatment of detail, and does not lend itself to coloring. As a medium, it was obviously better suited to the abstract idealization of Buddhist figures than to any more individualistic treatment with lifelike details.

What relationship did metal material bear to the historical development of style? In the first place, in a process that began in the Asuka and Hakuhō periods and continued through Tempyō on into the early Heian period, metal figures were gradually replaced by figures of other materials. In the same course of time, the style gradually became less abstract, starting with the proportions of the body and gradually extending to the treatment of details, and becoming increasingly figurative. Here one may detect a clear connection between style and materials.

Second, figures surviving from the Asuka, Hakuhō, and Tempyō periods (the periods in which metal figures were produced) are almost all Buddhas (Tathāgatas or Bodhisattvas). Metal statues of the Rāja and Deva—and especially the Gate Guardians (Niō), Four Generals (Shitennō), and Twelve Guards of Yakushi (Jūni Shinshō), later to become so popular as subjects—are almost entirely absent. It is true that examples in bronze of figures other than Buddhas (Tathāgatas or Bodhisattvas) are to be seen in the grotesque figures (pl. 22) that decorate the dais of the Yakushi (Bhaiṣajyaguru) Trinity in the Yakushiji temple, the *suien* on top of the pagoda of the Yakushiji, and the angels on the celebrated bronze lantern standing before the main hall of the Tōdaiji temple, but these are all in relief or open work, and constitute special cases. Of course, the fact that almost no metal figures of the Rāja or lesser divinities survive today does not justify the assertion that such figures were not made. However, the number of examples that we have today probably suffice to allow a guess at the general trend of the time. This trend is extraordinarily well defined:

the use of metal as a material was confined chiefly to the upper ranks of the iconographical hierarchy (Tathāgatas and Bodhisattvas) and rarely seen in the lower ranks.

This second point, I imagine, can be explained by the fact that figures of the high-ranking deities required idealization, whereas figures of the lower ranks required expression of their special functions. As examples, let us take the Yakushi Trinity and the Gate Guards in the Middle Gate (Chūmon) of the Hōryūji, which are generally considered to be representative works of the Hakuhō period. In the case of the Yakushi and his attendants (the Bodhisattvas Nikkō [pl. 2], and Gakkō), the expressions of the faces and the treatment of the bodies are related to the idealized disposition of the subjects, and not to particular emotions evinced under a particular set of circumstances. The Gate Guards, on the other hand, belong to the "wrathful" category of Buddhist figures, and depict a very particular emotion, rage, via the posture of a particular moment. This does not mean, however, that the Gate Guards figures have individuality. In their lack of individuality, there is no difference between the Gate Guards and the Yakushi Trinity. The difference lies in that where the figure of Buddha (Yakushi) seeks to express an eternal ideal—a universal nature, transcending time and space—the Guards express strength in wrath: that is, a particular emotion. One might say that it was for this reason the Yakushi Trinity was made in copper while clay was chosen for the Guards. If the explanation is correct, then the close connection between material and iconographic distinctions of rank also seems to suggest a close connection between stylistic characteristics and iconographic ranking. There are no metal Gate Guards or Four Generals. For these, other materials were used, which suggests that a different type of formal treatment was sought after in the two cases: Tathāgatas and Bodhisattvas on the one hand, and Gate Guards and Four Generals on the other.

From the Asuka into the Tempyō period, wood was already an important material, and in the Heian period it was used almost exclusively. Although the Heian period brought the

development of the technique of carving the statute from a single piece of wood (*ichiboku-bori*), as well as changes in the technique of using the chisel, it is difficult to link this widely used material with any particular iconographic ranking, as can be done in the case of metals. Another noteworthy phenomenon is a sudden reduction, in the early Heian period, in the number of the dry lacquer and clay figures so common in the Tempyō period, followed by their almost total disappearance in the late Heian period. I do not understand the relationship between this phenomenon and iconographic ranking and style. Nor can I explain adequately the reason why it should have happened. In the case of the Tempyō era at least, it seems safe to assume a close connection between the formulation of the so-called Tempyō style and techniques of making dry lacquer and clay figures. However, this is merely to say that such an assumption is possible; it does not increase our knowledge of the facts of Buddhist sculpture, nor does it make them any clearer.

Buddhist sculpture obeys iconographic laws. These laws have their origin in the way the Buddhist world is ordered, and their justifications exist independently of sculpture or painting as such. The Buddhist world forms a hierarchy. The Tathāgatas (Nyorai) stand at its peak, with Bodhisattvas (Bosatsu) as a special variant of the Tathāgata. Beneath them are various deities such as the Rāja (Myōō) and Deva (Ten). Last of all come the Arhats (Rakan), the Ten Chief Disciples (Jūdaideshi), the celebrated monks, and so forth. The Devas consist of various gods absorbed by Mahāyana Buddhism from other religions, and their original relationships of rank are reflected within the Buddhist hierarchy also. For example, Brahman and Indra, even in their Buddhist reincarnations as Bonten (Brahmā) and Taishakuten (Śakra Devānam Indra), still stand at the head of the Devas, and as such command the Four Generals and others who stand below them. For this reason, statues of Bonten and Taishakuten are idealized in a way that brings them close to the figures of Bodhisattvas. The Four Generals (see pl. 10) are shown as warrior generals, and are closest,

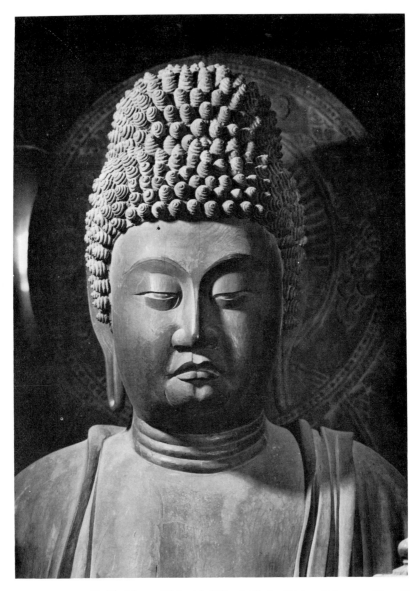

PLATE 9. Tathāgata Yakushi. Wood. Early Heian, 9th cent. *Jingoji.*

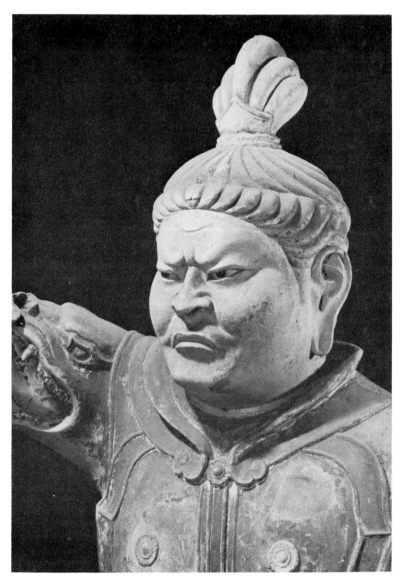

PLATE 10. One of the Four Generals (detail). Clay. Tempyō, 8th cent. *Kaidan'in, Tōdaiji.*

perhaps, to the Rāja. Similarly, the figures of Kichijōten (Mahāśrī) and Benzaiten (Sarasvatī), so common in Japanese Buddhims, resemble Bodhisattvas in their outward appearance. The Devas, thus, require special consideration on account of the complex relationships of rank that exist among them. Nevertheless, generally speaking the iconographic hierarchy corresponds to the progression in sculpture from the universal down to the most particular. The actual works to be found most conmmonly in Japan can be divided into three stages:

1. Tathāgatas and Bodhisattvas (with which one may include Brahmā and Indra)
2. Rājas (Myōō), Hachibushū, Four Generals (Shitennō), Twelve Guards of Yokushi (Jūnishimshō)
3. Arhat, Ten Chief Disciples, celebrated priests.

At the first level, what is portrayed is not an expression of rage or sadness or joy under special circumstances, but an idealized representation of the universal emotions proper to a Buddha, quite apart from whether the emotions or spiritual state happens to be compassion, enlightenment, or what have you. This has no connection with the closeness or otherwise of the bodily proportions to those of the human body, or with the degree to which the folds of the robe suggest the details of an actual robe. When the treatment is abstract and stylized the Buddha is remote from the human body; when it is figurative, it resembles closely the human body. Yet however closely the figure of a Tathāgata or Bodhisattva may resemble the human body, it merely approaches the universal, not individual, characteristics of the human body. In their remoteness from any expression of individuality, the Buddhist figures of the Asuka period and those of the Kamakura period are exactly the same. Thus to use the word "realism" with vague connotations of the expression of individuality, and then to talk of "Kamakura realism" is meaningless where the figures of Tathāgatas and Bodhisattvas are concerned.

At the second level, as is clearly shown by the expression of wrath that characterizes the Gate Guards, what is required is

the expression of a particular emotion—one that can only be expected under particular circumstances. In short, a particular emotion is required at the second level where a universal emotion was required at the first. This emotion may range from the divine wrath of a Rāja, or the Gate Guards, for example, to the indescribably subtle nuances of momentary expression seen in the Asura (Ashura) of the Kōfukuji. However, even this stage never goes so far as personal individuality. In as much as Unkei's celebrated Gate Guards at the Tōdaiji (pl. 19) are shown not, say, having an afternoon nap, but in a towering rage, they set out to capture the particular. But they do not aim showing the personal characteristics that distinguish one Guard from another.

At the third stage, at least in the figures of celebrated monks, the expression of individuality is important. Since the Arhats and Ten Chief Disciples are basically human beings, their figures can be treated as portrait sculpture in the same way as can the figures of celebrated monks. On the other hand, since they are traditional characters, they can also be treated on a par with figures at the second level and stereotyped; thus they belong, in a sense, to an intermediary level between the second and third levels.

In short, the iconographical order of precedence from the first to the third levels corresponds to a formal progression leading from universal, idealized forms to the ultimate in the particular—the appearance of an individual human being at one given particular moment.

What changes now took place in the styles of Buddhist sculpture at each of these three levels between the Asuka period and the Kamakura period? If one takes three Asuka works—the figure of Shaka (Śākyamuni) in the Golden Hall of the Hōryūji (pl. 4); the Guze Kannon in the Yumedono of the same temple (pl. 8); and the figure of Miroku in the Chūgūji nunnery (pl. 7)—one can detect features in common despite the fact that their postures and materials (metal, wood) are different. All three are made to be viewed from the front, and their postures suggest no movement. The robes are

stylized, and conceal the body. The body beneath the robes is far leaner than any real human body, and the details of the head are omitted, expression being concentrated in the down-gazing eyes and the mouth with its faint "archaic smile." The effect is of gentleness and inner harmony. Most important, the Asuka style employed abstraction to whittle away the body and spiritualize the expression of the face.

The transition from the Yumedono Guze Kannon (pl. 8) of the first half of the seventh century to the Shō Kannon in the Yakushiji (pl. 1), which dates from the second half of the same century, is a subtle one. Both figures stand straight with legs together. There is no suggestion of movement in the posture, and emphasis is on the frontal view. Nevertheless, in the Shō Kannon the modeling of the body, which in the Guze Kannon was completely hidden beneath the robe, now begins to be seen beneath the robe. The treatment of the folds of the robe is highly abstract and stylized, but an important change here is that the body is beginning to be given expression for its own sake. The features, too, are closer to those of a well-fleshed human face. This approach towards a model in nature, this shift away from the abstract and towards the figurative became decisive around the end of the seventh or beginning of the eighth century, with the Trinity in the Yakushiji, and especially with the attendant, standing figures of Nikkō and Gakkō that flank the central Yakushi. They mark the beginning of the Tempyō style.

The Buddhist figures of the Tempyō period, from the Nikkō (pl. 2) and Gakkō of the Yakushiji to the figures in the Sangatsudō of the Tōdaiji and the Jūichimen Kannon of the Shōrinji (pl. 3) are alike in showing not an emphasis on the spiritual at the expense of the body, but an incarnation of the spirit in the body—an idealization, that is, of the body. The head is no longer the focus of expression, but one part of the body as a whole. The robes are no longer there to conceal the body, but are draped thinly about it, to emphasize the modeling beneath. Gone is the emphasis on the frontal view; the body acquires its true three-dimensional volume. The motion-

less stance, legs close together, is exchanged for one with one leg somewhat in front of the other, knee bent, the body twisted slightly at the waist, so that the different parts of the body create a complex line. The Jūichimen Kannon of the Shōrinji (pl. 3), for instance, when viewed from the statue's left and slightly to the rear, reveals a fullness at the hips and a graceful shoulder line that cannot be seen from the front. The human body here is idealized in a way that emphasizes a stable sense of volume, harmonious proportions, and gracefully flowing line. This type of idealized figure has no relation to the physical characteristics of any particular individual. The path from Asuka to Tempyō leads the Buddhist sculptor gradually closer to the human form. But it does not lead him towards any particular forms, but to the universal form. It is a change from an abstract to a figurative style, not from the universal to the particular: a change of course under the marked influence of the Continent where the humanization of the Buddhist statues advanced from the Six Dynasties to T'ang.

The Esoteric Buddhism of the ninth century, however, added new elements to Buddhist sculpture. First, there was the deities' piercing gaze that glittered from the gloom of the inner sanctuaries of the temples. Examples are the Jūichimen Kannon of the Hokkeji, the Tathāgata Yakushi (pl. 9) and the Five Kokūzō Bodhisattva (Ākāśagarbha) of the Jingoji. Such a keenness of gaze was unknown in the Asuka and Tempyō periods. The eyes of the Buddhas of Asuka and Tempyō are peaceful, almost dreamy; for a Buddhist figure to glare was almost unknown. Yet in the inner sanctuaries of temples of Esoteric Buddhism of the Early Heian period, one finds eyes that stare with an intensity, an acuteness, an almost theatrical tension that can only be compared with that of the figures of Byzantine mosaics. Secondly, it added the sense of real flesh afforded by colored wooden carving. The sculptors of Tempyō had idealized the body; they had not expressed the feeling of flesh. The sculptured bodies, therefore, were universal bodies, not those of particular people. But Esoteric Buddhism, by careful use of the details of *ichiboku* (one block of wood) carving

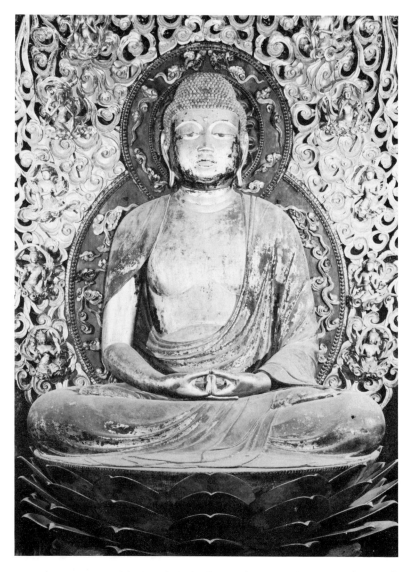

PLATE 11. Amida (Amitāba). By Jōchō. Wood. Late Heian, 11th cent. *Byōdōin.*

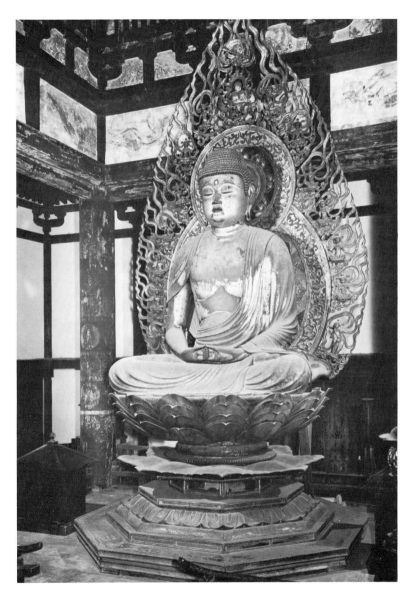

PLATE 12. Amida (Amitāba). Wood. Heian, early 12th cent. *Hōkaiji.*

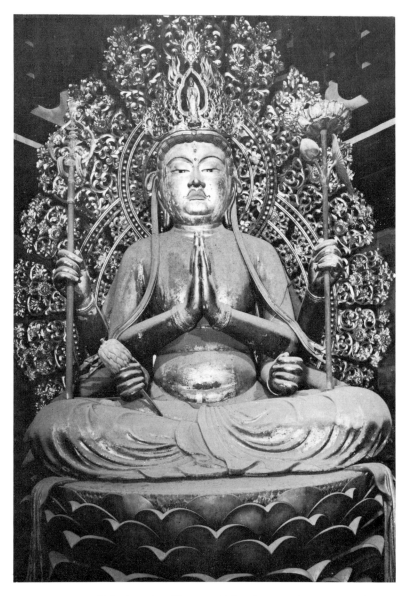

PLATE 13. Fukūkensaku Kannon. Wood. Kamakura, end of 12th cent. *Nan'endō, Kōfukuji.*

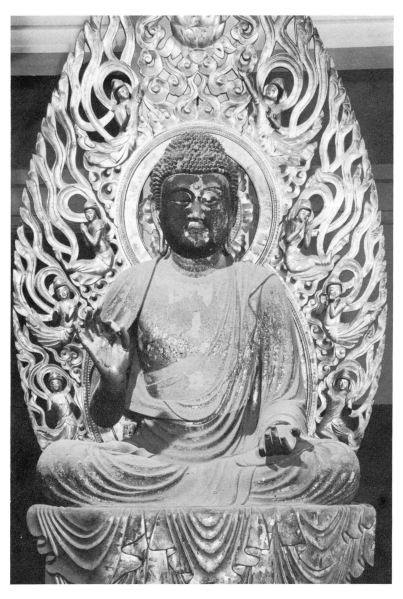

PLATE 14. Miroku (Maitreya). By Unkei. Wood. Kamakura, early 13th cent. *Nan'endō, Kōfukuji.*

in the darkness of its inner shrines, and by the application of color, succeeded in creating a vivid sense of physical presence. This physical presence is not an incarnation of the spirit, but something nonspiritual, something purely sensual.

It seems doubtful whether this can be called a development of the trend towards the figurative that appeared in Tempyō times. It might be true, perhaps, of the details. But this is not the crucial point that separates the Tempyō style from that of the Early Heian period. The crucial point is that the content of the universal has changed. In the Tempyō figures, the universal manifested itself in harmony; in the figures of the ninth century, it appeared as tension. This tension, in all likelihood, arose from the opposition of the generally spiritual, as seen in the flashing eyes, and the generally sensual, as seen in the vivid sense of the flesh.

In the Fujiwara period, Buddhist figures again lose their intensity of gaze. The intense physical presence also fades, and is replaced by graceful, idealized bodies and gentle facial expressions. The difference between the representative works of Fujiwara sculpture, such as Jochō's Amida in the Byōdōin (pl. 11) and the Amida in the Hokkaiji (pl. 12) and Tempyō sculpture is that the Fujiwara carried representationalism in detail one step further. While coming as close as possible to the natural model, they emphasize to the utmost limit the gentleness of expression, the graceful flow of the robes, the sense of stability in the posture, and the proportions of the body. As a result of the further development of figurative treatment, the figures give an utterly different impression from the figures of the Tempyō era. The latter are Buddhas in human form; the figures of the Fujiwara period are human forms endowed with Buddhahood. The Yakushi of the Tempyō era has a transcendental nature, while the Amida of the Fujiwara era is of this earth. The doctrine of the attainment of Buddhahood with this earthly body was, properly speaking, an Esoteric doctrine. But the Fujiwara aristocracy who likened the palace in the capital of Heian to the Pure Land of Amida may well have imagined that in the ideal young nobleman of Court society they had found Buddhahood achieved in the flesh.

How, then, does the sculpture of the Kamakura period differ from these? On the one hand, we have from the eleventh century Jōchō's statue of Amida in the Byōdōin (pl. 11) and the Amida in the Hokkaiji (pl. 12); on the other we have, from the end of the twelfth century, the Fukūkensaku Kannon by Kōkei in the Nan'endō (pl. 13) of the Kōfukuji temple and, from the early thirteenth century, the Miroku by Unkei (pl. 14), in the same hall. The difference between the two pairs of figures is extremely subtle. Some art historians detect a new "power of expression" in the latter pair. Kobayashi Tsuyoshi, for example, says of the Fukūkensaku Kannon, "The taut, resilient quality in the modeling of the face and body and the variety in the rise and fall of the folds of the robe are among its most outstanding characteristics." However, even within the same style one particular work can, of course, have characteristics markedly different from those of other works. The tautness and resilience referred to here are not present, it is true, in most late Fujiwara-period figures, but there is nothing lacking in resilience about Jochō's Amida. It would be difficult, by comparing Jochō's Amida and Unkei's Kannon, to deduce the emergence of a new style in the latter. Mr. Kobayashi in fact admits later in the same piece that the statue does not show the refined integration of style to be seen in the work of Unkei's later years. What does the work of "his later years" refer to? It refers to the figures of Asaṅga (pl. 32) and Vasubandhu in the Hokuendō of the Kōfukuji; but since these are close to portrait sculpture, it is impossible to discuss them in the category of Tathāgatas and Bodihisattvas. Where Tathāgatas and Bodhisattvas are concerned, the shift of style between the Fujiwara period and the Kamakura period is often —but not always, as we shall see again later—so subtle that it is well-nigh impossible to be sure that one has detected it at all. The brilliantly colored Mahāśrī of the Jōruriji was made in 1212, according to the temple records. But has it sufficient stylistic peculiarities to show that it does not belong to the Fujiwara period? Here again it is not easy, stylistically speaking, to distinguish the Fujiwara and Kamakura periods.

This is not to say, however, that the Kamakura style does

not show any special features at the level of idealization represented by Tathāgatas, Bodhisattvas, and other figures that can be classified with them. Among the special features that one could name are the sharpness of the ridges of the wooden carving—as seen, for example, in the Bodhisattva Monju (Mañjuśrī) in the Golden Hall of the Kōfukuji—which means that all the details are very vivid; and the fact that the mild countenances of the Fujiwara period are replaced by "clear-cut" faces in which the features are sharply defined. Thus on the one hand figurative treatment of the details is still more thorough than in Fujiwara sculpture, while on the other the idealization of body and face is no longer spiritual, but makes itself apparent as a balance in the form. "Mild features" implies facial expression. "Clear-cut features" are not expression; they are facial harmony visually perceived.

In this respect, there is undoubtedly a Kamakura style. What I wish to emphasize is that the transition to it from the Fujiwara style is smooth, and is far from being the sudden emergence of a "realism full of vivid individuality," as has been suggested. Is there, in fact, any individuality in the Buddhist images of the Kamakura period? I, for one, see none at all. One finds the expression of individuality as early as the portrait sculpture of the Tempyō era; in the Tathāgatas and Bodhisattvas of Kamakura times, there was none. The expression of individuality is not a question of period, but of relative rank in the iconographic order.

In short, Buddhist sculpture from Asuka until Kamakura does not, as some suggest, represent a gradual process of actualization—of coming closer to the live model—culminating, in Kamakura times, to the expression of an almost living and breathing individuality. If only one considers the figures of Tathāgatas and Bodhisattvas as a continuing category, then it is clear that from Asuka to Tempyō sculpture came closer to the living model in the proportions of the body; in the early Heian period, there was a similar approach in conveying the feeling of living flesh; in the late Heian and early Kamakura periods, there was a similar approach in the treatment of de-

tails; but at no stage was there an approach to a living model with any individual features. At no time was the sculptor required to give expression to a particular emotion manifested only under particular circumstances. The aim throughout was the general, the universal ideal. The nature of this ideal changed from age to age. In Asuka times, it was the spiritual triumphing over the physical; in the Tempyō era, it was the spirit embodied in the flesh; in the Kamakura period, it was a spiritual order reflected in purely visual terms. The makeup of the "spirit" doubtless differed from time to time: sometimes compassion, sometimes enlightenment, sometimes a quality different from these. But this is a question that transcends the morphology of Buddhist sculpture.

It is at the second iconographic level in which the aim is the particular. It begins with the group of clay figures attendant on the death of the Buddha and believed to date from the Hakuhō era, that is housed in the pagoda of the Hōryūji. Particularity is evident in the figures of Arhats shown expressing excessive grief (pl. 15). These figures do not show individuality in the sense that one Arhat differs from the other. Any details that would give such individuality are omitted; the aim is to still give the general idea of a type. What is shown, however, is not an ideal of what an Arhat should be at all times, but a number of Arhats demonstrating with their whole bodies a particular, restricted type of emotion—specifically, despair and grief—under the particular circumstances of the death of the Buddha. The feelings of despair and grief are not shown merely on the faces, but given full play in the execution of the bodies; one figure, for example, gazes up at the heavens, while another stares down at the earth with his hands on his knees. One might almost describe these figures as physical embodiments of the emotion of grief. It is not even especially important that the figures are Arhats, much less what particular Arhat is represented by any particular figure. The unknown sculptor of seventh-century Japan had more than adequate means at his disposal to give expression to the physical manifestations of grief and despair. The sculptural expres-

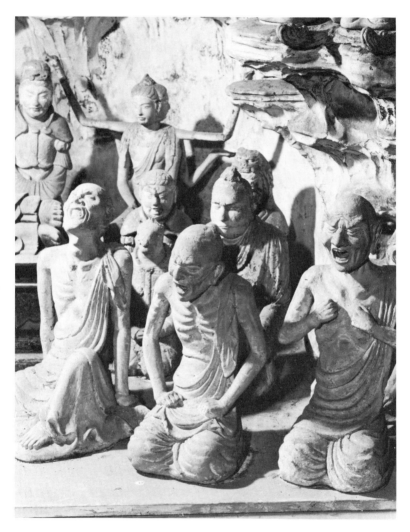

PLATE 15. Crying Arhats. Clay. Hakunō, early 8th cent. *Pagoda, Hōryūji.*

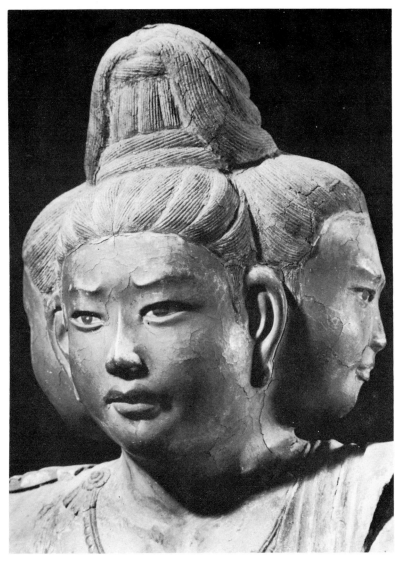

PLATE 16. Asura (detail). Dry lacquer. Tempyō, early 8th cent. *Kōfukuji.*

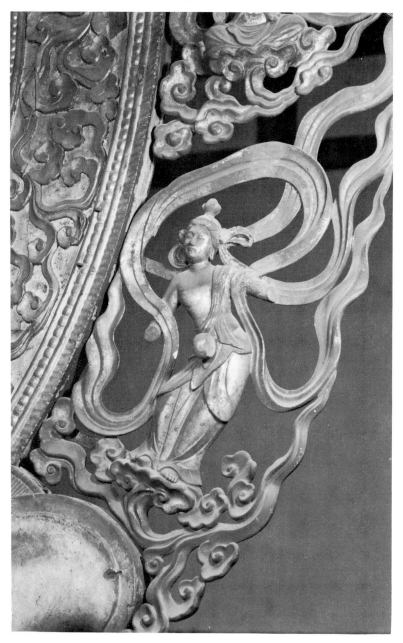

PLATE 17. Heavenly Being on Halo of Amida (*see pl. 12*).

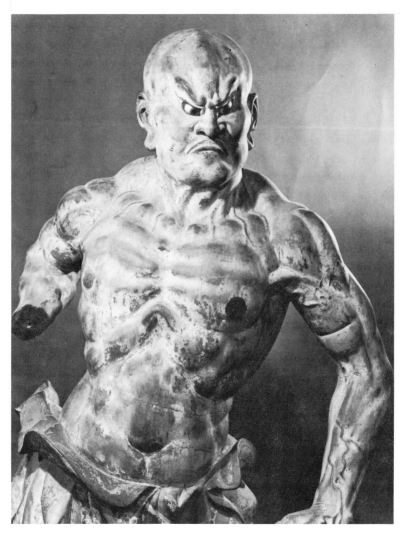

PLATE 18. Gate Guardian. By Jōkei. Wood. Kamakura, end of 12th cent. *Kōfukuji.*

sion of a particular emotion, the ultimate in sorrow, has already in this work attained perfection. To give expression to the grief of a particular person is a different task again, one that probably involves something less than the "ultimate in sorrow," for any emotion is, I suspect, something that transcends the individual.

With the clay and dry lacquer figures of the Tempyō era, there is an increase in the number of works that capture the subtle expressions of a human being at a particular moment in time. Typical examples are the Four Generals in the Kaidan'in of the Tōdaiji, the Ten Chief Disciples of the Kōfukuji, and the Hachibushū, especially the celebrated Asura figure (pl. 16) in the Kōfukuji—unshakable determination, self-questioning, the thought-weary prayer—it is not possible to identify them precisely, yet it is certain that each figure captures the expression of a particular moment. Nor is it necessarily the expression individuality; the abstract, stylized treatment of the faces is intended to emphasize the expression of the moment.

This does not mean, however, that the sculptural expression of a particular moment is restricted to the face alone. The Fujiwara period produced the *unchu kuyōbutsu* as well as the heavenly beings shown disporting themselves in the halo behind the figure of Amida in the Hokkaiji. These ecstatic figures are shown either playing musical instruments or dancing. Their graceful momentary poses—the bent knee, the trunk twisted at the waist, the line formed by the arms—are promptly captured by the sculptor before they can change into something quite different. The figures may represent Bodhisattvas, but they are not, of course, treated in the same way as ordinary Bodhisattvas. In their formal treatment, they belong in the same category as the heavenly beings playing instruments on the Tōdaiji lantern and, later, the heavenly beings in the halo of the Hokkaiji Amida. The most interesting feature of this last-mentioned halo is the angels shown dancing to the right and left at the bottom (pls. 12 and 17). The figures have solidity, and the proportions of their bodies are graceful, following those of the human body. In the slender twist of

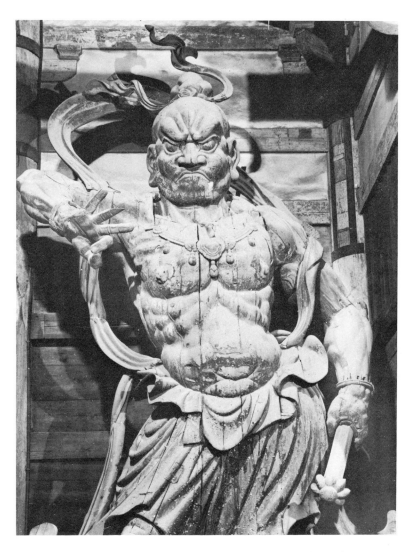

PLATE 19. Gate Guardian. By Unkei and Kaikei. Wood. Kamakura, early 13th cent. *South Gate, Tōdaiji.*

their waists, they have a sensual beauty of line that reminds one almost exactly of medieval sculpture in India. The artist was clearly interested, not so much in the ideal body of a heavenly being in general, as in particular postures of the ideal body.

In the Kamakura period, again, the Gate Guardians by Jōkei in the Kōfukuji and the Ryutōki (pl. 23) and Tentōki by Kōben portray muscular tension at a moment of extreme physical exertion. In this respect, Jōkei's Guardians (pl. 18) go farther, even, than the celebrated guardians by Unkei and Kaikei in the Great South Gate of the Tōdaiji (pl. 19). The latter portray figures with exaggerated treatment of the muscle but the figures are not necessarily shown at the moment at which they exert their full strength. Jōkei's Gate Guardians, however, not only have strength, but also are using it—which certainly means carving to portray faithfully the movement of the muscles of the human body. With the Ryutōki and Tentōki, it becomes clear that the treatment of demons and other supernatural beings in Buddhist sculpture has gradually drawn closer to the human body, adding to the sense of movement that one sees in the creatures crouching at the feet of the Four Generals in the Golden Hall of Hōryūji (pl. 21), in the relief work on the dais of the Yakushi (pl. 22) in the Yakushiji, and in the two figures just mentioned—until finally the figures rear up in a very frenzy of exertion.

In short, the Buddhist sculpture that we have surveyed at this second level of the hierarchy was, from the very outset, a portrayal of particular aspects of particular types of figure. This is as true of the seventh century as it was of the thirteenth. The changes lay in the choice of what particular aspects to represent. No violently weeping figures are to be found after the seventh century; no men exerting all their strength are to be found before the Kamakura period. Gracefully dancing heavenly beings are peculiar to the Fujiwara period, while the figures of the Four Generals, Hachibushū, and Ten Chief Disciples, with their subtle nuances of expression worthy of an actor in a modern drama, are characteristic

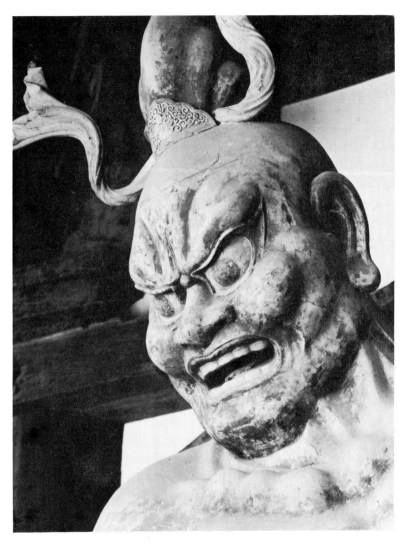

PLATE 20. Gate Guardian. Clay. Tempyō, early 8th cent. *Middle Gate, Hōryūji.*

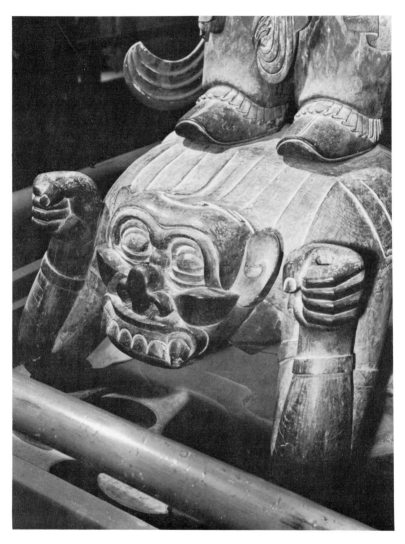

PLATE 21. Monster under the feet of one of the Four Generals. Copper. Asuka, early 7th cent. *Golden Hall, Hōryūji.*

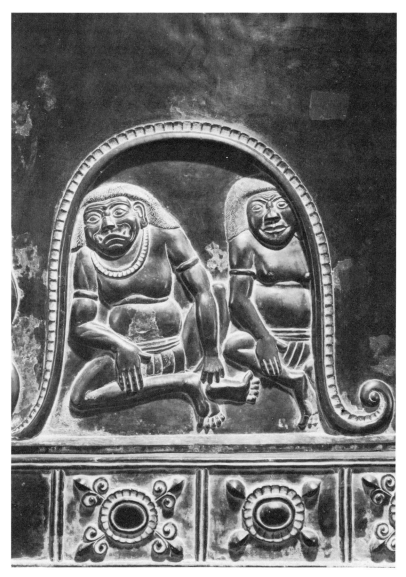

PLATE 22. Monsters on the pedestal of Tathāgata Yakushi. Copper. Tempyō, early 8th cent. *Yakushiji.*

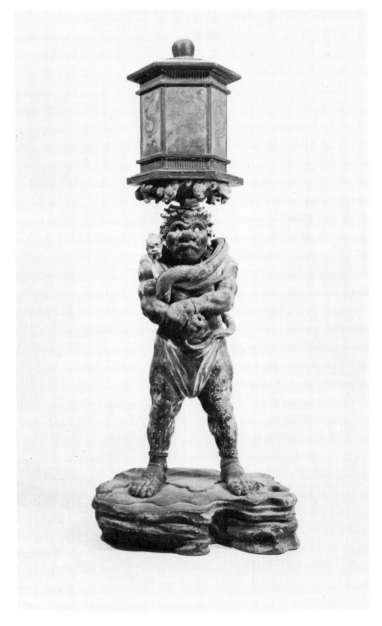

PLATE 23. Ryūtōki (lantern bearer). By Kōben. Wood. Kamakura, early 13th cent. *Kōfukuji.*

of the dry lacquer and clay statues of the Tempyō era. No age aimed at the depiction of individuality in the figure. At no time, historically speaking, did statues at this second hierarchical level show development in the direction of expressing individuality. If "realism" means the expression of individuality, then it is impossible to think of a "Kamakura realism" here. The changes that took place in the Kamakura period were not simple steps towards the figurative, but a development towards figurative treatment of the details of the muscles; the age, in other words, showed a tendency to consider the "particular" in terms of movement, of displays of strength.

Nevertheless, if one accepts the interpretation of "realism" as an expression of personal individuality, the term "Kamakura realism" is not entirely meaningless. The level at which it has some meaning is the third level of the iconographical hierarchy, in portrait sculpture or its equivalent. It is quite true that the Kamakura period produced a large number of masterpieces at this level. I believe, nevertheless, that this was not a sudden innovation but merely the technical consummation and quantitative proliferation marking the final stage of a long sequence.

The earliest portrait sculpture to which we have access today consists of two seated dry lacquer figures from the Tempyō era—the statues of Gyōshin and Ganjin (pls. 24 and 25), which are similar in style. The bodies of the two seated figures are almost indistinguishable. The exposed portions of the neck and chest show no detailed working of the sinews. The only difference in the postures is that Gyōshin's hands, emerging from the sleeves of his robe, are placed on his knees, while those of Ganjin's are folded. The treatment of the hands in themselves is crude in both cases. The folds of the robes covering the body also follow abstract patterns. There is no delicate carving on the head; details are omitted so as to show bone structure delineated in the most general terms. And here one discovers individuality, and a great difference between Gyōshin and Ganjin. The point of these portraits is in the handling of bone structure which does not, of course, change from time to time. Neither Gyōshin's face nor Ganjin's has

111

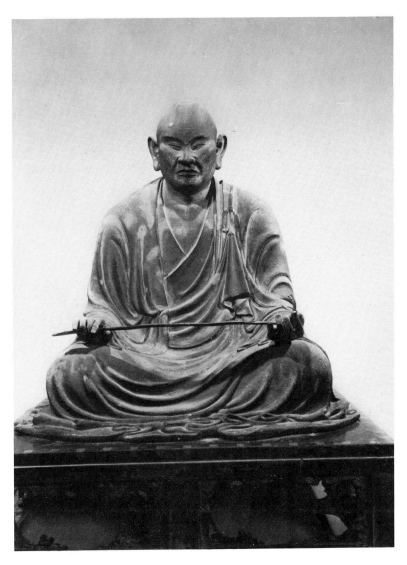

PLATE 24. Priest Gyōshin. Dry Lacquer. Tempyō, 8th cent. *Yume-dono, Hōryūji.*

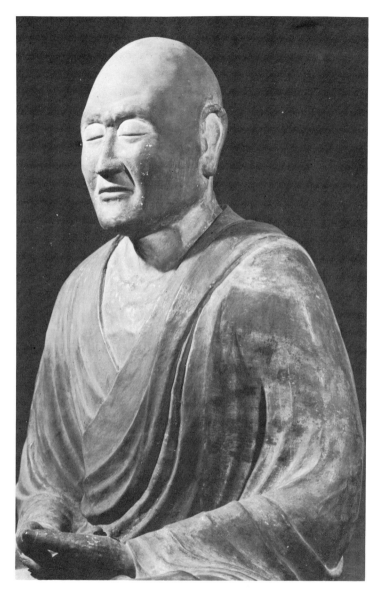

PLATE 25. Priest Ganjin. Dry Lacquer. Tempyō, 8th cent.
Tōshōdaiji.

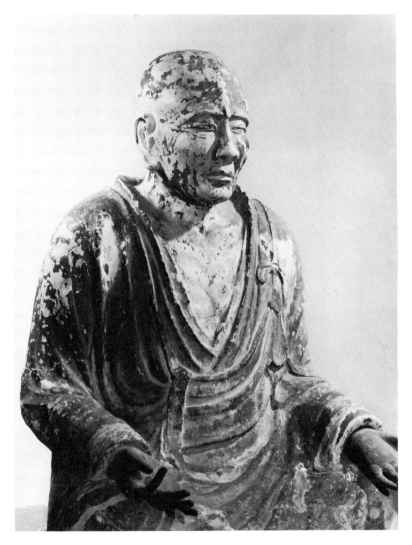

PLATE 26. Priest Dōsen. Clay. Early Heian, 9th cent. *Yumedono, Hōryūji.*

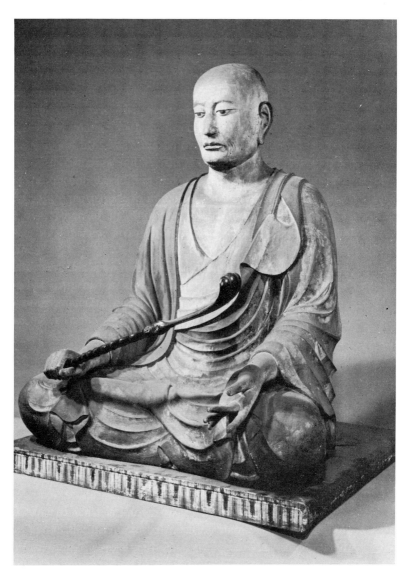

PLATE 27. Priest Rōben. Wood. Early Heian, 9th cent. *Tōdaiji.*

any particular expression, and in their quiet and motionless attitude the two statues are almost identical. But I think there is a great difference in their quality as statues. In the Ganjin figure, the folds of the robe are handled with remarkable skill, the flow of the line showing a kind of harmonious order. There is no such order in the Gyōshin figure. Ganjin's face, with its closed eyes, does not merely give an impression of quietude, but, by means of its bone structure, conveys a kind of personality as well. The face of the Gyōshin statue may convey the characteristics of the bone structure, but it is bone structure and nothing more; it conveys no suggestion of what was once a living personality. However, this is to a large extent my personal impression, and does not really concern us here.

The Yumedono of the Hōryūji is extraordinarily convenient for examining the changes that took place between the Tempyō and early Heian periods. Here one may see both the statue of Gyōshin (pl. 24) and that of Dōsen (pl. 26). They do not stand side by side, but by walking back and forth, one may compare the two works. The ninth-century figure of Dōsen follows the eighth-century statue of Gyōshin almost exactly in the treatment of the body and the folds of the robe. In the treatment of the head, however, it enters a completely new world. The details of the face, the wrinkles in the skin and the small bulges of muscle are carved faithfully, creating a face with an incomparably more vivid individuality than the Gyōshin figure, which omits such details almost entirely. For the first time, in a sense, individual facial characteristics take their place alongside individual characteristics of bone structure. Gyōshin's face has no expression; Dōsen's face is alive with the expression of a particular moment. The expression is peaceful, yet it promises to alter at any moment, whereas the face of Gyōshin is immobile to eternity.

I have already pointed out the similarity between the figures of Gyōshin and Dōsen. Among the statues attributed to the early Heian period there are, in addition to the Dōsen figure, the celebrated statues of Rōben (pl. 27) and Gien. The figure of Rōben is different in that the wood retains traces of its

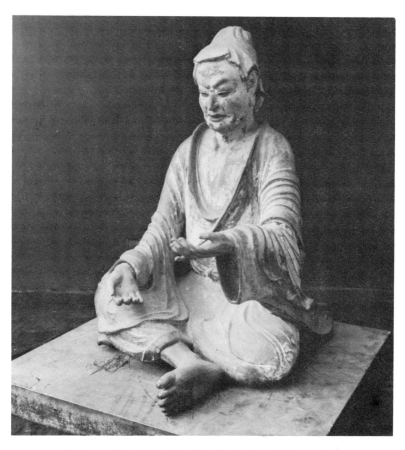

PLATE 28. Yuima (Vimalakīrti). Wood. Early Heian, 9th cent. *Hokkeji.*

117

original bright colors. Perhaps partly for this reason, the face gives a vivid impression of individuality, the eyes in particular having a liveliness totally absent in the portrait sculpture of the Tempyō era. There is no great difference in the treatment of the body and robe. In the figure of Gien, the carving on the head is deep, emphasizing the wrinkles of an old man's skin. The robe, too, is open at the front as far as the solar plexus, revealing the skinny chest beneath. The muscles of the neck, the collar bone, and the ribs stand out clearly, showing how the sculptor's interest extended even to the details of the body. The treatment of the ribs, however, is rough and careless. In other words, the statues of Dōsen, Rōben, and Gien share an emphasis on individuality in the face while following abstract patterns in the body and robes and the posture as a whole; in this they afford a sharp contrast with the figures of Gyōshin and Ganjin. The emphasis on individuality in the face was realized by means of the treatment of details, which indicated a movement towards the particular expression of the moment. The transition from Tempyō to early Heian at the level of portrait sculpture was obviously an effort to achieve the expression of more particular things with methods more directly representational. This transition, as represented by the contrast between the Gyōshin and Dōsen figures, is so distinct that it inclines one to look for a missing link. That missing link, I believe, is to be found in the figures of Yuima (Vimalakírti; pl. 28) in the Hokkeji and Monju (Mañjuśurī) in the Tōji. Although not portrait sculpture in the strict sense of the word, they are its equivalent stylistically—and they stand midway between the styles of the Gyōshin and Dōsen figures.

The ninth century perfected portrait sculpture in one coup. The epoch-making development of the expression of personal individuality took place not in the Kamakura period but in the Heian period. Almost certainly, the style of the former period was a continuation of that of the latter. Unfortunately, there is very little material with which to reconstruct the portrait sculpture of the late Heian period. Yet even if we rely solely on what little we have—the figures of Chishō Daishi from the

tenth century and of Prince Shōtoku from the eleventh—it seems likely that at no time in the three hundred years from the ninth century into the Kamakura period was the tradition of portrait sculpture entirely lost sight of.

At least where individual facial expression is concerned, neither Kōkei, who carved the figure of the Six Patriarchs of the Hossō sect (pl. 29) in the early Kamakura period, nor Unkei, who did the figures of Asaṅga (pl. 32) Vasubandhu, succeeded in outstripping the portrait sculptors of the ninth century. Alone, the sculptor of the statue of Chōgen (pl. 30) succeeded in creating a head without peer while carrying the figurative treatment of detail still further than others. Surely very few portrait sculptures, whether in the East or the West, have succeeded in penetrating the depths of character by means of capturing a subtle and momentary expression of a particular person with thoroughly representational methods. In this work, sculpture sets before us the whole charm, almost, of the actual human being. Yet it cannot be said that the statue of Chōgen is a typical work of Kamakura portrait sculpture. Portrait sculpture of the Kamakura period is characterized by the way its interest in expression extended not merely to the face and head but to the body as a whole. Technically speaking, it is the discovery of new means in the treatment of clothing and posture. Thin drapings characterize Buddhist sculpture derived from India, so that it is possible to devise ways of suggesting the swelling of the flesh beneath; and the Gate Guards are almost naked, so that it is possible to give detailed expression to muscular tension. The high priests of Japan, however, wore thick robes, and in portrait sculpture there was little opportunity to apply such devices. In short, on the body of a statue there were only two alternatives: to try to create an effect with the robe, independent of the human figure, or to try to give variety to the posture of the figure.

Among statues that adopt the traditional seated posture, the figures of Unkei and Tankei in the Rokuharamitsuji also follow a more or less traditional pattern in their handling of the robes.

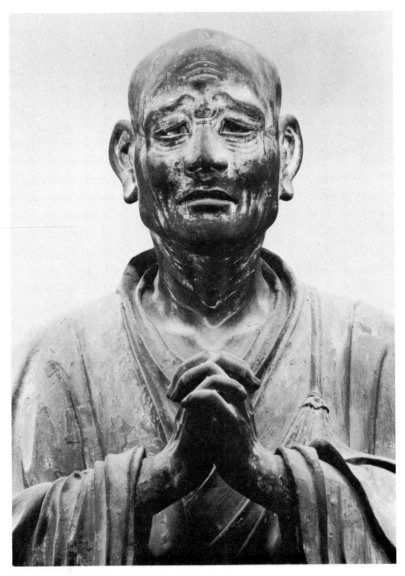

PLATE 29. One of the Six Patriarchs of the Hossō sect. By Kōkei and others. Wood. Kamakura, late 12th cent. *Nan'endō, Kōfukuji.*

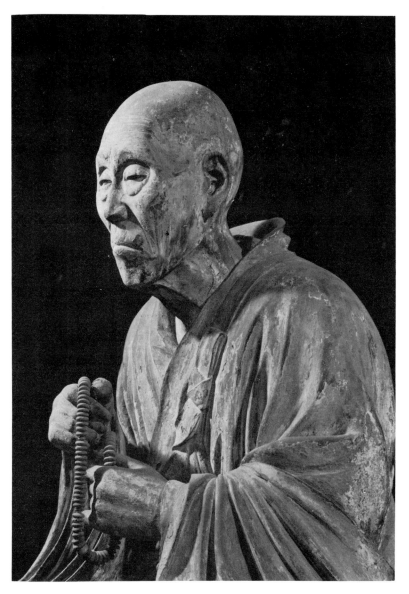

PLATE 30. Priest Chōgen. Wood. Kamakura, early 13th cent. *Tōdaiji.*

The figures of the Six Patriarchs of the Hossō sect, however, are different; the figure of Gempin, for example, has elbows bent, bringing the hands up to the area of the nipples. As a result, the robe over the forearm hangs away from the trunk and falls in large waves to near the left thigh on the left while on the right it covers the right knee, flowing down to a point past the edge of the pedestal. The figure with both hands stretched forward has added depth, and at the same time it gives pictorial movement to the robe. The figure of Eison in the Seidaiji has both hands on its knee, with the sleeves of the robe spread out over the pedestal to almost the same length on left and right. This part of the robe has absolutely no connection with the human body. The effect of the figure taken as a whole becomes increasingly pictorial—almost the same, in fact, as that of a painted portrait. One of the changes in the posture of the human figure is the posture in which it sits in the chair. A practical example is to be seen in the figure of Shunjō Kokushi, from the early part of the period and in the Bukkō Kokushi of the latter part of the period. The former sits motionless, gazing fixedly in front of him, while the latter bends forward, raising himself from the chair in a dynamic pose suggesting that he is about to address someone. However, it is the standing figures that show the change in posture at its most typical. The celebrated figure of the priest Kūya (pl. 31) stands resting his stick on the ground, with eyes half closed and a string of small figures of Amida proceeding from his mouth. The trials and weariness of the journey—the journey of the pilgrim to remote parts of the country, and also the journey of the pilgrim through life—are apparent not merely in the expression of the face but also in the posture of the whole body, which is bent forward slightly, leaning on the stick. The point of this standing figure is not so much in the individuality of the model as in its suggestion of the inner concentration of any human being under the special circumstances represented by the miraculous invocation of the Buddha in time of great stress. An example of this type of particularity of emotion in conjunction with a personal individuality ex-

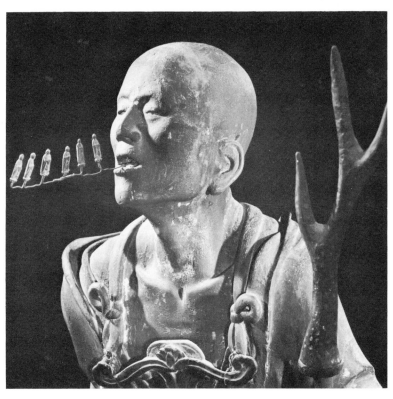

PLATE 31. Priest Kūya. By Kōshō. Wood. Kamakura, early 13th cent. *Rokuharamitsuji.*

pressed in the face, head, and posture of the whole body, is found in the figures of Asaṅga and Vasubandhu by Unkei, and especially in that of Asaṅga (pl. 32). These examples show the most typical characteristics of Kamakura portrait sculpture, as contrasted to that of the early Heian period. The Asanga figure stands nearly two meters high, firm and peaceful. The face is comparatively abstract, revealing the essentials and dispensing with unnecessary detail. Yet not only does it show a bone structure as individual as that of the figures of the Tempyō era, but the momentary expression is captured with extraordinary vividness. In the tightly compressed lips and the eyes gazing fixedly at one spot one senses the conviction and determination of a man about to go into action the next moment. The whole posture, suggesting that the figure is just about to take a step forward, breathes an air of calm, as of a man who will brave fire or flood, yet is not driven on by violent emotion but remains unhurried and contained, backed up by a conviction that nothing can ruffle. This is not a walking posture, yet neither is it a posture that is eternally at rest. It is, rather, a subtle posture in which rest is about to give way to motion. Even the robe plays a part in creating this posture between rest and motion: on the one hand it departs from the traditional pattern, on the other it also transcends a merely decorative effect.

The Tempyō era discovered individuality in portrait sculpture. The early Heian period elaborated facial expression. The Kamakura period developed the expressive potentialities of posture. In the process, abstract techniques gradually gave way to the figurative. In the same process, the two aspects of particularity—man in general in a particular situation, and a particular individual in a general situation—gradually fuse together. The result was the image of a particular individual in a particular situation.

In short, the style of Buddhist sculpture changed from Asuka to Kamakura in different ways according to different iconographic ranks of figures such as Buddhas (Tathāgata and Bodhisattva), lower deities (Rāja and Deva) and monks' por-

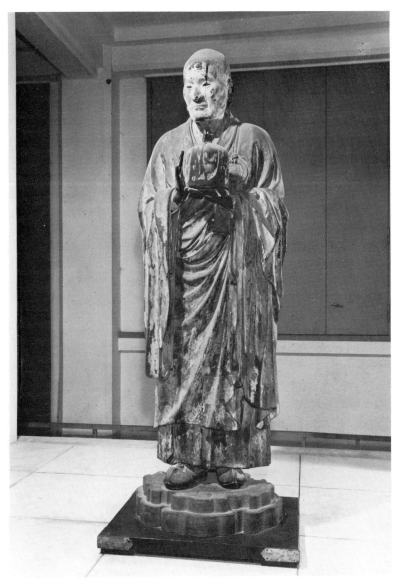

PLATE 32. Asaṅga (Mujaku). By Unkei and others. Wood. Kama-kura, early 13th cent. *Hokuendō, Kōfukuji.*

traits. The shift of technique from abstract to representational was more or less common to the figures of all levels. The development from the universal to the particular was hardly noticeable as regards the Buddhas, while the particularization of expression characterized the figure of lower deities, without however coming any closer to the individuality. It was monks' portraits that became more and more individual and increasingly marked by the expression of particular emotions. Thus, we may conclude that the morphology of Buddhist sculpture in early Japan can be described with a certain precision by separately observing the figures according to iconographic ranks; and by using a framework of pairs of concepts: abstract, representational, universal and particular.

The Tale of Genji
Picture Scroll

In the autumn of 1964, the Gotō Art Museum at Kaminoge in Tokyo provided the public with a rare opportunity to see the surviving fragments of the celebrated Tale of Genji picture scroll gathered in one place. The work, of course, is one of the most celebrated in all Japanese art, and can be seen in reproduction at any time. Nevertheless, it was only when I saw the original that I fully appreciated the reasons it is generally considered to be a masterpiece.

The three outstanding characteristics of the scroll, as has frequently been pointed out, are the method of composition known in Japanese as *fukinuki-yatai*; the style of painting known as *tsukuri-e*; and the method of depicting human features known as *hikime-kagibana*. *Fukinuki-yatai* indicates a

method of composition whereby the roof of a building is removed and the scene within a room or rooms is shown above and at an angle. The same technique is found in many other picture scrolls (see pl. 36). The *tsukuri-e* technique involves executing a detailed preliminary sketch in fine ink lines, then filling in the whole space with rich colors, the outlines being painted in again afterwards where desired. *Hikime-kagibana* ("slit-eyes hook-nose") is a highly stylized method of depicting human features that employs single brush lines for the eyes and a simple hooked line for the nose, thus producing faces devoid of any individuality. It is generally accepted that the last two of these three characteristics distinguish picture scrolls in the tradition of the Tale of Genji from those in the tradition of the almost equally celebrated Shigisan Engi Scroll from the same period (pl. 33).

What bearing do these stylistic characteristics have on the content of the tale depicted? First of all, there might be a connection between the type of story that unfolds indoors—specifically, within the narrow confines of life at court—and the *fukinuki-yatai* technique, which makes visible all events taking place inside the house. Second, there would seem to be a certain affinity between a tale that shows such sensitivity towards the colors of clothing and the *tsukuri-e* style which emphasizes colors rather than contours. As Japanese art historian Akiyama Terukazu has pointed out, it is possible to detect, even in the fragments that remain, a distinctly symbolic use of color in the scroll.

Third, there is undoubtedly a close connection between a tale that relates human emotions less to individual personality than to the situation in which the individual finds himself, and the impersonal technique of *hikime-kagibana*.

Individuality is shown by means of facial expressions. A situation, however, is expressed in the movements of the characters. And emotions, though reflected in the face in conjunction with the individual personality, can be given full expression—at least if the artist has the skill of the author of the Genji Scroll—as something separate from individuality, by

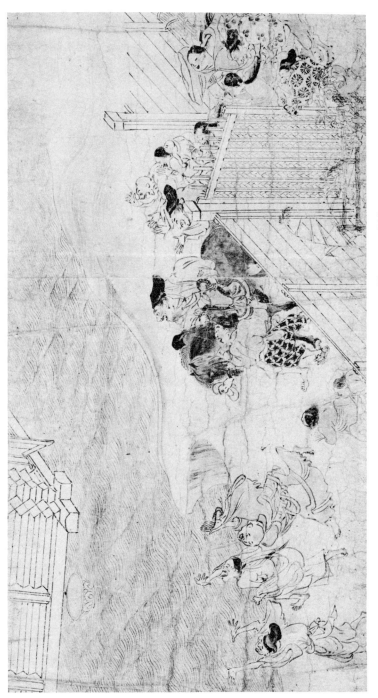

PLATE 33. Shigisan-engi Picture Scroll (detail). Late Heian, 12th cent. *Chogosonchiji*.

showing the movements and subtle differences of posture of the human beings placed together in a particular situation. For example, the face of a woman holding a child may be done in the *hikime-kagibana* style; even her identity may be unclear from the picture; yet the stooping posture, the inclination of the head, the gentle slope of the line from the shoulders down the arms, is adequate to express the emotions of any woman who lifts up a child in her arms. The heroine is womankind, not a particular woman. The situation—the woman with her child, their meeting with the father—is real enough, and so are the emotions of the woman.

This treatment is closely related to the way in which the *Tale of Genji* itself emphasizes the particularity of situations, stressing not so much the particularity of individuals as the emotions that any human being is likely to feel in a particular situation. For the moment, however, let us pass over the relationship between the novel and the picture scroll, and return to consideration of the scroll.

The surviving sections of the Tale of Genji Scroll consist of nineteen fragments—fifteen in the three scrolls of the "Tokugawa version" and four in the single scroll of the "Masuda version," now in the Gotō Art Museum. What were their chief pictorial qualities that impressed me upon seeing them all together? I asked myself what quality in them makes them masterpieces of pure painting, even when divorced from the original story which they were intended to illustrate. It can be summed up, I believe, as the quite extraordinary refinement, the delicacy and subtlety, with which each picture is divided by means of a large number of straight lines.

The refinement is of an order not to be found, I feel, anywhere else in Japanese art—or even, to the best of my knowledge, in the history of Asian art as a whole. The artist who *most consciously* studied the possibilities of pictorial geometry—if such it can be called—was the Dutch painter Mondriaan; but the man who brought it to its peak of *sensuous refinement* was the unknown Japanese artist who painted the Tale of Genji picture scroll.

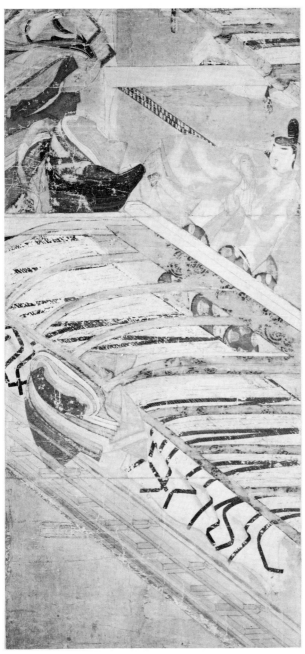

PLATE 34. Tale of Genji Scroll (detail). Kashiwagi III.
Tokugawa Museum.

The straight lines dividing the pictures consist of objects such as lintels, verandas and their handrails, bamboo blinds, pillars, and other sections of buildings. Thus they are connected with the *fukinuki-yatai* technique, but this technique is not enough to explain them. The typical picture is divided by a large number of parallel lines running from bottom left to top right, and the long strips of space thus created being further subdivided by a number of vertical lines. This division of space is effected with an amazing subtlety.

Moreover, the same skill is shown in the way in which the appropriate human figures—complexes of form and color—are distributed among the spaces thus created. The pictures *Kashiwagi No. 3* (Tokugawa version) and *Suzumushi No. 2* (Masuda version) have never been equalled in such purely abstract handling of space (see plates 34 and 35).

The method whereby a picture is composed on diagonal and vertical stratification, with color supplied by means of human figures disposed within these spaces, is not exclusive to the Tale of Genji Scroll. Here, however, the artist's control is so sure that not even the shortest vertical line could be displaced without disturbing the whole. Only the Genji Scroll achieves such perfection in the stable harmony created by a necessary minimum of lines, and in the balance between the spaces created by those lines and color.

The painting of these pictures constituted a definitive event in the history of the Japanese sensibility. Even the great screen paintings of Sōtatsu, would surely never have been possible without the high degree of refinement shown at this early date in the feeling for the structure of space.

During the period between the Genji Scroll and the school of Sōtatsu, Kōrin, and their followers, society changed and painting, too, changed in size and in the use of color and line. Influences from China intervened, were developed, transformed, and combined with the already existing styles to produce an extraordinarily large number of works. Yet, a consistent quality runs throughout all the painting. It is not an emphasis on naturalism, nor a mood, nor a particular type of

brushwork, nor a preference for certain themes, nor is it even a special feeling for color. Rather, it is this particular feeling for the structure of space.

It is obvious that the Genji Scroll has a close relationship with the story. Moreover, as we have already seen, in technical aspects such as its composition and coloring and its stylized treatment of human faces, it faithfully reflects the world of the story. Nevertheless, if the unique aspect of the Tale of Genji Scroll is its quality as abstract painting, then the question arises whether there is a connection between the original novel and this quality. If such a connection should exist, it would be far deeper than any mere connection between illustration and story.

It is doubtless impossible to construct any direct connection between the quality of a novel and the purely formal qualities of the pictures that illustrate it. However, it is possible to consider the single culture that gave birth to both the *Tale of Genji* and the Tale of Genji Scroll. Even where no relationship exists between their themes, it is natural to suppose that the highest type of literary expression and the highest type of formal expression to which a single culture has given birth should have some close bearing on each other within the structure of that culture.

To put it differently, what makes the *Tale of Genji* a literary masterpiece and what makes the Tale of Genji Scroll a masterpiece of visual form should find common ground somewhere in the culture of the Fujiwara era. Before inquiring precisely where that common ground lies, it is necessary to examine one more question, by considering what makes the novel a literary monument. I believe that the essence of the *Tale of Genji* lies in its treatment of time. It is not a psychological novel, nor is it an *Entwicklungsroman*; it does not primarily concern itself with either religious, ethical, or social problems. One can read it, of course, in any of these ways, but these interpretations do not make it such an imperishable masterpiece.

Extreme refinement of the aesthetic sensibility is un-

PLATE 36. Ichiji-Rendai-Hokke Sutra (front page). Late Heian, 12th cent. *Yamato Bunkakan Museum.*

doubtedly present, but I doubt whether a novel can endure by aesthetic sensibility alone. A great work is characterized by the way it confronts us, with irresistible force, with some aspect of the reality of human life.

In the *Tale of Genji*, the reality portrayed is the flow of time, in which season yields to season, governments change, generations alternate; in which men are born, grow up, make love, suffer, grow old, and die; in which the past overlaps with the present and the future too is enfolded within the present. And it is, more than anything else, because of its intense feeling for the actuality of time that the *Tale of Genji* is among the great works of Eastern and Western literature and impresses us more than any other novel or tale written in Japan since the eleventh century.

Thus, time in the *Tale of Genji* is expressed by the function of space in the Tale of Genji picture scroll. The time portrayed in the literary work is the time of the everyday world —concrete, actual, unconcerned with ultimates. The lack of interest in eternity enables the novel to be so sensitive to the passage of time. The space of the picture scroll, on the other hand, is the sensuous, subtle space of the everyday world devoid of any rationally imposed symmetry. It is precisely its lack of interest in geometry that gives the picture scroll its infinite sensitivity towards the structure of space.

These particular qualities of time and space derive from a common background: the thoroughgoing worldliness and preoccupation with everyday life of the court culture of the Fujiwara era; and the extraordinary refinement of the world of the senses that was an outcome of that very worldliness. It is here, and here only I suspect, that the *Tale of Genji* and the Tale of Genji picture scroll, in their most essential qualities as literature and art, find a common ground.

I sense something here that lies near the source of all Japanese culture. The basic structure of that world remains unchanged to this day. Even today, surely, these same special qualities of time and of space are most pervasive whenever Japanese art comes anywhere close to subtlety.

Notes on Sōtatsu

In the hierarchical society of Tokugawa Japan, the upper class of samurai embellished screens and sliding doors of their residences with decorative paintings of the Kanō school; the lower samurai, particularly intellectuals on the fringe of samurai society, sought their ideals, their realm of evasion, in the practice of calligraphy and a free-style painting in India ink called *nanga*. On the other hand the upper class *chōnin*, prosperous merchant families, supported the Sōtatsu-Kōrin school which produced delightful works in painting, pottery and some other minor arts, while the urban mass, the middle and lower *chōnin*, could enjoy a great variety of woodcut prints in accordance with their own taste. Those who did not create their own style in art were the aristocrats, who no

longer played a major role as upholders of culture in that period, and the rural population, who had not yet gained access to the cultural heritage and development in the towns.

After the Meiji Reform, the tradition of the Kanō school continued to live in the academy of arts, notably through Kanō Hōgai; the *nanga* school also remained creative for a long time, mainly due to the last great artist of that school, Tomioka Tessai. As for woodcut prints, whose artistic value—as everyone knows—was discovered by the Europeans, they exercized a great influence on the post-impressionists during the time of the *japonisme* at the turn of the century. But as regards the Sōtatsu-Kōrin school, neither the Europeans nor the Japanese were aware until quite recently of its artistic significance, although it is precisely in that school that one can find the most typical and probably the most perfect expression of Japanese aesthetic tradition.

The Sōtatsu-Kōrin school (often abbreviated in Japanese *rimpa*) was founded in the late sixteenth century by Hon'ami Kōetsu, calligrapher and potter, and Tawaraya Sōtatsu, a painter. About a hundred years later the tradition of that school was reactivated by two brothers of the Ogata family, the painter Kōrin and the potter Kenzan. Another century after the Ogata brothers, Sakai Hōitsu developed the legacy of his predecessors.

Sakai Hōitsu was the second son of the feudal lord of the province of Himeji who, as an artist, respected and emulated the style and subject matter of Ogata Kōrin. Hon'ami Kōetsu was born into a Kyōto family whose members had for some time been famous as sword connoisseurs, and who had close personal contact with aristocrats and upper-class samurai in the city. As for Sōtatsu, practically nothing is known about his family background. It is, however, widely assumed that he lived mainly in Kyōto and worked together with Kōetsu. The paintings of Sōtatsu—as far as we know them—represented scenes form the *Tale of Genji* and from the *Tale of Ise*, as well as other aspects of aristocratic society in the Heian period. In other words, so far as the subject matter was concerned, Sō-

tatsu at the end of the sixteenth and beginning of the seventeenth century still relied on the Heian tradition.

The family background of the Ogata brothers was quite different. They were born into a prosperous merchant family dealing in cloth. Their subject matter in painting as well as in pottery decoration were mainly landscapes, flowers, birds and other animals, objects which they could certainly observe all around them. They were the artists par excellence of the *chōnin* class, interested in their own environment rather than the traditional subject matter taken from the legendary splendor of Heian culture.

Generally speaking, the early Tokugawa culture in both literature and visual arts continued to owe much to the legacy of the Heian period. It was in the middle of the Tokugawa era that the artistic life in the towns was increasingly dominated by the newly emerged class, the *chōnin* who, now self-confident, created their own style and treated their own subject matter in literature, theatre and the visual arts. In the late Tokugawa period, the flourishing *chōnin* culture finally penetrated to some extent even into the milieu of the samurai. If this broad description of the development of the Tokugawa culture is correct, then the argument may be allowed that the artists of three different generations (Sōtatsu, Kōrin, Hōitsu) reflected, in terms of their family background and choice of subject, the history of Tokugawa culture itself. Even for this aspect alone, the school of these artists may be worth our attention, and the founders of the school, Kōetsu and Sōtatsu in particular, deserve special treatment in the art history of Japan.

Hon'ami Kōetsu lived with his family and other artists, at least for a number of years of his life, in a village called Takagamine in the mountains northwest of Kyōto. He founded there a kind of artists' community which produced not only paintings, but also handicrafts such as lacquerware and silver and gold inlays (pl. 37), through collaboration of a good many artisans. Kōetsu himself presided over the artistic life of the community as arbiter of taste. It is known that Kōetsu was a believer of the Nichiren sect, but it is practically impossible

to establish any relationship between his Buddhist belief and his art. The works of Kōetsu, as well as the paintings of Sōtatsu, were destined for secular use and were completely secular in spirit and subject matter. The case of Kenzan was similar: he is said to have been an adherent of the Zen sect, but a relationship between his belief and his art is not recognizable. It may be safe to say that the artists of *rimpa*, including Kōetsu and Kenzan, all produced basically secular art, as was the case of most artists of the Tokugawa period. Although nothing is known of the life of Sōtatsu, as already mentioned, it is important to note here that most probably he worked in the circle around Kōetsu in the Takagamine community.

The originality of Sōtatsu as an artist can be summed up as follows: first, the miniature-like treatment of detail shows an extremely skilful hand in drawing, and at the same time, a refined taste for color combinations which often included gold and silver. Good examples are the heavily decorated ox-cart in the Sekiya Screen (pl. 38; from the *Tale of Genji*) and also the costumes of the dancers in the Bugaku Screen (pl. 39). Second, by means of highly stylized abstract forms that divide the space by bold simple lines, the composition of a painting by Sōtatsu never fails to achieve an agreeable balance of proportions. This can be observed, for instance, in the Sekiya Screen with its mass of homogenous green color, of which the contours flow gracefully, and in the Bugaku Screen, which has no background landscape, but where a particularly subtle equilibrium is reached through the grouping of the dancers in the space. Sōtatsu here does not simply describe the gestures of dancers in one moment, but renders alive, so to speak, the space in which the dancers move.

The technique of miniature was highly developed in different cultures and different times, in some cases much before the time of Sōtatsu, like the mandala in Tibet, miniatures in Persia and India, illuminations in Ireland and other Western countries in medieval times. The use of abstract lines and shapes in painting went to the extreme in the Western world in our century, for example, in the colored paper collage of Matisse

PLATE 37. Lid of Writing Ink Box. Attributed to Kōetsu (A.D. 1558–1637). Early Edo, early 17th cent. *Ashibune Makie Suzuribako, Tokyo National Museum.*

PLATE 38. Sekiya Screen (three panels). By Sōtatsu. Early Edo,
early 17th cent. *Seikadō, Tokyo.*

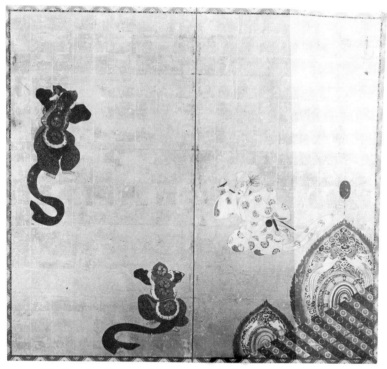

PLATE 39. Bugaku Screen (three panels). By Sōtatsu. Early Edo, early 17th cent. *Sanbō'in, Daigoji.*

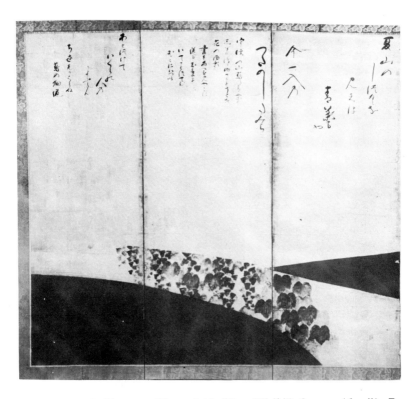

PLATE 40. Tsuta no Hosomichi ("Ivy Walk") Screen (detail). By Sōtatsu. Early Edo, early 17th cent. *Tokugawa Museum.*

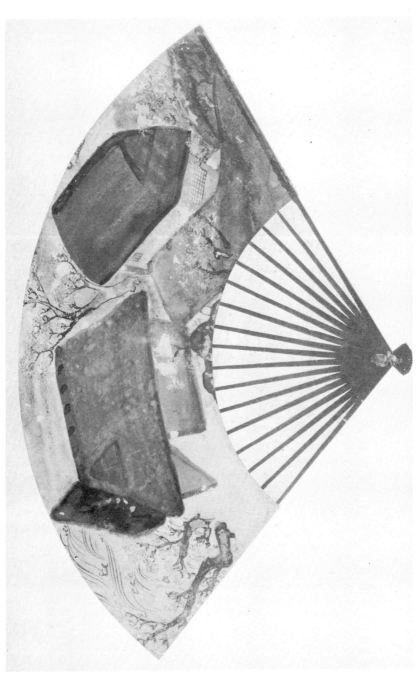

PLATE 41. Fan Screen. By Sōtatsu. Early Edo, early 17th cent. *Sanbo'in, Daigoji.*

and the paintings of Mondriaan. It seems just to say that the originality of Sōtatsu lies in the combination of miniature-like details and, at the same time, an abstract presentation of space, the fusion of two entirely different techniques in a single painting, resulting in a harmonious whole. In this sense the Sōtatsu style was original, indeed an epoch-making event in the history of Japanese art. Such an event was not easily buried in the darkness of the past, and provoked far-reaching repercussions in subsequent generations. In fact, a century later, Ogata Kōrin followed in Sōtatsu's footsteps and developed his own style, integrating even the technique of the Kanō school. If the stream in the middle of Kōrin's Screen of Red and White Plum Trees was as abstract as the background hills of the Sekiya Screen, his miniature treatment of the moss-covered bark of the plum trees recalled Sōtatsu's elaboration of details of the decorated ox-cart. Also striking was the similarity of the way in which Kōrin grouped the iris flowers in his Iris Scroll (pl. 42) with the composition of dancing figures by Sōtasu (the Bugaku Screen).

Most art historians tend to explain the style of Sōtatsu in relation with the tradition of Yamato-e, or Japanese-style painting, of which the origin goes back to the scroll paintings of the Heian and Kamakura periods. Among those scroll paintings which we can see now the oldest and perhaps greatest is the Tale of Genji Scroll. As I have mentioned in the preceding chapter, this scroll is characterized by a combination of subtle space division by means of straight lines on the one hand and descriptive parts in miniature technique on the other. Sōtatsu's works might not have been possible without the culture which once produced the Genji Scroll and made of it an artistic tradition which never died even at the height of Chinese-influenced brush painting of the Muromachi period. But the tradition was inherited not only by Sōtatsu, but also by many other artists. The tradition of the Heian arts alone does not explain why a possibility, immanent in Heian culture, was developed to perfection in the late sixteenth century and not in other periods; by Sōtatsu and not by other artists. To this

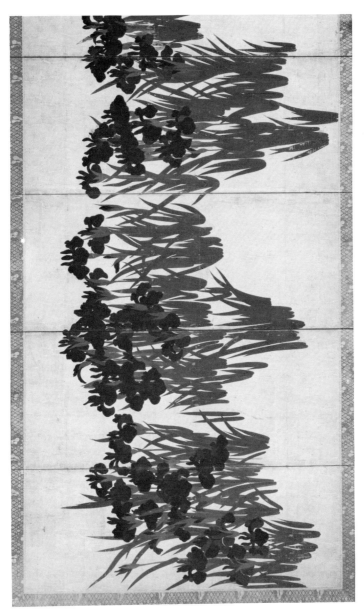

question a definite answer cannot be given here. But it is worth noting, in this respect, the very probable collaboration between Sōtatsu and the artisans around Hon'ami Kōetsu. Sōtatsu was primarily a painter. In addition to working with India ink or colors on silk or paper, he also used colors, gold and silver, to decorate the surface of pottery and lacquerware. The size of his paintings or drawings varied from the smallness of *tanzaku* (a sheet of paper for one short poem) through the standard size of hanging scrolls, to the large six-panel folding screen. Not all artists painted on surfaces so disparate in size or used such a variety of materials. It may be understandable that Sōtatsu was exceptionally sensitive to the one aesthetic quality which did not much depend on the size of the painting or the materials used: the structure of space itself.

Working with artisans, decorating different objects, Sōtatsu was in a particularly favorable position to develop his aesthetic geometry. In contrast to an object such as the hanging scroll, which was to be looked at from a certain distance, were small intimate objects like inkstone cases or teacups, that were held in hands, closely observed, appreciated even through the sense of touch. In such objects, visual and tactile impressions were inseparable; the detail became as important as the whole. From the experience of decorating such objects the artist may easily have come to the conclusion that detail bears a meaning, not only as part of the whole, but also for its own sake. One can imagine a Sōtatsu before a large folding screen, trying to be faithful to his own technique and artistic conviction which he had primarily developed through his work with teacups, inkstone cases, folding fans, *tanzaku* and the like. The result should be quite different from work of traditional artists who also treated large surfaces, as, for example, the Kanō school.

A new approach to art must have demanded much courage from an artist. Although we do not know much about the life of Sōtatsu himself, we know something about the age in which he lived, the second half of the sixteenth century. It was a period of adventure, politically (with involvement in civil wars and military expeditions to Korea) and spiritually (with the

secularization of Buddhism and a challenge by Christianity). The sense of vitality and vehement movement in Sōtatsu's screen of the gods of storm and lightning indicates that the artist was not detached from the vigorous spirit of his age. Generally speaking there were three different approaches to painting in Japanese history. First is the representational approach, typical for a category of artists from the unknown painter of the Shigisan Engi Scroll to Hokusai in his caricatures. These artists were keen observers of human life, describing with their brushes the behavior of people, gestures and facial expressions in various circumstances. Their style was characterized by an economy of lines which permitted them to emphasize powerfully some particular aspect of the model. The strong appeal of this kind of painting or drawing is not of a pure aesthetic nature, as in the case of a great many representational paintings elsewhere. Needless to say, the skill in pictorial representation of the environment does not distinguish Japanese tradition from that of other cultures, from the Stone Age to the present. It would not make such sense, therefore, to search here for the characteristics of the Japanese aesthetic world.

Second is an abstract expressionistic approach. A certain category of artists, such as painters of Buddhist orientation, from Mokuan through Sesshū to Sengai, working in India ink, tried to express the "inner world" of their own moods, states of mind, personalities through the spontaneous movement of the brush. The ideal of these artists was *kiin* (in Chinese *ch'i yin*), a spiritual quality which was to be appreciated as an expression of the artist himself rather than as representation of an object. This tradition of Chinese origin was deeply rooted in Japanese art from the Muromachi period onward, but the Japanese artists of this category could never free themselves from the heavy influence of Chinese ideas and technique. Here again it is not quite reasonable to see, as do some Japanese and Western observers of Japanese culture, a properly Japanese tradition.

Third is a formalistic approach, adopted by the artists of the

yamato-e school (tradition of the Genji Scroll) and of the Sōtatsu-Kōrin school. Relatively free from Chinese influence, those artists were primarily concerned with graceful lines, agreeable combinations of colors, refined proportions in composition, rather than the representational quality of drawing or the powerful movement of the brush as a means of self-expression. If the characteristics of Japanese aesthetics were manifest in Japanese painting, they were most typically present in the works of those schools. The world of daily life to which the Japanese mind traditionally was attached more deeply than to a world beyond, was transformed, so to speak, into a secular art, marked by a subtle formalism, which was brought to perfection by Sōtatsu and his school.

As for the particular interest in detail detached from the whole, this was one of the characteristics of Japanese culture in general. Just to quote a few examples: during the Tokugawa period, when Japanese architecture was less under the continental influence, the layout of the residences of feudal lords consisted of a succession of rooms, loosely connected with each other by corridors. Each section of the building was conceived as an independent unity without consideration for a general design. In literature too, most authors were extremely interested in isolated particular facts, often irrelevant to the context of the whole. When Kamo no Chōmei, for example, discussed poems and poets in his essay *Mumyōshō*, he never tired of talking about the exact position of a tomb, or the present condition of the remains of the residence of some ancient poet, not because it had something to do with the prosody of Japanese poetry, but because the author's attitude to his environment was such that those details were important for their own sake. When Sōtatsu used his brush to elaborate the details of an ox-cart, he was faithful in his own way to Japanese cultural tradition.

Thus the art of Tawaraya Sōtatsu, original and epoch-making in Japanese history, was indeed a perfect visual expression of the traditional Japanese mind and sensitivity, manifest through ages also in other cultural spheres: in architecture, in literature, and, in a sense, even in social and political life.

Notes on Tea Ceremony

There are, roughly speaking, two different views concerning the relationship between life and art. For one, art constitutes its own aim, and serves no other purpose whatsoever in life; I shall call this view "art for art's sake." The other sees art as serving some other purpose in life outside itself, either ethical, political, or pleasurable, and recognizes its worth to the extent that it succeeds in such service. One might call this view "art for life's sake." However, the view of life and art typified by the Japanese cult of the tea ceremony is unusual in not belonging to either category.

The views of Rikyū, the man most responsible for formulating the tea ceremony as we know it today, cannot be termed "art for art's sake," since he strove to live the tenets of his own

teaching in every aspect of his life; yet neither can be called "art for life's sake," since he, quite simply, had *no* life apart from tea. The cult of tea, in fact, is a bold attempt to fashion life itself into a kind of art object; it does exist for life, but life for art. Here, then, lies another, third way of looking at the life-art relationship, one that I will call for convenience the "life for art's sake" approach. It is distinguished from the "art for art's sake" outlook by the fact that art here does not erect its own world independently of man's other activities; instead, all the various activities that make up life are absorbed, as it were, into a single aesthetic system.

The first conscious appearances of the idea of "art for art's sake" in the history of the Japanese occur in the poets Shunzei, Teika, and the *Shin-Kokinshū* anthology, around the end of the twelfth century and the beginning of the thirteenth. The idea of "art for life's sake," on the other hand, was dominant chiefly in the Edo period, and in particular from the eighteenth century on. Typical of this age are, on the one hand, the Confucianists, with their emphasis on the moral and educational properties of art, and on the other the *ukiyo-e* artists, who resolutely viewed art as an instrument of pleasure. The age of "life for art's sake" began and reached its peak between the late Muromachi period on into the early Edo period, i.e., the fifteenth, sixteenth, and seventeenth centuries. It was the age of the tea ceremony.

By what process did the Japanese achieve a view of life for art's sake? The background against which the idea of art for art's sake appeared was, of course, the collapse of the system of aristocratic rule that had characterized the Heian period. In the latter half of the twelfth century, when the course of collapse had become apparent even to the most casual observer, one section of the aristocracy sought to separate aristocratic culture from the crumbling aristocratic society, and to create a world of art independent of the chaos of everyday life, a world into which they themselves could take refuge. The frequently quoted phrase from the *Meigetsuki*: "Arms and red banners are not my concern," sums up very succinctly

what was happening at the time. Nor was the attitude expressed here exclusive to the author of the *Meigetsuki*, for it was shared by the leading poets represented in the *Shin-Kokin-shū*. Their attitude, in other words, is one of escape from social change, expressed in terms of aristocratic culture. Aristocratic culture, however, cannot survive for long without an aristocratic society. Thus, while it was possible for Teika, who was brought up in aristocratic society, to ignore completely what was happening in the world at large and to cling to his aristocratic art, it must have been far more difficult for the later generations that were to grow up in a world very different from his. Since the collapse of aristocratic society at the end of the twelfth century was not, in practice, total, this escapist literature with its ideas of art for art's sake—this world of artifice, nurtured on the past—was to linger on for the following centuries to give rise to a "literature of recluses," partly Buddhist, partly profane in the traditional style of Heian prose and poetry.

The gradual collapse of aristocratic society also had a great effect on Buddhism. The process of decay found immediate rationalization in the first place, in the prevailing idea of the "Latter Day of the Law"—the idea that the world had reached the period in which Buddhism, as predicted in the scriptures, would go into a decline and society lapse into evil ways. The Buddhists attributed the physical and moral chaos of society to a decline in the power of Buddhism. And a new philosophy by which man might live in this "Latter Day" did emerge in the latter half of the twelfth century, in the form of the new Buddhist sects that were to dominate the Buddhism of the Kamakura period. One of the new sects emphasized belief in the "next world," and salvation after death, since no salvation was to be found in the present world. This promised salvation was unrelated to the individual's zeal in doing good during his life on earth, and depended solely on the intervention from above of an absolute being. The absolute being and man were linked, not by moral effort, but by religious faith alone. It was, in short, a doctrine of prayer and dependence. The ideas

of salvation in the next world and dependence on a supreme being were first expounded by Hōnen, further developed by Shinran, and came thereafter to form one of the mainstreams of Japanese Buddhism. However, since these teachings sought to cope with a wicked world purely from the standpoint of faith, they embraced no cultural philosophy dealing with questions of morality or art. For such a philosophy, one must look to a second new form of Buddhism introduced in the effort to cope with the "Latter Day." That second form was Zen.

In place of salvation in the next world and dependence on an absolute being, Zen laid stress on the "Void" and on self-help. To attain awareness of the "Void," the individual must make efforts—efforts, moreover, whose nature was not left to his own inclinations but was subject to a strict method; this is witnessed, for example, by the existence of a code of discipline that extends from the performance of *zazen* (sitting *zen*) and the use of *kōan* (paradoxical questions) all the way down to minor details of the novices' meals. It is not difficult to imagine the significance that this Zen emphasis on obtaining control of one's own emotions through methodical religious training was to have for the life of the individual, and in particular for the life of the warrior going into battle. Although Zen is basically an offshoot of monastic Buddhism, in the midst of a general trend towards the secularization of society from the Muromachi period onwards, it gave rise in practice to a kind of warrior's code of ethics known as *bushidō*. Another aspect of Zen, again—its emphasis on the "Void"—was to give rise, against the same background of social secularization, to the system of aesthetics typified by the tea ceremony with its emphasis on *wabi*. *Wabi*, in the sense in which it was used in the fifteenth and sixteenth centuries, was none other than the aesthetic, sensuous expression of the awareness of the "Void."

The beauty and harmony that man perceived in the simplest, most rustic dwelling, once he discovered that even the most ornate palace was essentially no different from that dwelling, are the basic principles underlying the aesthetic of

the tea ceremony. The decisive quality that distinguishes this aesthetic from "art for art's sake" is that in tea ceremony, social life and art are not considered separately; rather, a transformation of life into art is achieved by means of a very special view of the whole social life. In very general terms, the first step in the secularization of culture took place when this view of "life for art's sake" took over from the view of "life for religion's sake" within the monasteries. In the Edo period, as the secularization proceeded still further, the focus gradually shifted to everyday society, and "art for life's sake" came to be produced and enjoyed in accordance with the everyday requirements of the merchant class. This, in its broadest outline, is what happened historically. And if one probes a little more deeply, the history of the tea ceremony can itself be seen as a reflection of this larger historical process.

The history of the tea ceremony can be roughly divided into three periods. The first extended from the fifteenth century to the seventeenth century, and its leading exponents were Murata Jukō (1423–1502) in the fifteenth century, Takeno Jōō (1504?–1555?) and Sen Rikyū (1520–1590) in the sixteenth century, and Kobori Enshū (1579–1647) in the seventeenth century. Jukō was in the service of the Ashikaga family, Rikyū in that of Nobunaga and Hideyoshi, and Enshū in that of the Tokugawa family. This is the period of *wabi* in the proper sense of the word, and of "life for art's sake." In the case of these tea masters, the transformation of life into art was achieved under the patronage of despotic authority. The masters were "arbiters of taste" for their age in the same sense as, say, Petronius; they maintained the same type of perilous relationship with authority as did Petronius, and like Petronius they were put to death when they failed to maintain that relationship. Their transformation of life into art was not the transformation of the life of society. It was an undertaking possible only to particular individuals under particular circumstances—to the specialists, that is, who were masters of the tea ceremony.

The second period of the tea ceremony extended from the seventeenth century to the nineteenth century, and its leading exponents were Katagiri Sekishū (1605–1673) in the seventeenth century, Matsudaira Fumai (1751–1818) in the eighteenth century, and Ii Naosuke (1815–1860) in the nineteenth century. These men were all *daimyō*, ministers of the Shogunate, and not professional artists. For them to turn the whole of their lives into art was impossible. They achieved it in only one section of their lives, leading a kind of double existence as politicians or administrators on the one hand, and adepts of the tea ceremony on the other. It is pointless to inquire here which of the two aspects was more important; we can only assume that, since they did in fact lead this dual life, both its aspects meant a lot to them. The second period sees the tea ceremony as such cease to be an end in itself; instead, it functions in the service of and as one of its adjuncts—the whole life, that is, of the individual concerned. Thus even within the history of the tea ceremony, a shift had occurred from "life for the sake of art" to "art for the sake of life." "Life" here, though, was in every sense that of the individual; it had no direct relationship either with society or with other individuals.

In the third period of the tea ceremony, however—in the twentieth century—the tea master has become an instructor. Since an instructor is one who teaches others, "art for the sake of the individual life" has become "art for the sake of the life of society." The process corresponds almost exactly with that of the commercialization of the tea ceremony. The first stage in the process of commercialization occurred before the Second World War, when the study of the tea ceremony under a teacher was confined almost entirely to women of the upper classes; to be versed in the tea ceremony served as a symbol of social rank. The second stage of commercialization, from the end of the war until the present day, has seen what was once a luxury, a symbol of social prestige, become an item of mass consumption. In this sense, the same phenomenon has occurred with tea ceremony lessons as with refrigerators and cars.

However, where the widespread use of refrigerators was the result of a drop in prices made possible by technological advances and the postwar rise in the purchasing power of the masses, the popularization of the tea ceremony has been due in large measure to the policy adopted by large business firms of providing their women workers with the opportunity for inexpensive lessons. Whatever the case, the development of the tea ceremony from "life for art's sake," through "art for life's sake" and on to "art for society's sake," even though it may not in itself reflect the process of secularization that has been going on in Japanese culture for centuries past, at least illustrates the process of the commercialization of art that is its result. Thus the sociology of the tea ceremony impinges on the economics of the tea ceremony.

In the cult of tea, the view of life as art extends to its every aspect. The man entering the tea ceremony room does so as an individual, shedding as far as possible all symbols of social rank and role. This custom serves fully to emphasize the personal, private nature of the gathering. Only the plainest of food is served. Records of celebrated tea ceremonies, which describe the food served with the greatest attention to detail, show that nothing could be farther from the sumptuousness of conventional banquet. The food is low in proteins and calories; the guest who is not satisfied is expected to make do with a little extra rice. In appearance, the tea ceremony room resembles a small country cottage; any appearance of lavishness—comfort, even—is deliberately shuned.

The tea cult, in short, clearly requires a particular and consistent attitude towards every aspect of daily life. Nor is this all, for the articles one finds in the room itself—the scroll hung in the alcove and the flowers placed there, the incense that is burnt, the bowls that are used for the tea—require in the practitioner of tea a very particular approach towards painting (or calligraphy), flower arrangement, incense, and pottery respectively. This approach shown in the tea ceremony towards the practical appurtenances of everyday life and towards art is part of the tea adept in every moment of his

life. The tea ceremony, in other words, could not exist at all if its practitioners did not view the whole of life itself as an art.

It is doubtful, however, whether the tea ceremony can be considered a pure art, for it invariably implies a gathering, and accordingly embraces not only the tea adept's attitude to the physical accessories of the ceremony but his relations with the other human beings involved who are his guests. The "transformation of life" into art can have only a metaphorical meaning in such a context. The tea ceremony is a kind of technique aimed at highlighting and intensifying the meeting of human beings that lies at its heart by formalizing that meeting to an extreme degree. If such can be called art, then without doubt it represents, in its most profound sense, the transformation of life. The technique is, ultimately considered, the technique of living; it can even be—as in the case of Rikyū —a technique of dying. It was by providing this, as it were, style for life and death, that the great masters of tea contributed to the civilization of Edo.

Assuming that the tea ceremony implies a consistent attitude towards both things and human beings, in what, precisely, does that attitude consist? The world of tea is monochrome. The surfaces of its building are free from artificial coloring. Pillars, walls, ceilings and floors preserve the native textures of the materials of which they are built. The architecture of the *chashitsu* (tea ceremony room) clearly rejects any sensuous effect that could be achieved through the arrangements of color. Colorful paintings are never used in the alcove, only ink monochromes. In their subjects the pictures avoid all sensuous stimuli, such as the *ukiyo-e* provides with its portrayals of beautiful women. The bowls and other utensils employ no striking colors; everything is *shibui*. The sensual appeal of sound is also rejected. There is no music; sound—the occasional patter of rain on the roof, perhaps—is only the kind likely to heighten the intensity of awareness of silence. In the world of tea, in short, there is a conscious and systematic rejection of sensuous pleasure.

Denial of sensuous enjoyment is hardly an indigenous Japanese trait. It is absent from the romances of the Heian period, from the *Konjaku Monogatari* and *Heike Monogatari* of the Kamakura period. Nor is it found, in the Edo period, in the sliding-door paintings of the school of Sōtatsu and Kōrin or in the Kanō school, in the *ukiyo-e* print or in the works of Chikamatsu and Tamenaga Shunsui. This denial of the senses could only have occurred after, and under the influence of, the thoroughgoing Buddhistic rejection of the present world that occurred in the late twelfth and early thirteenth centuries— in other words, after the widespread acknowledgment of the idea that all phenomena are "empty." Rejection of the senses is not, of course, enough in itself to produce art, since art is ultimately a sensuous mode of expression. The chief characteristic of the aesthetic of tea lies, surely, in the elaborate procedure whereby the denial of pleasure directly related to the senses leads to the discovery of what one might term a spiritualized, internalized pleasure of the senses. Tea is the sensuous expression of the denial of the senses. This, at least, is the principle of the style of tea ceremony perfected by Rikyū. *Nambōroku*, a work on the tea ceremony written by a pupil of Rikyū's, gives extraordinarily clear expression to this point:

"The spirit of the austere tea ceremony taught by Jōō," he said, "was identical with that of a poem by Teika in the *Shin-Kokinshū* anthology: 'As far as the eye can see, no cherry blossom, no autumn maple, nothing but the thatched hut by the bay at dusk in the autumn.' This is the true outlook of the tea adept."

It is Rikyū himself who is said to have made these remarks. What he says, in short, is that the tea-ceremony room is in no sense a crude thing of the type of the "thatched hut by the bay," but a transformation of the *shoin* style of architecture into something approximating to that hut—in other words, the internalization and spiritualization of sensuous pleasure. For the same reason he says: "people are always looking outside, wondering when the cherry blossom will flower on this hill

or in that wood, without realizing that cherry blossoms and autumn maples are all in their own hearts."

If the cherry blossoms and autumn maples are indeed in one's own heart, then it is only natural that the same work should cite as the ideal "a house with a roof that does not leak, enough food not to starve." Everything relates to a calculated simplicity. The plain setting of the tea-ceremony room will be designed to provide just stimulus sufficient to summon up the beauty "in the heart."

The aesthetic harmony that the tea adept finds in that state of mind is not the harmony of a logical order, but a harmony born between the human mind and Nature. The simplicity of setting in the tea-ceremony room is not the simplicity of ordered, geometrical lines and shapes, but a simplicity in which only a minimum of artifice is applied to the natural surroundings. Or rather, it is naturalness itself. Where the gardens at Versailles are an extension of the building, the architecture of the tea-ceremony room blends, just as it is, with Nature. Where the Parthenon, for example, depends on the assertion of a rational order in the face of the chaos of Nature, in tea ceremony, even the building itself depends on harmony with the surroundings. Since Nature changes seasonally and according to the light at different times of the day, this harmony with Nature, thus, must also mean harmony with the shifting seasons and the changing weather. A marble temple on top of a rocky mountain pits itself against the strong sunlight and blue sky of the Mediterranean coast, essentially uninfluenced by seasonal changes; but in the tea-ceremony room, man is made acutely sensitive to delicate changes in Nature, from the light that filters through the small window to the flower in the alcove, from the temperature of the water in the stone washbasin at the entrance to the rustling of the leaves of the trees in the garden. Beginning with the denial of the senses, the tea ceremony ends in an unparalleled refinement of the senses' response towards seasonal and climatic changes.

This attitude to Nature, as refined by the tea ceremony, sums up one aspect of Japanese aesthetics generally. The same close relationship with Nature lies at the heart of the Japanese

tradition of lyric poetry, from the descriptions of Nature in the *Manyōshū*, through the *Kokinshū*, with its lyrics inspired by the seasonal round, and the *Shin-Kokinshū* in which Nature was invested with the gentle melancholy of a vanishing way of life, to the intense feeling for Nature revealed in Bashō's *haiku*. One could also say that the tea-ceremony room sums up the characteristics of Japanese domestic architecture, at least from the beginning of the Tokugawa period. The building is in converse with the garden, the garden in converse with Nature. The interior of the room, the building, and the garden are all alike in emphasizing naturalness; the naturalness is not, as it would have been in China, the breaking down into flowing lines of a stricter order and symmetry: in Japanese aesthetics this naturalness is both the beginning and the end.

The second principle of the tea ceremony is the way it invests the whole of life in the present moment. Here, too, one might detect a consistent attitude to life and art as a whole. The history of Japanese lyric verse, starting as it does with mainly short verse forms, rapidly concentrating on the 31-syllable *tanka* form, and culminating in the 17-syllable *haiku*, bears clear witness to this attitude. It is also apparent in a kind of pragmatism where everyday life is concerned, a willingness to live in accordance with the prevailing situation without clinging to abstract, universal principles. In the tea ceremony, however, this attitude is not merely observed: it is observed consciously. This self-awareness must be attributed, again, to Buddhism, and especially to Zen Buddhism.

Zen emphasizes the concept of "Void." The awareness of "Void" as it affects the present cannot be separated from the knowledge that the past no longer exists and the future does not yet exist. The operation whereby Zen relates the present back to the void begins with its refusal to view past, present, and future in their continuous aspect, seeing them instead as an eternal present in which the past and future are comprehended. That is why the "present" of the tea ceremony, which evolved after the Zen of the thirteenth century, is different from the "present" of life and art before that time.

That is not all, however. The actual tea ceremony, in which

the art of the devotee finds its summation, occurs only once. In creating a poem, a poet can rewrite again and again. Teika, whose verse was the most consciously fashioned of all, went so far as to say that it was best to put in the first line of a poem after one had written the rest, including the last line. The finished verse remains, not only for the poet, but for posterity. The same is true with oil painting. The ink monochrome is different; it cannot be touched up. Once the laden brush touches the paper, it has to move, whether one likes it or not. Everything is decided in that instant; insofar as the retouching seen in the oil painting is not possible, the ink monochrome is an art of the moment. The work itself, however, remains.

With the actor's art, his work does not remain. As a result of long training, the actor creates a performance. His acting does not admit of amendment, but consists of a series of momentary expressions. What is more, once the curtain falls the performance is over and disappears without a trace. Even so the stage is, in theory at least, independent both of the world outside the greenroom and of its audience. Though it may be impossible for a particular actor to recreate for a different type of audience the same performance that he achieved ten years previously, an actor playing the same role from the same greenroom in the same year can probably recreate the same performance to a considerable extent. With the tea ceremony, not only is amendment impossible and no trace is left of one particular gathering, but a "repeat performance," even, is almost impossible. Unlike the stage performance, the tea ceremony depends on season and climate. Unlike the nameless theatre audiences, its guests are discrete individuals, who participate in the tea ceremony in a far more positive way than the audience in a theatre. For the host, his guests are to be compared less to an "audience" than to co-performers. The encounter between particular individual and particular individual at the tea ceremony is essentially something that happens only once, and never occurs again in quite the same way. This is because life itself occurs only once. Thus one type of artistic expression —the type in which everything is decided in the moment—

finds ultimate expression in the tea ceremony. In this sense, the art of the tea adept constitutes a kind of high point of all art. One might even say that it sums up the human condition itself.

As Ii Naosuke expressed it so admirably in the *Chanoyu Ichie-shū*, "The gathering for the tea ceremony is essentially once in a lifetime. Even should the same host and guests assemble again, it is impossible to return to today's meeting. For this reason, the host should take care over every detail." In the tea ceremony, life and art become one. This is the uultimate meaning of the transformation of life into art.

Artistic Creativity
Today

In Ueno Park in Tokyo, there are three very dissimilar pieces of architecture. The first is the Hyōkeikan; the second is the National Museum; and the third is the Tokyo Festival Hall (plates 43, 44, 45). They represent, respectively, the three stages in the history of Japanese architecture since the Meiji Restoration of 1868.

The Hyōkeikan is a faithful imitation of Western architecture. A similar type of imitation is to be seen in the Akasaka Palace also in Tokyo, and was also to be seen, until recently, in the brick office buildings that stood in the Marunouchi business area of the capital. They are all examples of the first series of buildings erected in Japan using Western materials and techniques. They resemble the government offices—exact

replicas of what they were accustomed to at home—that the British set up in the heart of the great Indian cities. They reproduce exactly forms that were evolved without any reference whatsoever to the natural surroundings, culture, and history of their new habitat, forms evolved in a country where all these factors were vastly different. The one difference between the Western buildings of India and these early Western buildings in Japan is that the former were built in India by Englishmen for the use of Englishmen, whereas the latter were built in Japan by Japanese for the use of Japanese. It was precisely this difference that made it possible for Japanese architecture to progress to its second stage.

The National Museum is a peculiar structure, product of a blend of the forms of traditional Japanese architecture and the structural methods of concrete buildings. Another, similar example is to be found in the Tokyo building, now known as Kudan Kaikan (Officers' Club before the war), which is a perfect expression in architecture of the nationalism of the 1930s. It occurred to somebody that imitation pure and simple was rather reprehensible; Japan must have its "own" architecture, a blend of the cultures of East and West. The immediate result of such thinking was this kind of monstrosity. It is characterized by a total lack of relationship between the traditional forms (for example, the shape of the roof) that it incorporates and the structure of the building as a whole. The structure of building as a whole is subject to restrictions imposed by its size, the materials used, and the purpose for which it is intended. To take Japanese forms, which were developed for buildings of utterly different sizes and purposes and using utterly different materials, and attempt, on the grounds that they are "traditional," to graft them onto concrete buildings is like trying to graft bamboo onto a tree. The result may indeed be "peculiarly Japanese," but it does not constitute peculiarly Japanese "architecture." The compromise between the cultures of East and West is, literally, a compromise, and not a fusion. All theories apart, the National Museum and the Kudan Kaikan are surely the most glaringly obvious witnesses to the

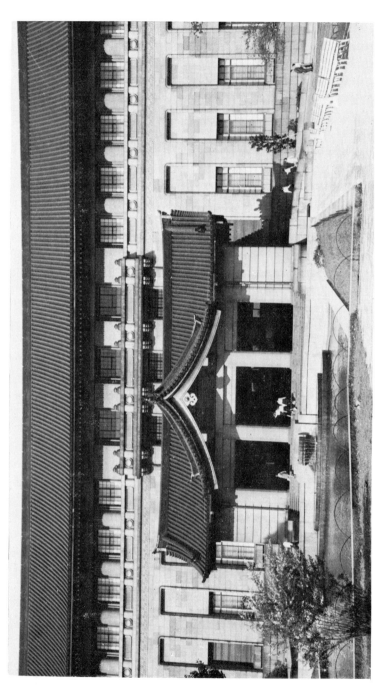

PLATE 43. Hyōkeikan, 1900. *Ueno, Tokyo.*

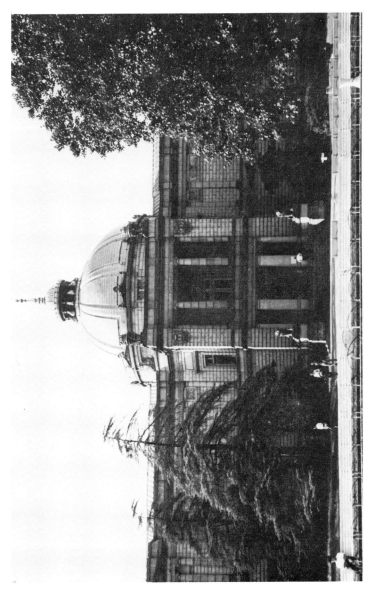

PLATE 44. National Museum, 1932–1937. *Ueno, Tokyo.*

truth of this. The ancient Egyptians, in their art, placed a bird's head on top of a human body without reference to the structure of the body; in the same way, the ancient Greeks stuck a human torso on the body of a horse, again without reference to the latter's structure. The results were monsters. The Japanese of the 1930s stuck a "traditional" roof on top of a concrete building with no relevance to the building's structure; and the result, though doubtless in this case involuntary, was equally grotesque.

Yet the buildings of this period do something more than bear witness to the unfailingly grotesque nature of the results; they also testify to a technical ability adequate to creating them. The period between the two world wars saw Japan assimilate completely the techniques of building concrete structures. Without that assimilation, the third era of modern Japanese architecture that began after World War II would never have been possible.

The third building, the Festival Hall, is a postwar structure. Its chief characteristic is that in it one finds a Japanese architect using what might be called the "international language" of contemporary architecture in order to express himself. Compared with the compromise style that was a mixture of the international language and the traditional language of Japan, this building represents a completely qualitative change, and not simply one of degree. One can no more make a coherent building using two architectural languages than one can make a coherent sentence using two languages in the linguistic sense. Yet two different people—Le Corbusier and Wright, say—can both express what they want to express in one and the same language. It is only since the end of World War II that leading Japanese architects have sought to express their own personalities in the international language. In theory at least, the question of whether the results are "Japanese" or not is not of primary importance. In practice, one is justified in expecting that a quality characteristic of the work of Japanese will make itself felt in such buildings, and what happens, I would suggest, is in fact the creation of a peculiarly Japanese

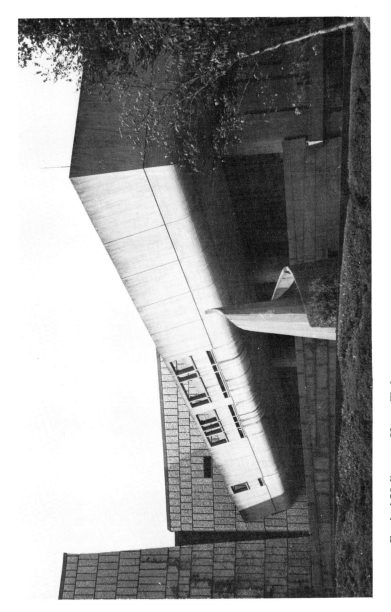

PLATE 45. Festival Hall, 1960. *Ueno, Tokyo.*

architecture. But this is not, of course, the aim; the aim is, quite simply, to create architecture. The trouble with the compromise style was that it acquired its aims on the wrong way round. The creation of a contemporary Japanese architecture, in other words, was not a development from the prewar compromise style, but became possible only through the rejection of that style. The question is not one of technology, but involves the whole basic concept of architecture. And any question that involves the basic concept of architecture must involve basic questions affecting the entire culture.

These three buildings in Ueno Park illustrate with extraordinary vividness the three stages in the recent history of Japanese architecture—imitation of the West, compromise between East and West, and creativity via an international language. Historically speaking, the three stages are very clearly divided; one finds almost no "compromise" structures from the first period, and in the second period scarcely any of the creativity characterizing the third period. The third period dates from the end of World War II, and more especially from the recovery of Japan's independence. It is this period, I feel, that should be referred to as the "contemporary" period, in which sense "contemporary" is synonymous with "creative" in modern Japanese architecture. The question arises, now, of whether the same things can be said of modern Japanese art outside the field of architecture. I believe that, in principle, they can, and that the three buildings in Ueno Park will serve as prototypes in analyzing the development of arts other than architecture as well. Even so, the development of each of the arts must inevitably in practice diverge from the prototypes found in architecture in ways determined by its own special nature. The divergence grows progressively greater as one considers music, painting, and literature, in that order, since the raw materials of music are more closely tied to a particular, historical culture than those of architecture, those of painting are still more so than those of music, and those of literature are even more closely tied than those of painting.

The musicians of the Meiji era began by imitating Western music, using Western instruments. This first era of music, that of imitation pure and simple, was followed by an era of compromise. *Samisen* and Western orchestra would be combined in a "concerto for *samisen*;" orchestral works were composed that incorporated the melodies of Japanese folk songs. The "concerto for *samisen*" may be called the "Kudan Kaikan of music." The incorporation of Japanese folk melodies in an orchestral piece can, admittedly, produce a pleasant enough small work, but that is all. Between, say, the structure of German romantic music and the nature of the melodies it employed, there was a rather closer relationship, and it was this, doubtless, that made possible the development of German music in the nineteenth century. This "compromise music" is sometimes done skilfully, sometimes unskilfully. Yet even where it is skilful, it rarely becomes creative. The creative period for Japanese composers began after the end of World War II. Here too, "contemporary" and "creative" are synonymous, and here too creativity is inseparable from the newly acquired ability of Japanese composers to handle an international musical vocabulary freely, for their own purposes. One thinks immediately of Ogura Rō, Irino Yoshirō, Takemitsu Tōru.

This is only to speak of "Western" music, however. What, then, of traditional Japanese music? "Japanese" music, indeed, still accounts for an important part of Japanese musical culture. But it is not the creative part. The music of the Noh drama is believed to have undergone little development after the sixteenth century at the latest. *Jōruri* music, which accompanies the puppet theater, did not develop after the eighteenth century. It was precisely because the traditional music had ceased to be creative, while imitation of Western music was rife, that a distinction was made in the first period between "Western" and "Japanese" music. The distinction becomes meaningless once contemporary Japanese music has become creative. Music composed creatively by Japanese is all Japanese, and not Western, music. The Hyōkeikan is a "Western-

style" building, but the Festival Hall is a Japanese building. Many "purely Japanese" houses are still, of course, being built today. But architects have no hand in most of them, and even where they do, they show almost no architectural creativity. Since I am concerned here with creativity in contemporary art, and not with artistic culture as a whole, I shall say nothing of the Noh flute, of which none could be fonder than myself, or of the puppet drama, or of "Otomisan" and all the other "popular songs" that once held sway over the public. The fact remains that both Japanese and Western music existed in their own right. Why should contemporary Japanese music have come into being as a development from Western music rather than from Japanese music? Why should contemporary Japanese architecture have developed, not from the traditional Japanese dwelling, but starting from and surpassing the "Western buildings" of the Meiji era? This is a very large problem indeed, but before examining it, I should like to glance at what has happened in painting and literature.

Just as architecture had its "Japanese buildings" and "Western buildings" and music its "Japanese music" and "Western music," so painting had its "Japanese-style painting" (the Japanese term *nihon-ga* is often used even in English books on Japanese art) and its "Western-style painting." And as long as these distinctions lasted, the "Western" side was bound to see, first outright imitation, then "compromise." Japanese oil painting too, it seems, began with imitation, and continued with compromise elements added whenever the occasion required. There were two circumstances affecting painting, however, that differed fundamentally from those affecting architecture and music. One involved the nature of painting as such, the other the special nature of the history of painting in Japan.

First, a characteristic that distinguishes painting in general from architecture and music is that painting sets out to depict human beings and nature. The composition entitled "The Girl With the Flaxen Hair," for example, is in no sense a depiction of the girl's appearance. It would be perfectly possible to name

the same composition "The Girl With the Raven Hair." Obviously this alternative cannot be chosen for a *painting* of the same title. To make hair black would mean changing the color of the background. To change the background would mean changing the color of the girl's clothes in turn. Thus, a Japanese painter who portrays a Japanese girl with jet black hair cannot simply imitate the French painter who did the girl with the flaxen hair, but must discover for himself a color scheme totally unfamiliar to the French artist. There is, in fact, a well known painting by Kishida Ryūsei, "Portrait of Reiko," in which he did just that. However, where the artist is not a man of the stature of Kishida, but feels an obligation to make his girl's hair flaxen—and a large proportion of Japanese oil painters felt precisely that obligation—the difficulty arises that Japan does not have a supply of flaxen-haired maidens. Quite apart from the color of the girl's hair, the particular blue of the sky of Southern France is not to be found in Japan, either. Nor is it a question of color alone. There is the fact that the tradition of Japanese and Chinese painting did not include the naked human figure. This being so, all Japanese painters who wanted to learn oil painting had to go off to France. This was by no means solely because they wished to acquire the *techniques* of Western painting. Rather, the very nature of painting meant that to produce a really thoroughgoing imitation one had to go to the country in question. An art that depicts man and nature cannot escape from social and natural conditions. The "Hyōkeikan of oil painting" was produced by Saeki Yūzō not in Tokyo, but in Paris.

Second, although traditional Japanese architecture and traditional Japanese music had long since ceased to develop, Japanese painting was showing continual development. This is a very important difference. All the while Saeki was painting "oils" in Paris, Tomioka Tessai in Kyōto was absorbed in producing not "Japanese painting" but, quite simply, pictures. Thus it came about that the greatest artists that Japan has produced between the Meiji Restoration and the present day have been those artists who were farthest from the contempo-

rary reality of Japan. Quite apart from Tessai, even, a whole succession of *nihon-ga* artists from Kanō Hōgai to Yokoyama Taikan sought to overcome the stagnation that had long afflicted the *nihon-ga* by taking over techniques from Western painting. Yet it is clear that they were not merely the equivalent in painting of the National Museum or Kudan Kaikan. They were not trying to add "Japanese" elements to concrete structures that they had only just learned how to build, but were seeking to absorb foreign elements into the world of the *nihon-ga*—into a tradition, a structure, of which they were already masters. If this is compromise, then the Kudan Kaikan and the *samisen* concert were compromise of a very different and much lower order. Since this was the situation on the *nihon-ga* side, even with the oil-painting artists compromise pure and simple was unlikely to occur. Their only recourse was to flock to Paris in increasing numbers and to devote themselves more and more wholeheartedly to imitation. The compromise that they finally succeeded in producing is represented by artists such as Leonard Foujita. Foujita's unique achievement lay in employing the techniques of fine brush line and shading in oil painting. I say unique because his work is successful as *dessein* rather than oil painting. Nevertheless, compromise here, as goes without saying, transcends compromise almost completely, and succeeds in creating its own individual world. In such a case it scarcely matters what the beginnings were. The point is that there were factors in oil painting that made it difficult to produce simple compromises, as in other fields. And this is why the overwhelming tendency towards imitation has continued for so long.

What of the postwar period, then—has the same phenomenon occurred in the world of painting as in those of architecture and music? Certain facts will be clear at once; that the artists working in Japanese media (the *nihon-ga* artists) and the artists working in oils are, by now, preoccupied with so-called "abstract" painting; that in this sense the distinction between "Japanese" and "Western" painting has begun to disappear; and that "abstract" painting, practiced as it is not

only in Japan but in most countries throughout the world, has become in effect a kind of international form. I will leave aside for the moment the question of whether this international form can be compared with, say, the international style of contemporary architecture prevailing since the Bauhaus or the international musical language invented by Schoenberg. It is enough for our purposes here to affirm that contemporary painting, too, is by now characterized not by imitation of Western painting, nor by compromise between East and West, but by self-expression within a species of international form. It is probably safe to say that the prototype afforded by architecture can also be recognized, more or less, in the post-Restoration history of painting, albeit obscured by far more complex fluctuations.

In the case of literature, the picture is far more complicated than in architecture, music or painting. Literature means verbal expression, but verbal expression is not confined to literature. In this respect, it completely differs from concrete structures, musical sounds, and oils, which as means of expression are found almost exclusively in architecture, music, and painting. By means of words, literature is bound far more closely than probably any other art to the historical society and its culture. There is no literary equivalent of the Hyōkeikan. Modern literature begins with compromise, without any era of outright imitation of the West. I am speaking here of Japanese literature since the Meiji Restoration, not of the history of Japanese literature. In terms of the whole history, the equivalent of the Hyōkeikan is to be found in the *Kaifūsō*, or, much later, in the verse and prose of the monks of the "Five Monasteries." The relationship of Japanese literature with Chinese literature is above all different *linguistically* from its relationship with Western literature.

However, the compromise here was not that of the artists in oils who imitated Western models by giving them Japanese touches, but resembled, rather, the compromise of those traditional artists who used the materials of the *nihon-ga* and worked within the traditional field, yet sought at the same

175

time to introduce certain elements from the techniques of oil painting. The level attained in such a case will depend, in a sense, on the capacity of the traditional culture for digesting new things. The influence exerted on the Impressionists by the *ukiyo-e* of Edo-period Japan was a triumph for the Impressionists, not for Japanese art. The influence of German literature on Mori Ogai was a result of Ogai's own greatness rather than the grace of German literature. The level of the traditional Japanese culture, however—as Nagai Kafū, among others, pointed out—has declined steadily ever since Meiji times. It is for precisely this reason that literature since Mori Ogai and Natsume Sōseki has never been able to attain the heights that Meiji "compromise" literature achieved in those two artists.

What has happened since the end of World War II? The structure of compromise has not changed. Even now, the literary vocabulary has still not become international. In this, literature differs fundamentally from architecture, music, and painting. Literature, however, is influenced far more directly than architecture, music, or painting by changes in the life of society, and social life has changed markedly since the end of the war. Nowadays, life in the great cities of the world, from London to Tokyo, from New York to Rome, has become, on the surface at least, almost identical. If the way of life is almost the same, then the types of problems it gives rise to will be very similar. This is a new situation, one unknown to the writers of Meiji times. In literature, the era of compromise was not preceded by an era of outright imitation. And for just the same reasons, compromise cannot be followed by an age of self-expression via an international vocabulary. Literature that is a compromise to begin with remains a compromise always. Yet the inner nature of the compromise is obliged to change as the situation changes, as the social system and ways of life become internationalized. It is this newness that characterizes "contemporary" literature.

To sum up, the "contemporary" in Japanese art can be dated from the end of World War II. Two phenomena charac-

terize this "contemporary" age. One is the fact, reflected most vividly in literature, that Japanese society has been internationalized. The other, demonstrated best by architecture, music, and painting, is that international styles have come to provide the framework within which the artist seeks expression. These international styles were perfected, not within Japan, but in the world outside Japan. Thus the two phenomena can be said to represent changes that have occurred since the end of World War II within as well as outside Japan. In discussing any change, however, it is necessary to compare what went before and what came after. In other words, in order to give an account of contemporary Japanese art, it is necessary to trace the changes that have occurred in Japan since the Meiji Restoration at least, and also the changes that have occurred outside Japan.

The most conspicuous changes that have taken place in Japan since the Meiji Restoration are usually referred to collectively as "modernization." In discussing the modernization of Japan in general, and not merely in reference to art, Western and Japanese scholars unanimously agree in recognizing the great influence exerted by "the West." How did Japanese society change under the influence of the West? How far were these changes backed up by conditions existing at home, and how far were they determined by influence from abroad? No attention, or almost none, is paid in such discussions to how the West itself has changed during the same period. Where relations with Japan are concerned, the West has been treated, as it were, as an "eternal" West, and the only concern of scholars has been the approach adopted by the Japanese towards this unchanging entity. Yet there is no eternal West, any more than there is an eternal Japan. Japan undoubtedly changed vastly during the century from 1860 to 1960—but so did the West also. Insofar as relations between Japan and the West are vital to the changes that have affected Japan, no account of the latter can be complete without taking into consideration the changes in the West itself. To restrict our discussion here to art, the difference between the Hyōkeikan

and Festival Hall cannot be accounted for adequately solely in terms of the change in the attitude of the Japanese to Western architecture. Indeed, no such generalized thing as "Western architecture" exists in the first place. What exists is the neo-classicism of the late nineteenth century, or contemporary architecture since the Bauhaus. When Japanese architects have taken different attitudes towards these two types of architecture—types which differ fundamentally, in their basic principles—it is hopelessly one-sided to try to explain this in terms of a change on the Japanese side. In the same way, there is no such thing as, say, "Western literature," and even if there were, Western literature as a whole has not influenced Japanese writers. They were influenced by specific sections of Western literature, such as the nineteenth century novel—but the nineteenth century novel is not, by itself, "Western literature." Where art and literature are concerned at least, no discussion of changes in Japan during the past century can afford to ignore the changes that took place in the West during the same century. And especially when considering the "contemporary" in Japan, it is necessary to define the nature of the "contemporary" outside, and not only inside Japan.

The chief factors promoting change within Japan have almost certainly been, first, the secularization of culture, and second, the industrialization of society. The first factor became all-pervasive during the Tokugawa period, and made possible the cultural developments following the Meiji Restoration. The second has been fulfilled in the period between the Meiji Restoration and the present, and gives the background of contemporary art its special characteristics.

The necessary condition outside Japan was that Western culture should break out of the framework of the "Western" and open itself to things outside the Western world. This process was tied up within the West itself, with the secularization of culture, the development of industrial technology, and the emergence of mass society, and would also seem to be related, where the outside world was concerned, with the impasse reached by imperial colonialism and its subsequent de-

cline. In short, around the time of World War I, the national cultures of the nineteenth century began to give way to today's international culture.

If the relationship between Japan and the West is considered in this light, it can be said that Japanese artists from the Meiji Restoration until World War II were dealing with the national cultures of a West in which ways of life differed markedly from their own, whereas since World War II they have been in contact with an international culture in a world where ways of life have come to resemble each other. Between the Meiji Restoration and World War II, Japanese artists took from the outside world, but did not participate in its culture. Today, they participate in its culture at the same time as they take over some of its elements. This represents not only a change in Japanese artists, but also a change in the world outside.

However, this is no more than a general pattern, accounting for what happened in the broadest terms. I want next to go into more concrete detail, first discussing conditions within Japan, then turning to the situation in the Outside World.

The history of Japanese art and literature begins with an extraordinarily clearcut dual structure. The national religion of eighth-century Japan was Buddhism. The Emperor himself subscribed to the faith, and any rapid survey of the culture of this age, the age that saw the erection of the Great Buddha of the Tōdaiji, would suggest that it had no culture that was not associated in some way with Buddhism. The great buildings of the time that survive today are all Buddhist temples, and the murals and sculpture that they house represent the highest perfection of what is known to art historians as the Tempyō style. Yet all this is counterbalanced by the twenty volumes of the *Manyōshū*, the great anthology of Japanese verse compiled during the same period, which shows almost no influence whatsoever from Buddhism. Particularly significant is the section entitled *Azuma-uta*—believed to be a collection of verse written by the common people of the day—since one

179

may search in it almost entirely in vain for any sign that Buddhism was practiced at all in Japan at the time. The contrast must be called odd at the very least. Art (architecture, painting, sculpture) was Buddhistic through and through; one is reminded, for example, of the age of the great cathedrals in Western Europe during the twelfth and thirteenth centuries. In that Golden Age of Gothic art, a literature uninfluenced by Christianity would have been almost inconceivable. Yet in the Golden Age of Buddhist art in Japan, during the seventh and eighth centuries (when the overwhelming majority of the verses in the *Manyōshū* were composed), the poets of Japan ignored Buddhism the religion.

Such an extremely clear-cut dual structure is by no means easy to account for. One reason, of course, was that Buddhism centered on the capital of Nara, and that its influence did not extend to the eastern provinces—the "Azuma" (east) of the Azuma-uta. Another was that Buddhism, being an imported system of ideas adopted by the aristocracy and bureaucracy, did not permeate the masses of the people. Yet the complete lack of concern for Buddhism shown by the *Manyōshū* extends to most of the poets of the Court and aristocracy, and not only to the unknown provincial poets of the Azuma-uta section. Kakinomoto no Hitomaro, for instance, was a Court poet who wrote a large number of elegies. If Buddhism had held any real meaning for Hitomaro, then as a poet he would surely have given expression to it in his verse, and it would have been reflected especially strongly in his elegies. Yet almost no Buddhistic terms are to be found in these elegies, nor are any particularly Buddhistic ways of thinking detectable. It seems unlikely that one can explain the absolute split between Buddhistic art and non-Buddhistic literature in seventh- and eighth-century Japan simply as a reflection of the dual structure of society. One can only conclude that there was also a dual structure of mind within each individual, with a Buddhist aspect and a non-Buddhist aspect that found their self-expression in Buddhist art and non-Buddhist literature respectively.

This dual structure within the spiritual life was almost certainly not a simple opposition between superficiality and profoundity. The Buddhist art of the Tempyō era is something more than an imitation of the culture of the continent. The circumstances that led to artistic expression at such a high level cannot be dismissed as a superficial influence from Buddhism. Yet it is equally true, of course, that the verse in the *Manyōshū* reveals the depth and refinement of a spiritual level that was *not* influenced by Buddhism. In short, the contrast between the art of the Tempyō era and the *Manyōshū* is worthy of note not merely because it is so clearly defined, but also because it is a contrast, at a highly refined level, between the art and literature of Japan. One must conclude that beyond the contrast there lay, not simply a difference between the shallow and the profound, nor a difference in degree of "enlightenment"—i.e., absorption of foreign civilization—but a dual structure of the spirit that had its origins in an incompatibility of the Buddhist system of ideas and the Japanese spiritual makeup existing before the introduction of Buddhism. If one thinks in this fashion, two problems naturally arise. The first is, what is the precise nature of this "incompatibility"? Second, why should it happen that the Buddhistic and non-Buddhistic areas should manifest themselves in art and literature respectively, and not the other way round? To try to answer the first of these questions is not in the province of this essay. As for the second question, it seems safe to say that the decisive factor here was language. The sculptors of the Nara period were able to express themselves in a kind of international language (the style of Buddhist sculpture that extended from Gandhara to northern China and on to the Korean peninsula). The poets of the *Manyōshū*, however, wrote their verse in Japanese.

Buddhism was not to find self-expression in Japan—in other words, a true Buddhist literature would not emerge—until the Buddhism of the Kamakura period. The historic significance of Kamakura can be summed up as its challenge to the dual structure of the spirit. As a result, in the succeeding Muromachi period the eighth century dichotomy of art and litera-

ture showed itself felt as a contrast within literature itself. In thoroughgoingness, the contrast within literature yielded nothing to the former. Japanese actors performed on the same stage both the Noh—a Buddhistic drama—and the *Kyōgen* farces, which had no connection with Buddhism whatsoever. The Japanese masses who had created the *Azuma-uta* in the eighth century, who had been at work in the volume of Japanese Tales in the *Konjaku Monogatari* of the Heian period, showed such a keen enjoyment of the present world (and, when the need arose, such a keen iconoclasm) in the *Kyōgen*. Even temple Buddhism was more or less secularized, when temples multiplied contacts with the common people in the Muromachi period. Buddhism did not really change the Japanese masses, but the Japanese masses changed Buddhism.

Eventually, the Edo period was, in a double sense, to carry through to its logical conclusion the secularization of culture that started in the Muromachi period. First, the theories of Confucianism gave a check to Buddhism as the ruling system of ideas. The reason the eighteenth-century scholar, Motoori Norinaga, in doing battle with the Confucianists was much less eager to attack the Buddhists, was that by then, Buddhism's power had declined too seriously for it to be a worthwhile adversary. Second, in the course of the Edo period Confucianism itself gradually changed from a Sung-style metaphysical (if not necessarily religious) system to a set of moral precepts and political principles. In a sense, a phenomenon akin to that of secularization occurred within Confucianism as well. As a result, by the middle of the nineteenth century, when the Black Ships appeared off Japan's shores, Japan was entirely devoid of any system of absolute values based on belief in an absolute being. What it did have, however, was an industrious people with a high level of education—a secular and pragmatically minded people. Such a state of affairs was undoubtedly highly favorable to the introduction of foreign ideas—more favorable, in fact, than is to be found anywhere else in Asia even today. A system of values that rests on a relationship with an absolute being is closed to other systems of values. A

system that includes no such relationship, and is thus relative only to itself, is open to other systems. Provided there are convincing practical reasons, it will willingly take over elements from outside and make them a part of itself.

The influx of Western ideas into Japan following the Meiji Restoration was, of course, a result of the Meiji government's attempts to modernize the country on Western lines. However, this was by no means the whole reason. The Meiji Restoration sought to take from the outside world only what it wanted, and to leave what it did not want. Generally speaking, it wanted administrative and industrial techniques; it did not want political and social ideas. It seems safe to assume that the authorities had no interest in Western ideas throughout the whole field of art and literature. Quite obviously, then, the Meiji-period intelligentsia sought to take over from Western systems of thought more than the authorities wanted it to— even, at times, in the face of attempts at suppression. This is something that would be difficult to account for if a receptivity to Western ideas had not been there in the first place.

However, although on the theoretical side favorable conditions (the thorough secularization of society that had already occurred in the Tokugawa period) for the adoption of Western ideas already existed, other conditions affecting the more practical aspects of living made the taking-over of Western-style ways of life difficult. Although the industrialization of the nation had made great strides by the time of World War II, it had not yet brought about a decisive change in the daily lives of the people. Even after World War I, the public's chief supply of proteins came from vegetable foodstuffs; most women wore Japanese dress all the time; and almost all Japanese lived the traditional life in traditional Japanese houses. The family—in the eyes of the civil code at least—rested on absolute respect for paternal authority and discrimination between men and women. Not only did the village community form a firmly established social system in the agricultural area, but, as many recent studies have shown, the pattern it provided was also carried over into almost all organizations in the towns.

All these things bear a close relationship to the degree of industrialization of the country. In fact, a dual structure was apparent, on a wide and deep-reaching scale, in every aspect of the process of industrialization itself—the development of heavy industry versus traditional patterns of daily consumption; the modern industry in the urban areas versus the maintenance of a tenant farmer system in the agricultural communities; and, even, within industry itself the modernization of the large industries versus the backwardness of smaller industries. Thus, should a Japanese intellectual, for example, find himself converted to the socialist ideas newly imported from abroad—and we have already seen how the necessary intellectual conditions for such a conversion were already present— that conversion immediately made itself felt as a split between his inner and his outer selves. In the first place, the idea of organizing the working class in order to effect changes in society as a whole, far from creating a tie between the intellectuals and the workers, was likely to divorce him from them still further, in this country where the level of industrialization had not yet given birth to a powerful proletariat. In the second place, a set of ideas so far removed from the actualities of the individual's everyday life necessarily forced him to distinguish between outwardly professed and inwardly practiced sets of values. Socialist ideas, moreover, are only one example of a general trend. In taking over so many ideas from Western society into a society that differed so conspicuously from it, Japanese culture in the late nineteenth and first half of the twentieth century could not help but evolve a dual structure similar to that which the culture of the eighth century evolved in its relationship with Buddhism. The Japanese lived in houses that combined both Western and Japanese elements; they distinguished the occasions on which they would eat Japanese food and Western food, or wear Japanese dress and Western dress; they set up separate faculties of Japanese music and Western music in their academies; and their art schools had separate faculties of Japanese painting and Western painting. The only fields in which the distinction between Japanese and

Western was not made from the outset were the natural sciences and literature. Natural science was too remote from daily life and its values, while literature was too close.

In the sciences, from the start there was no "Japanese-style physics." In medicine, Japan had the traditional Chinese herbal medicine, yet despite this the Meiji government officially adopted Western medicine for teaching in its colleges, rejecting any dual system. It was in this period that Mori Ogai, army physician and celebrated novelist, proclaimed "Medicine is one." Nobody, however, claimed that art was one.

Just as the Japanese way of life is something peculiar to Japanese society, so is the sense of values that is inseparably bound up with that way of life. The sense of values fostered by the village community is structurally quite different from the sense of values traditional to the individualistic society of the West. It is only to be expected, therefore, that the attempt to introduce Western thought and Western styles and techniques of art should create a gap between these and Japanese society, with its circumstances so different from those of the West.

It was the man of letters who sensed that gap most keenly. Thus the idea became widespread among writers that the only thing Western literature and Japanese literature had in common was the name "literature," and that the two must be judged by completely different standards. This idea led, for example, to the writing of large numbers of *watakushi-shōsetsu* ("I-novels") in Japan between the two world wars, and these novels served in turn to support the schism. That way of thinking, however, concealed a double misapprehension. The first necessity in order to protect the *watakushi-shōsetsu* was not a standard different from that used for Western literature, but simply a different one from that used for the nineteenth-century novel. It was because of the mistaken idea that "nineteenth-century novel" and "Western literature" were synonymous that the necessity for two different standards came to be expounded. Second, the idea that the *watakushi-shōsetsu* represented a break with the tradition of Japanese

literature was similarly inspired by the mistaken equation of that literature with the literature of the writers of popular novelettes in the Edo period. In fact, after the Meiji Restoration there was no other Japanese literature quite so traditional as the *watakushi-shōsetsu.*

Generally speaking, post-Restoration Japanese literature, far from representing a break with tradition, was traditional at least to the same extent that the painters of *nihon-ga* were traditional in relation to the painters in oils. Few will dispute that the two great mainstreams of tradition in Japanese literature are formed by the short poems that begin with the *Manyōshū* and by the prose diary form that begins with the *Kagerō no Nikki* and extends to the diaries and belles lettres of the Edo period. What happened to these two great currents following the Meiji Restoration? The poet Masaoka Shiki with his "Araragi" school consciously attempted a return to the *Manyōshū.* The novelists of "naturalism," writing their *watakushi-shōsetsu,* unconsciously returned to the *Kagerō no Nikki.* They represent, rather, an almost complete disappearance of the foreign influences (from Chinese and Western literature) that had affected Japanese literature since the days of the *Manyōshū* and *Kagerō no Nikki.* If the novelists who wrote *watakushi-shōsetsu* likened themselves to painters in oils and spoke largely of a "break with tradition," the reason lay mostly in a confusion of ideas caused by their hopeless misapprehension of the traditions of Western and Japanese literature. That portion of the Japanese literary tradition that had always depended on close converse with foreign systems of ideas was carried on following the Restoration by Natsume Sōseki and Mori Ogai. And both Sōseki and Ogai, far from proclaiming a break with tradition, ceaselessly stressed their ties with it.

Today, the situation has changed. Since the end of World War II, and especially since the latter half of the nineteen-fifties, the industrialization of the nation has reached the point of changing the ways of life of the Japanese people. In the great cities at least, the pattern of daily life is scarcely distin-

guishable from that of any other industrialized nation. The man who travels by subway from the suburbs to his place of work and goes home in the evening to watch the television is much the same in both Japan and the West. Japan is separated by a wide gap, moreover, from that majority of areas of the world that has a high infant mortality rate and a high rate of illiteracy. Given a great similarity between Western and Japanese societies, then those societies are likely to spawn similar problems: from the traffic problem to juvenile crime, from the problems of mass education to the privileges of big business, from political apathy among the masses to the vulgarization of television entertainment. A large number of the inconveniences, and difficult problems encountered in everyday life in Japan have occurred not because they are Japanese but because they are un-Japanese. The difference between Japan and the West is merely, for example, that baseball and *sumō* are popular in Japan whereas football and bicycle racing are popular in the West; it is not that people in Japan watch baseball while their counterparts in the West watch Shakespeare.

Moreover, the progress in industrialization and economic prosperity of the second half of the 1950s and onward occurred within the framework of an internationalized social system. When actual life is internationalized, the sense of values attached to it is also, to a certain extent, internationalized. This is all the more true since Japan's postwar systems were based on principles different from those of prewar systems, and the new principles are championed via the normal educational system. The sense of values typical of the village community respects "human harmony"—a Confucian concept—within the community at the expense of individual rights. However, with the breakdown of the village community in the agricultural areas and the new emphasis on individual rights in normal education, a transition from a sense of values centering on the community to one centering on the individual is inevitable. The one does not, of course, completely replace the other. One would hardly expect the community pattern of values to dis-

appear overnight, nor could individualism appear in Japan in precisely the same form that it once took in Western society. It means, rather, that a remarkable number of problems are common both to the West today, where individualism is being hard pressed by a mass society, and to Japan, where emerging individualism has to struggle with the traditional sense of community on the one hand and, on the other, with the pressures of a similar mass society.

It is safe to say, thus, that contemporary Japanese society is coming to resemble Western society both in actual life and in its sense of values. This process, I think, is more accurately described as "internationalization" than as "westernization." Whatever one calls it, however, the reality remains. Added to this, communications have developed greatly both inside and outside Japan. Thanks to developments in techniques of photographic reproduction and recording, one can get an idea, without moving from one's home, of the art and music of any country in the world. With the spread of air travel, foreign artists can come to perform in Japan, and Japanese artists go to work abroad, with an ease unthinkable before the war. Quite apart from recordings, the number of first-rate foreign musicians who have been heard in Tokyo during the past ten years is probably dozens of times greater than the total number heard during the fifty-odd years from the Restoration until the beginning of World War II. Nor is it only music; during the past ten years, it has been possible to see in Tokyo a far greater quantity of foreign art than throughout the half-century preceding the war.

Thanks to a combination of all these circumstances, Japanese architects, musicians, and painters have begun to express themselves in international society using an international language. Before this could happen, the domestic conditions just described were necessary—but they were not, of course, sufficient in themselves. No architect, whatever his nationality, can participate in international society unless there already exists an "international society of architects." In the Meiji era, the absence of the necessary conditions at home was the deci-

sive factor, but even if they had been present, there was no international world of architecture outside Japan. All that existed outside Japan at that time was "Western architecture" and the tradition of painting that had existed in the West since the Renaissance. It would have been impossible for Japan to participate in the world of Western architecture. It would have been equally impossible, not only for a Japanese, but for almost any non-French artist to have a hand in the development of Impressionism. It is the internationalization of Western architecture and art in modern times that made possible the participation of Japanese architects and artists in international society. As to what happened outside Japan—in the West, that is—I will have more to say later.

Literature has no international language. Nevertheless, the nature of the exchanges between Japanese literature and foreign literature has begun to undergo a great change nowadays. In the past, there was translation from foreign languages into Japanese, but very little translation from Japanese into other languages. The greatest single factor here, of course, was the small number of foreigners who learned Japanese. Today, after World War II, the number of people learning Japanese has increased conspicuously (more than one hundred times the prewar figure), especially in the English-speaking nations, so that the number of translations of Japanese literature is also on the increase. Japanese men of letters journey abroad far more commonly than before the war. Most important, Japanese society has come to resemble Western society, with the natural result that the idea of judging Japanese literature by an entirely different standard from Western literature has gone out of fashion. At the same time, the range of themes with which literature deals has become far wider, and the activities of the man of letters have become far more diverse. This is probably the most prominent factor in any summing-up of the characteristics of contemporary Japanese literature. Never before have Japanese writers tried to portray such a wide range of figures—from elder statesmen to slum dwellers, from stockbrokers to scientists, from miners to black

soldiers. Never before have they considered it necessary, or feasible, to take a hand in controversies over legal *causes célèbres*, to oppose ratification of a military treaty, or form a union to protect authors' copyrights.

A greater range of themes and a greater scope in the writer's activities do not necessarily mean an immediate improvement in the quality of the literature produced. The quality of a work is related to the quality of the literary language, and of its public. Ever since the Restoration, the literary language has come ever closer to the colloquial, and the colloquial has tended to change ever more rapidly, a tendency that by now has become acute. This has meant that the literary language has come increasingly to reflect the instability of the colloquial. Unfortunately, it is not possible to erect a firm structure of ideas using unstable words, and writers who are sensitive to words have been obliged to adopt one or the other of two alternatives. Either they have sought (as does Kawabata Yasunari) to divest literature as far as possible of intellectual content, concentrating instead on giving subtle expression to a succession of sensuous experiences. Or (as does Ishikawa Jun) they see the writer as being powerless to do anything about the instability of the spoken language, and have thus removed their literary language from the colloquial, relying instead on the language of the literary classics. And, where the vocabulary of the literary classics has proved inadequate, they have taken words (as does Kobayashi Hideo) used in translating from Western languages, and used them in the same senses as they have in those languages. The second approach, which resists the general tendency for the literary and colloquial languages to come close to each other, was first evolved by Mori Ogai. However, the lowering of the public's ability to appreciate literary classics since Ogai's time has been so marked, that there is litle hope of a contemporary writer producing work of Ogai's standard. Ogai could write in *kambun* (the peculiar sinicized form of Japanese produced by imposing Japanese readings and word-order on a basically Chinese text). His public could at least read, if not write it. Today, even the

writer cannot write *kambun*, and can only read it with the greatest difficulty. As for his public, the majority cannot even read it. Some may object that *kambun* is not Japanese at any rate, but a kind of Chinese. The controversy does not concern us here; it is, nonetheless, certain that *kambun* has been of vital historical importance to the literary language of Japan. Ishikawa Jun and Kobayashi Hideo, then, are exceptions among contemporary writers. Even Kawabata Yasunari is an exception. Most writers have come to the conclusion that the only difference between a newspaper article and a work of literature lies in the content. That conclusion can justly be called a characteristic of contemporary Japanese literature, since, so far as I am aware, it has no parallel in any other country at any other period of history. Stendhal learned, he said, from the *Code Napoleon*; but he did not claim to write novels in the same style as newspaper articles.

Along with the broadening of literature's range of themes following the war, the range of readers also widened. It is difficult to say which is cause and which effect, but the two phenomena occurred together. Assuming that today there are ten times as many readers as before World War II, then the range of literature's themes will obviously have to be extended if it is to appeal to such a wide readership, and the style, too, will have to be correspondingly easy to understand. To use Ogai as an example again, following World War I, his "historical biographies" were serialized in a daily newspaper. It would almost certainly be impossible for a daily newspaper nowadays, after World War II, to serialize, say, Ishikawa Jun's *Shokoku Kijin-den* (*Biographies of Strange Persons*). The reason lies in the spread of the idea that literature ought by its nature to be read by a large number of people. The prevailing idea in Japan thirty years ago was that anything read by a large number of people was not literature. These two diametrically opposed views of the relationship between literature and the reader are illustrated by the custom whereby what was in the old days "popular fiction" is now referred to as "the genre novel."

The expansion of literature's public and its range of themes, of course, is peculiar to the mass society, and not only Japan. The same phenomenon can be observed in varying degrees anywhere where higher education has become widespread, mass communications are highly developed, and the middle-class pattern of consumption has been adopted by the masses. In this sense, perhaps, literature too has been "internationalized" since the war. It was something that was bound to happen in every field of culture when Japan, heir to both the Edo-period secularization of culture and post-Restoration industrialization, found itself in an increasingly expanding relationship with the outside world. The internationalization of culture naturally strengthens Japanese awareness of cultural tradition. The two trends do not contradict, but complement each other.

I would stress again here that in talking of "internationalization" I do not refer to "international cultural exchanges" of the type that involve demonstrating Japanese flower arrangement, dancing, and *kakemono* to wealthy and leisured foreigners. I refer, of course, to the contemporary universalization of concepts of art. It means Iwaki Hiroyuki and Ozawa Seiji conducting Brahms and Tchaikovsky in Berlin and San Francisco; it means Irino Yoshiro composing chamber music in the style not of ancient *gagaku* but of Schoenberg; it means the success of many painters of so-called "abstract art" in giving expression to Japanese sentiments without worrying overly much about Paris; it means, in particular, the success of Tange Kenzō and other Japanese architects in displaying an increasing creativity within the universal realm of contemporary architecture. It may also mean the determination of an Oe Kenzaburō or a Kaikō Ken to create their own literature out of the upheaval wrought by war in Japanese society. There is no space here to discuss the content of their work. What I have been concerned with is the domestic conditions that have made their work possible. The next question is that of conditions abroad.

The contemporary age—as André Malraux first pointed out explicitly—has seen the establishment of a universal concept

of art. All Malraux's writings on art resolve ultimately to one insight: that art is one. It is the West today, he says, that has evolved for the first time a single concept of art that embraces the art of every age and region on earth.

Why should such a concept have come into being? One factor is the development of techniques of photographic reproduction, but more basic is the secularization of Western art. What are the results of the emergence of such a concept? First, it opens the way, in theory at least, to the appreciation of the art of every period and every area of the world. Second, it exerts an effect on the creation of contemporary art, producing its own style. This, in broad terms, is the theory developed by Malraux, which he applies in considerable detail, especially in relation to painting and sculpture.

The same theory, however, can be extended to apply not only to painting and sculpture but also to architecture and probably to music. It also seems likely to prove useful in explaining phenomena found in at least one section of modern literature.

The concepts of art generally held in the West until the end of the nineteenth century were purely Western. Thus the act of artistic creation allowed no opening for infiltration by influences from non-Western cultures. From the Renaissance on, the ideal in architecture was Greek, and even in painting, until the emergence of Impressionism, the ideal had its ultimate roots in Greece and Rome and in Renaissance Italy. Thus medieval painting was not regarded as in a different style from that of fifteenth-century Italy, but as unskilful painting that fell far short of the latter's achievement. For nineteenth-century Europe, this means, there was only one ideal style in art. For the architect, classical Greece; for the artist, fifteenth-century Italy; for the musician, German Romanticism; for the writer, the situation was more complex, yet even so it was only very rarely that he recognized a culture outside the European. Western art at that time was not only Western in the sense that it was produced by Western people, but Western also in the sense that it entertained no exchanges with non-Western culture, and that it showed clearly definable

stylistic characteristics. "Western music" did not refer vaguely to the music performed by Western people, but to music characterized by a particular tonality, particular rhythms, particular instruments (the violin and other string instruments, the piano, the human voice as typified by *bel canto*). Schoenberg is noted for having smashed the traditional tonal structure. Yet even Schoenberg's most "advanced" music sounds unmistakably Western, presumably because of the traditional rhythms and the constant predominance of the strings. The reason why the music of the Noh does not sound Western is not merely a question of tonality; it is a question of complex rhythms totally unrelated to the basic rhythms of Western music, and of an orchestra devoid of strings, using instead a single flute and percussion instruments. The Western music that Japan heard at the end of the nineteenth century consisted almost exclusively—apart from Protestant hymns, Scottish folk songs, melodies by Foster and marches for military bands—of Romantic music of the period following Mozart and preceding Wagner, together with arias from Italian operas. It is hardly coincidental that Beethoven should have become so widely known in Japan, for Beethoven represents the summing-up, the transcending, and the highest peak of all that was implied in this concept of music.

Where Western pictures are concerned, the things that most struck Shiba Kōkan in the late eigtheeenth century were the perspective and realism of Dutch etchings (in his time photographic techniques had not yet been developed). The oil painting learned by Asai Chū in the late nineteenth century— but "learned" at a level that set him above almost all subsequent Japanese paint artists in oils—was not even Impressionism, but French Academism. "Western painting" for the Japanese artist was by no means the whole of Western painting, but the painting of the West of the nineteenth century, a fact of incalculable significance. It was no more than the painting of one very particular age, clearly distinguishable by its typical palette, by its idealized human forms traceable ultimately to Hellenism, by devices used to make a flat canvas

appear three-dimensional (geometrical perspective and chiaroscuro), and by the non-Christian themes (historical subjects, landscapes, still-lifes). Learning as he did from these, Asai Chū (1856–1907) was able to paint Japanese landscapes. If he had had to learn from Renaissance painting, he would probably have been obliged—unless he invented the landscape in oils for himself—to paint pictures of Christ on the cross. In Mexico, which was converted to Christianity at an early date, Mexican artists did, in fact, use oils to portray Christ and Mary. There was no way for this to happen in nineteenth-century Japan, however. The secularization of painting in nineteenth-century Europe was doubtless an indispensable condition if the Japanese were to receive its influence. However, so long as the source of ideal painting lay in Renaissance Italy, so long as its ideal was essentially something unacceptable to Asai Chū, the learning of techniques was possible but artistic creation was impossible. There are two outstanding features to oil-painting in Japan from Asai Chū on to Umehara Ryuzaburō (1888–). One is the diligence shown by almost all artists in learning each new technique as it appeared; the other is the almost complete lack of any artist who succeeded in producing a style of his own. These two features are closely related to each other. Western painting in the nineteenth century was so thoroughgoing in its exclusiveness that there was almost no possibility of anyone outside the Western cultural sphere making any essential contribution to it.

Where literature was concerned, Romanticism opened up the era of national literatures. The contrast between the eighteenth century and nineteenth century was a contrast between pan-Europism and nationalism. Voltaire was active at the Prussian court, then went off to England where he wrote his celebrated "Letters." Rousseau came from the highlands of Switzerland, worked on the central plain of France, and extended his influence as far as Weimar. Goethe himself wrote of his travels to Italy, was partial to Shakespeare, and thought of himself less as a German poet than as a citizen of Europe. Montesquieu remarked that the good of the nation comes be-

fore that of the self, the good of mankind before that of the nation. Since Montesquieu knew little of the Persians, while China was quite beyond his sphere of consideration, "mankind" meant, in effect, "the West." Europism depended for its existence on some principle that transcended frontiers—for instance, the concept of reason and classical aesthetics that then seemed so universal. The nineteenth century and Romanticism replaced the universal reason of the eighteenth century with "history."

It is impossible to divorce "history" from the special characteristics of race and nation. It is a natural process that universal principles should give way to principles of particularity or individuality. Thus Hegel's historicism gradually led to Fichte's nationalism. The brothers Grimm collected German folktales, as well as compiled a dictionary of the German language. The whole culture that began in the theater with Wallenstein, and ended with the Ring of the Nibelung tetralogy, was essentially national. The same can be said of the English novel of the Victorian era, and of the French novel from Balzac to Flaubert. It was not the music of Beethoven, but of Mozart that Stendhal said he would go a thousand miles to hear. It was Shakespeare, not any of the novelists of Victorian England, who aroused his enthusiasm to the point of writing a book on the subject. There is no such thing as nineteenth-century European literature; there is nothing but English literature, and French literature, and German literature, all independent and exclusive of each other. To ask, for example, what Tayama Katai (generally known to have been influenced by Flaubert) got from European literature is an inaccurate way of phrasing the question. To be accurate, one should ask what it was that Tayama got from Flaubert. Even the English and Germans, who derived so much from Voltaire, gained almost nothing from Flaubert. The Japanese are much farther removed from the national culture of France than either the English or the Germans. Why should it be Flaubert of all people—rather than, say, Voltaire—who meant so much to them? Western literature in the nineteenth century

was based not merely on the national individuality but also on that of the author. "Individuality" here, of course, does not refer to the characteristic flavor or personality of the author, but to his consciously determined standpoint, his consciously chosen attitude. Insofar as the decision or choice is ultimately based on the free will of the individual, respect for individuality is inseparable from respect for the freedom of the individual. Emphasis on individuality in art and literature, accordingly, can only make sense in a society that respects the freedom of the individual. In practice, though, respect for the freedom of the individual in society is, generally speaking, impossible to separate from the history of bourgeois society in the West. In this sense too, then, there was a deep gulf between Japanese literature at the end of the nineteenth century and nineteenth-century Western literature. This point, however, has already been discussed, and there is no need to go into it in detail here. It is enough here to make it clear that the West in the nineteenth century, in its literature as well as its music and art, had an extraordinarily well-defined nature of its own, and one that was purely European.

In the case of painting and sculpture, the broad contact with arts outside those of Europe made possible by recent advances in techniques of reproduction have gradually weakened that exclusively European nature, and the same kind of effect, one imagines, has been achieved by the advances made in techniques of recorded sound-reproduction. Even in literature, the greater availability of translations from foreign languages must have worked to a certain extent in the same way. Nor is it merely a question of convenient techniques of reproduction; modern technological advances have made it easier to move works of art, and easier in particular for artists to travel. The Impressionists managed somehow to scrape an acquaintance with the *ukiyo-e* woodblock print, but of other art outside Europe, whether it were from Ajanta or Tung-huang or the Hōryūji, they knew nothing. They knew nothing of the ink monochromes of Sung and Yüan China, nothing of the sculpture of black Africa, nothing of Etruscan art, nothing of Peru

or of Mexico. Even within their own past, it is safe to say that they were not qualified to make any adequate evaluation of Romanesque architecture and sculpture or even, where its painting was concerned, of Gothic art. The contemporary artist knows all of these through photographs and some of them probably directly through travel. It is the whole of world art. In relation to that whole, Western art since the Renaissance is seen to constitute only one, very special part. In the same way, the musicians of the West in the nineteenth century had probably never heard the music of India or Japan, and some among the audiences who went to concerts may never have heard any Palestrina or Purcell. Nowadays, however, thanks to the high degree of development achieved by reproduction techniques, "music"—not only for Olivier Messiaen but for the Californian housewife, even—does not mean only music from Mozart to Wagner, but the whole of music, of every age and every race, from Palestrina to Schoenberg, from the songs of Arabia to the instrumental music of India. Even Schoenberg's most "advanced" music, as I said earlier, sounds unmistakably Western on account of its rhythms and its use of strings. But Pierre Boulez's *Portrait de Mallarmé*, despite Mallarmé's verses, no longer sounds completely Western either in its tonality or in its rhythms or in the orchestra it uses. The question is no longer whether something is Western music but whether it is music. In this sense, modern music can be likened to modern art. The modern art of the West may resemble the masks of Africa, or Etruscan bronzes, or the two-dimensional pictures of Byzantine art, or the calligraphy of China and Japan—anything, in fact, rather than the art of Renaissance Italy. The Impressionists opened the way to painting without mixing colors. Picasso discarded the classical idealization of the human form, and Matisse abandoned the attempt to make a two-dimensional surface appear to be three-dimensional. Especially in painting, the "West," as typified by the glorification of fifteenth-century Italy, can be said by now to have lost all its basic characteristics. Even the man of letters lives today in surroundings very different from

those prevailing at the end of the nineteenth century. For him, literature no longer means Western literature since Homer; it also means the Near East since *Gilgamesh,* China since the *Shih-ching,* and at least some parts of Indian and Japanese literature. Translations of the classical literature of areas outside Europe are today within the reach of the masses.

It goes without saying that the extension of the modern concept of art to embrace areas outside Europe was not due exclusively to the technological advances that made photographic and translated sources readily available. While such technical means vastly increased Europe's knowledge of arts other than its own, it did not change its evaluation of them. An increase in knowledge is a necessary condition for a change in evaluation, but is far from sufficient in itself. To take Romanesque sculpture, for example, the question was not so much that nineteenth-century Europe did not know it but rather that no value was attached to it. The idea of the West as the center of all art is only one aspect of the idea of the West as the center of all culture. The idea of the West as the center of culture postulates a view of the world based on belief in an absolute being. So long as that view remains unshaken, then the West, like Claudel's Columbus, can look at any amount of Mexican sculpture without recognizing its value as such; for all truth, all justice, and all light reside in the West, outside which there can be nothing but error and evil and darkness. The European system of values, including of course, values in art, was absolute, recognizing no system outside its own. It was such a system of values, directed outside Europe, that made possible the Crusades in the Middle Ages, that justified the campaigns to destroy the cultures of Central and South America by the Spaniards in the sixteenth century, and that provided the pretext for the colonial imperialism of Britain and France in the nineteenth century. Even the notorious Opium War, for example, was described by British Prime Minister Palmerston as a war that would undoubtedly promote "the civilization of mankind" as well as British commercial interests. Not only was "the civilization of mankind" identified

with the culture of the West, but it corresponded almost exactly with British commercial interests! There was little likelihood, while colonial imperialism was at its height, of any breakdown in the view of the West as the center of all culture, and so long as the breakdown did not occur, there was little hope of a Ruskin being persuaded to take seriously an art so far from that of the pre-Raphaelites as that of the Chinese. However, by time colonial imperialism arrived at an impasse and after two world wars found itself almost entirely bankrupt—even before that, from the eighteenth century on, the basis of the view of the West as the center of culture was beginning, slowly, to break down. It was the process of secularization that gradually took place within Western culture itself. When Western art ceased to be created in the service of an only God, it became difficult—at least in theory —to maintain the idea of Western art as the only art. Once the musician of the modern age emerged from the church and began to write for concert performance; once the artist began to portray windmills in Holland, cows at pasture in Normandy, or the postman at Arles instead of the Blessed Virgin —then the latent possibility existed of seeing some value in the music of India and the painting of China. The reasons why the West in the nineteenth century did not, in practice, abandon its egocentric view of world art was that the tradition was too deeply ingrained; that knowledge of Indian music and Chinese art was still confined to the merest handful of specialists; and that colonial imperialism in every respect regulated the attitude of Europeans to the world outside. The "contemporary" world did not come into being until secularization had become still more thorough, until tradition, once so firmly rooted, had bowed before irresistible logic of the twentieth century, until knowledge of non-European cultures became general, and until the age of colonial imperialism came to an end. Not until the contemporary age in this sense began did ideas of art become universal rather than something centered in the West. Not until the advent of the contemporary age is art evaluated as art, does it come to embrace all the

works produced in every area and every age by every culture. In the West today, there is no contradiction between not accepting the religion of the Congo, but nonetheless attaching high artistic value to the masks made for that religion. The reason is that contemporary Western society has established artistic value as a category separate from religion.

However, there is a difference between recognizing the value of the Congo masks and actually creating them. That is likely to be the overwhelming and inescapable impression of anyone who actually sees them—for instance, in the Museum of Congolese Art in Brussels. The men who made the masks saw in them a magical power—but, one suspects, no special value as art. On the other hand, the people who see artistic value in the masks could not themselves produce such powerful forms. In the Congo, there is artistic creativity; in contemporary Belgium, there is artistic appreciation. The creators of art do not evaluate, the evaluators do not create. Nor is this contrast confined to the Congo and Belgium, for it is found between fifteenth-century Belgium and twentieth-century Belgium too. In short, for the present age Van der Weyden's *Pieta* is nothing more than art in the same sense as is Cézanne's *The Card Players*. For Van der Weyden himself, his picture was almost certainly a *pieta* before it was art. That is why his *Pieta* is superb.

In the *pietas* of medieval Europe and the Bodhisattvas of Six Dynasties China were conjoined each society's system of values and the artist's system of values. The theme was supplied by society, rather than discovered by the artist. The artist worked out his style as he handled the themes provided by society. The style is realized through the medium of the individual, but it also transcends him. Both the Gothic style and the Six Dynasties style can be considered to have persisted for at least three centuries. During these periods, the artist displayed his individuality within the framework of given themes and a given style. But the display of individuality was not his goal. That is why even the names of the great artist of the Villeneuve *Pieta* and the great sculptor of the Northern Wei

head of a Buddha are unknown to us. Nowadays, however, there is no meeting-place in art for society's system of values and that of the artist. The secularization of culture in a bourgeois society has brought with it the alienation of culture, or at least of art. As on the one hand the earning of money has become the principal interest of society, the artist has created a micro-society of artists (and art lovers) in which art is an end in itself. Beginning in the literary salons and the cafés, the movement spread from Montmartre to the left bank of the Seine, and has lain in the background of a series of phenomena extending from Greenwich Village to the literary and artistic world of Tokyo. The "series of phenomena" in question can be summed up as the alienation of the artist in bourgeois society. The artist's disheveled locks, the difference in appearance today between the man of literature and the bank clerk, are undoubtedly a superficial manifestation of this alienation. The artists of Renaissance Italy were by no means always unkempt, nor were French men of letters in the reign of Louis XIV invariably eccentric in their dress. Every dissonance between the artist and society began with Romanticism and the nineteenth century and bourgeois society. Ever since that time, society and the artist have been moving in different directions. Society no longer provides the contemporary artist his themes. He choses them himself. He paints an apple, or his own wife—anything, in fact, but Virgin Marys. He even has to choose his own style. Admittedly, there have been a number of recognizable movements in the Parisian artistic world since Impressionism—Surrealism, Cubism, Fauvism, and other new attempts occurring at about ten-year intervals. But even allowing for the enormous stepping-up in the general pace of social change, none of these could be compared with the three hundred years of the Gothic or Six Dynasties styles. Style, too, has nowadays to be created by the artist himself; which means that the contemporary has been obliged to concentrate on the display of individuality.

However, such a display does not in itself make art. To create art is to create new forms. Contemporary artists of

today, alienated as they are from society, are obliged to create a new world of form apart from society, a world based solely on individuality. The realistic depiction of life is not possible today because the world created by the artist must be as different as possible from the real world. Reality can only find a place as a weapon for criticism and accusation, which in the case of art implies *deformation* that exaggerates the ugliness and evil of the world. This state of affairs is neither a temporary passing fashion nor a product of the whim of individual artists. So long as the artist's values and those of society are estranged, so long as the artist is alienated from society, it seems unlikely that this situation is going to change.

What is called "abstract painting" is no more than an extreme expression of the artist's determination to create a world completely different from the world we see about us every day. It is for basically the same reason that figurative painting is accompanied by out-and-out deformation. Deformation is either a depiction of the world as it never was (as in Rouault), or a portrayal of the evil of the world (as in Dubuffet). Nor does this apply to painting only. On the one hand, *Jeanne d'Arc au Bûcher*; on the other *Wozzeck*. On the one hand *Joseph and His Brothers*, on the other *Felix Krull*: the essential question in contemporary art is not whether it is abstract or not, whether it is realistic or not, but the fact that art does not accept society as it is. It is not simply that culture, in that society, has been secularized. Nor is it simply that the desire for wealth and material comfort have become the focuses of interest. Society has been organized and technologized. The organization buries the individual, and technology methodically trains the human in how to think. This training, however, gives no clue as to how to create method. Creative scholarship may lead to technological advances, but technology is unlikely to lead to creative scholarship, much less art.

However, in trying to expel "society" from his creative activities, the artist also tends to drive out all elements that are the province of other arts. His reason for seeking to expel "society" is to create a world different from the society about

him, and to use that difference as a means of protecting the artistic value of his work; without a sense that the artistic value of his work is imperilled, he would never make the conscious effort to break with society. And, feeling that artistic value is imperilled, he naturally becomes sensitive concerning the inner harmony and organization of his work. The inner harmony and organization of a work become closer-knit by the removal of all elements that are not necessary to that particular art (that are, thus, accidental). The poet removes all things that are not poetic from his poems; the architect removes all thing that are not, properly speaking, architectural from his buildings; and the artist removes from his canvases everything that is not pictorial—anything "three-dimensional," for example, or anything that is literary. It is this that lies beneath the logic of the movement towards "pure poetry," "pure architecture," and "pure painting." It was precisely such a movement that occurred between the end of the nineteenth century and the early twentieth century.

The French poet Mallarmé tried to rid poetry of its prose elements. The "prose" elements were to be found, for instance, in the function of words as symbols. The pursuit of the purely poetic function of words implied an attempt to handle words not as symbols, but as things (in the same way as oils in painting, or sounds in music). What Mallarmé sought to do in his work was to strip words of their symbolic function. Words, unfortunately—even in the collections of Mallarmé's verse—cannot help but retain to some degree the meanings they possess in prose. The poet sought what was, essentially, impossible; and Mallarmé, naturally enough, lapsed into something close to silence. The prose element, moreover, represents our experience of everyday life; thus to pursue a purely "poetic" experience must be to deprive the world of poetry of the fruits of that everyday experience. First, all social restrictions are removed, then emotions that cannot escape social restrictions—so that, in the end, the act of versification itself is left as the only theme of verse. Mallarmé's poems are all in one sense *l'art poétique*, and the only thing they can lead to is silence. The

quest for pure poetry led, inevitably, to the denial of poetry. In painting, Mondriaan sought what Mallarmé sought in verse. One senses at work in Mallarmé's verse a firmness of purpose probably surpassing anything to be found in earlier nineteenth-century poets, and a sensative intellect that would not admit of the faintest suggestion of sentimentality (which did not, in other words trust in the accidental). Reviewing Mondriaan's work chronologically, one is made aware of an almost horrifying drama of the spirit. The attempt to rid painting of all non-pictorial (irrelevant) elements begins with the removal of the optical illusion that makes a two-dimensional surface seem three-dimensional. Form and color are divested of their symbolic functions and treated purely as objects. In other words, the only content proper to pure painting is a combination of line, surface, and color *per se*. If one reduces the line, surface, and color to their most basic elements—straight lines, and the surfaces they enclose, and primary colors—one arrives naturally at Mondriaan's final conclusion. Mondriaan did not conceive of this solution all at once; he started with what seemed to be figurative landscapes in the Expressionist style, and followed a long path before he finally reached—or rather, was forced to—that conclusion. His last works divide a rectangular canvas by means of a number of irregularly spaced, straight black lines running vertically and horizontally, and fill the rectangles thus created with red, yellow, blue, and other relatively simple colors. The result can hardly be called a "painting" any more. Anyone, it might seem, could without difficulty make a similar painting (but it would only be superficially similar, not the same; it is not particularly difficult to distinguish a Mondriaan from imitations), with the result that there appeared a succession of artists who imitated his style. Mondriaan had peeled the layers off the onion of painting, and when he had done there was scarcely anything left at the heart. To take an almost nonexistent heart as one's model is the height of foolishness. To understand why he peeled off so many layers—or why he was forced to peel them off—is to understand Mondriaan's greatness. To understand Mondriaan's greatness is to understand

Mallarmé's greatness, and to understand Mondriaan and Mallarmé is tantamount to perceiving the inner logic, not only of modern painting, not only of modern verse, but of modern art in general.

The German architect Gropius embarked on the purification of architecture via the Bauhaus movement. According to Gropius himself, the Bauhaus aimed not simply at functionalism, but at the creation of new architectural space. Creative work requires a vision founded in the imagination; this vision varies from architect to architect, and the buildings of Gropius were, indeed, different from those of Le Corbusier or Wright. Yet if one sees a baroque building and a modern building side-by-side in a European town, one can see almost at a glance what are the general characteristics of modern architecture. Modern architecture is a product of structural needs and no more. Or rather, it rejects all ornament that is divorced from the structure. This did not happen, of course, by chance, but was the result of a conscious quest after the purely architectural on the part of modern architects. The quest after the pure poem or the pure picture was, as we have seen, like peeling the layers of an onion, but the quest for pure architecture was not necessarily so, for a good reason. Whereas the poem and the painting are ends in themselves, architecture must always serve an end that transcends itself. There can be no "architecture for architecture's sake." Architecture means dwellings or art galleries or assembly halls. The fundamental differences between fifteenth-century painting and modern painting is that the former transcends painting, while in the latter painting is its own goal. Thus the road to pure painting was the road to the empty canvas. There is no such fundamental difference, however, between the thirteenth-century cathedral at Rheims and the Guggenheim Museum in New York.

The literary man who wrote prose did not take—nor could he have taken—the path followed by the poet, the artist and the architect. A pure poem is at least conceivable. "Pure prose" is quite inconceivable, so profound are the ties of prose with literature and with life. When the man of letters found himself

unable to accept the system of values prevailing within his society, and as he became increasingly aware of that fact—which is precisely the state in which contemporary literature finds itself—one of two phenomena occurred of necessity. Either he set up his own system of values, irrespective of society, or he concentrated in his literary activities on proposing a different set of values for society. An extreme case of the former is the eccentric writer, such as Kafka. An extreme example of the latter is the philosopher-author, Sartre, for example. In a secular, bourgeois society both the Catholic author and the Marxist author can be said to belong to the second category. The author in nineteenth-century Europe was neither eccentric nor philosopher. Nor was he a Catholic in the sense of, say, Graham Greene or a socialist in the sense of Bertold Brecht. It is true that the nineteenth century had its Nerval, its Kierkegaard, above all its Dostoevsky. But these were modern writers who happened to live and die in the nineteenth century. The age in which they lived did not know them. The eccentric is eccentric because he totally ignores the conventions of bourgeois society, and the philosopher is a philosopher because he seeks universal concepts that transcend those conventions. If contemporary literature is characterized by eccentrics and philosophers, it means, almost certainly, that contemporary literature transcends the traditional culture of Western bourgeois society. There is no international style in literature, but in its essence contemporary literature shows a universal trend of a kind.

When one looks at this general configuration from a Japanese vantage point, it is apparent that it was not only Japan that was "opened up" following the end of World War II. In the mid-nineteenth century, when Japan first set about the commercial and technological opening-up of the nation, the art and literature of the West were still closed. Today, in the mid-twentieth century, when Japan has embarked on an intellectual opening-up of the nation, the art and literature of the West are also far more open. There is no reason to suppose that the indigestion induced in Japan before World War II

by the one-sided introduction of Western culture will occur again as a result of the exchanges of this postwar era. Both sides have changed too much for that. The importance of the other side's having changed lies in its bearing on the universality of the concept of art. Once a universal concept is created, no matter who is responsible, it belongs to everybody. We have already accepted that idea where science is concerned, and almost certainly, in the years ahead, we shall come to accept it in contemporary art as well.

Acknowledgments

I wish to acknowledge with thanks the work of Mr. John Bester, who translated from the original Japanese seven of the eight essays of this book ["Introduction" and "Notes on Sōtatsu" were written in English by the author]; the effort of Lorna Price, University of California Press, in editing the manuscript; and the valuable suggestions offered by Mrs. Hilda Kato while the manuscript was being written.

Several people have kindly assisted me in obtaining photographs of various works of art and permission to use them in illustrating this book. Thanks are due Mr. Takasaka Tomohide, who himself made three photographs (pls. 43, 44, 45), and arranged to provide numerous others through the archive of Iwanami Eiga; to photographers Irie Yasukichi, Sakamoto Manshichi (pls. 12, 34, 35, 42); and to the National Museum (pl. 6), the Yamato Bunkakan (pl. 36), and the Gotō Museum (pl. 35) for permission to reproduce works of art in their holding.

Works Cited

Alain. *Système des beaux-arts* (ed. nouv. avec notes), Paris, 1926.

Bréhier, Louis. *L'art chrétien, son développement iconographique, des origines à nos jours* (2ᵉ ed.), Paris, 1928.

Fenollosa, E. F. *Epochs of Chinese and Japanese Art*, Vol. I, New York, 1963.

Focillon, Henri. *Art d'Occident* (2ᵉ ed.), Paris, 1947.

——. *Vie des formes* (2ᵉ ed.), Paris, 1947.

Gropius, Walter. *Scope of Total Architecture*, New York, 1962.

Kobayashi, Takeshi. "Fujiwara Jidai no Chōkoku," *Sekai Bijutsu Zenshū* (Heibonsha), XV, Tokyo, 1954.

Kuno, Takeshi. *Nihon no Chōkoku*, Tokyo, 1960.

Minamoto, Toyomune. "Kamakura Muromachi Jidai no Chōkoku," *Sekai Bijutsu Zenshu*, (Heibonsha), XV, 1954.

Mizuno, Seiichi. "Asuka Hakuhō Butsu no Keifu," *Bukkyō Geijutsu*, No. 1, 1949.

Paine, R. T. and A. Soper. *The Art and Architecture of Japan*, London, 1955.

Ueno, Naoaki. "Kodai no Chōkoku," *Sekai Bijutsu Zenshū* (Heibonsha), IX, Tokyo, 1952.

Wölfflin, Heinrich. *Kunstgeschichtliche Grundbegriffe* (8th ed.), Munich, 1943.

Worringer, Wilhelm. *Abstraktion und Einfühlung* (new ed.), Munich, 1959.

——. *Griechentum und Gothik*, Munich, 1928.

Yashiro, Yukio. *Two Thousand Years of Japanese Art*, New York, 1958.

Index

Index